P9-DMY-759

ROBERT

SPENCER

The Cities, the Towns, the Crowds: The Paintings of

ROBERT SPENCER

BY BRIAN H. PETERSON

JAMES A. MICHENER ART MUSEUM
Bucks County, Pennsylvania

UNIVERSITY OF PENNSYLVANIA PRESS
Philadelphia

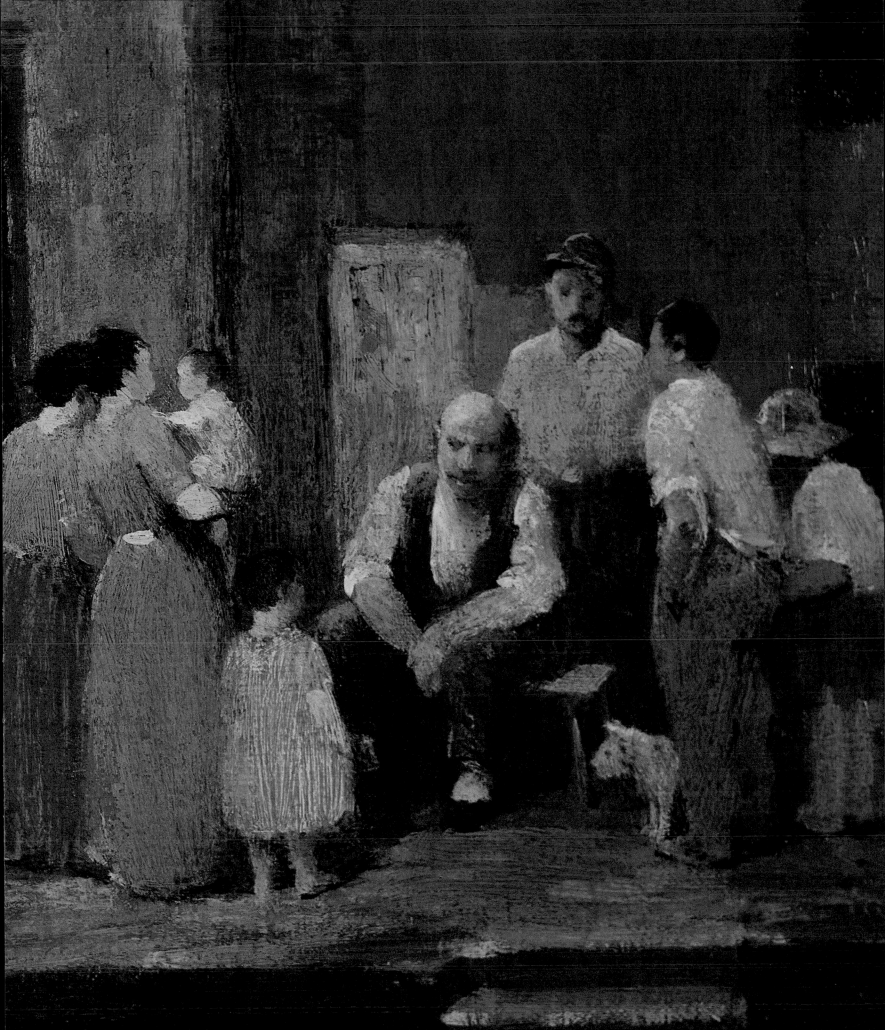

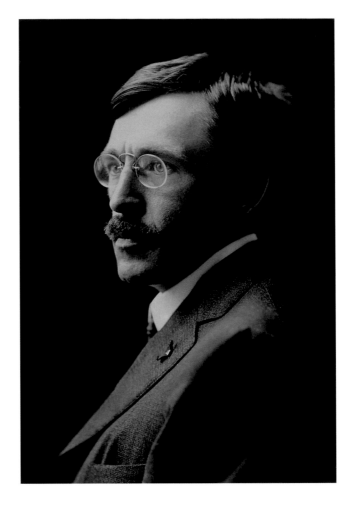

*"A landscape without a building or a figure is a very lonely picture to me.
I love the cities—the towns—the crowds."*

ROBERT SPENCER

Copyright © 2004 James A. Michener Art Museum
138 S. Pine Street
Doylestown, PA 18901
www.michenerartmuseum.org

Copublished by the James A. Michener Art Museum
 and University of Pennsylvania Press
4200 Pine Street
Philadelphia, PA 19104-4011
www.upenn.edu/pennpress

All rights reserved.

Designed by Jeff Wincapaw
Edited by Paula Brisco
Proofread by Sharon Vonasch and Carrie Wicks
Typeset by Jennifer Sugden
Photography by Will Brown, Shuzo Uemoto
Separations by iocolor, Seattle
Produced by Marquand Books, Inc., Seattle
 www.marquand.com
Printed and bound by C&C Offset Printing Co., Ltd., China

Library of Congress Cataloging-in-Publication Data
Peterson, Brian H.
 The cities, the towns, the crowds : the paintings of Robert
Spencer / by Brian H. Peterson.
 p. cm.
 ISBN 0-8122-3829-X (hardcover : alk. paper)
 1. Spencer, Robert, 1879–1931. 2. Painters—Pennsylvania—
Biography. 3. Impressionism (Art)—Pennsylvania. I. Title.
ND237.S644225P48 2004
759.13—dc22 2004003710

Frontispiece: *Near the Blacksmith's Shop,* 1914 (detail; pl. 43)
Page iv: Robert Spencer, ca. 1920. Courtesy of Shayla Spencer
Page v: *Woman Hanging Out Clothes,* 1917 (detail; pl. 48)
Page vi: *The Blue Gown,* 1915 (detail; pl. 44)
Page xiv: *The Other Shore,* 1923 (detail; pl. 36)
Page xvi: *A Day in March,* ca. 1918 (detail; pl. 29)
Page 20: *The Exodus,* 1928 (detail; pl. 68)
Page 26: *Washday,* ca. 1918 (detail; pl. 50)
Page 32: *The Marble Shop,* ca. 1910 (detail; pl. 5)
Page 48: *Wharves,* 1925 (detail; pl. 39)
Page 80: *Night Life,* 1931 (detail, pl. 58)
Page 98: *The Upper City,* 1927 (detail; pl. 60)
Page 108: *Study for "The Exodus,"* 1927 (detail; pl. 67)
Page 122: *The Other Shore,* 1923 (detail; pl. 36)

Dimensions of works are cited with height preceding width.

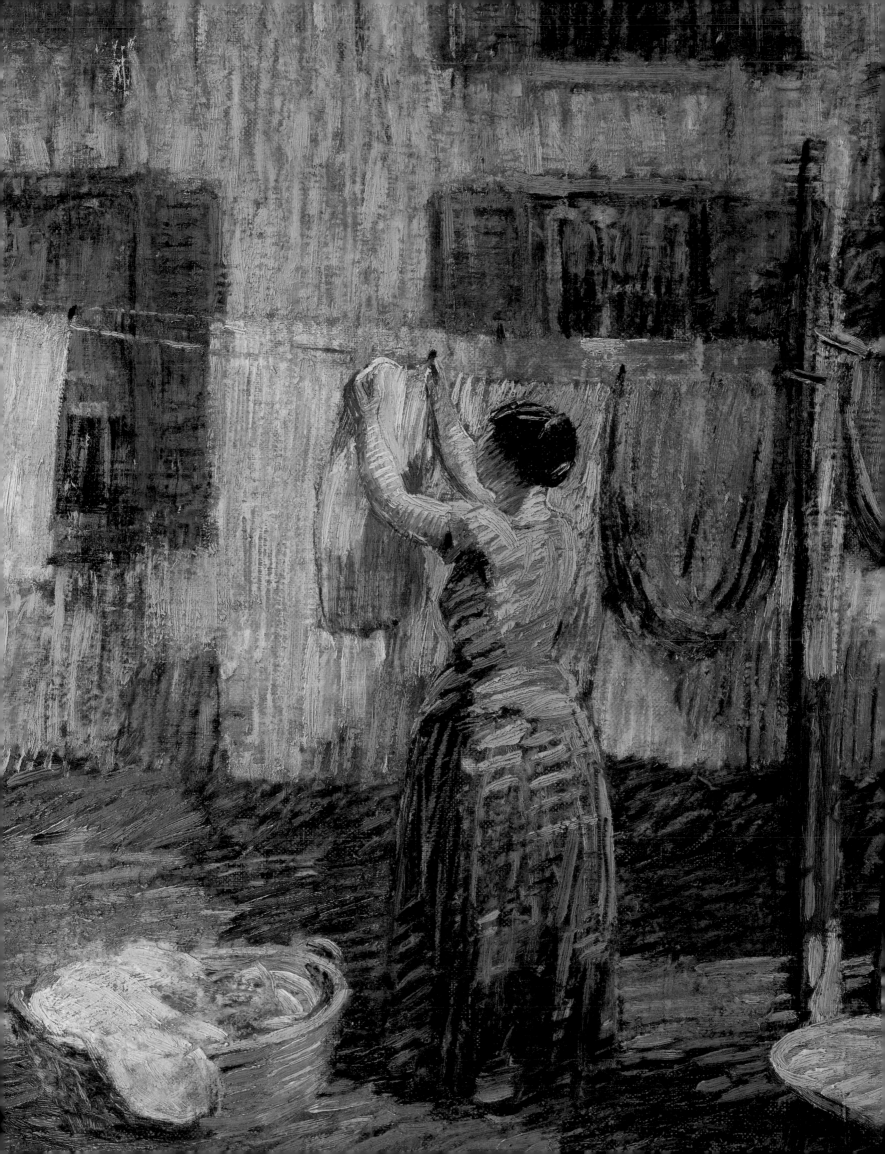

FOREWORD

The world of a Daniel Garber landscape is an ordered and optimistic universe. The golden light reveals trees, sky, riverbank, and perhaps a quaint but not-too-decayed barn with a nearby sheep or cow grazing peacefully in a lush field. An Edward Redfield snow scene portrays a similar universe despite the change of season. In Redfield's world, sunshine usually floods the landscape. A passing storm has deposited a soft blanket of pure white snow. The pristine splendor is broken only by the tracks of a friendly horse pulling a sleigh through the silent countryside. For both these artists the beauty of nature was emblematic of a kind of divinity whose presence is found in the everyday vistas that can still be seen from countless hilltops across all of Bucks County.

America may have been at war in Europe, the Great Depression may have put millions on breadlines, and influenza may have filled local hospitals with the sick and dying. That was not, in general, the world the Pennsylvania impressionists chose to depict. The Bucks County artists loved the land. They believed it was their mission to express that love by applying pigment to canvas, so that viewers could be inspired by what the artists saw and then reproduced in their paintings. With his characteristic rugged simplicity, Redfield expressed the prevailing mind-set best when he said, "Beauty should guide all who paint. What is the use of painting ugliness?"

One can't help but wonder what Redfield thought of Robert Spencer's rundown Bucks County mills, not to mention his washerwomen, revolutionaries, prostitutes, and thieves. Spencer's universe was radically different from that of his Pennsylvania impressionist colleagues, but it could be argued that Spencer loved his canal workers and tenements just as much as Redfield loved his rustic villages and babbling brooks. Spencer was captivated by the energy and hubbub of daily life, and by the inherent character of buildings that showed the wear and tear of the decades. Perhaps Spencer would have argued that his world was, in its own way, just as beautiful as Redfield's. That is one of the challenges of Spencer's work: to see his subject matter and style not from the vantage point of the brightly lit impressionist palette, but with the fresh eyes that the artist himself brought from New York City to Bucks County in 1906.

Another challenge with Spencer is understanding the man himself and the relationship between the man and the work. The life of Robert Spencer was far from perfect. Clearly he suffered from some form of acute, chronic depression that gradually took control of his life, until eventually, as he said, life was "bitter in one's mouth." While he and his wife, Margaret, loved each other intensely, his marriage turned sour, and conflict sprang forth at every dinner party and family gathering. Margaret retreated to her studio (she had the only key), while Robert haunted the harbors of New York City, making sketches of tugboats and longshoremen. One day he even hid in the family's well with an oil lamp and a book because he wanted to avoid some guests! This brooding man made canvases that sometimes appear to reflect this worldview, with their muted tones and tired, bedraggled factory workers. Near the end of his life, his personal struggles seem to be explored in a series of allegorical paintings that examine the conflict between the individual and the mob.

Often we look for handy, simplistic ways to sum up an artist's life and work, and with Spencer, a commonly heard refrain goes something like this: depressed, suicidal painter whose palette usually matched his mood. There is probably some truth to this assessment, but more often than not his work is colorful, energetic, and full of the romance and vitality of the human animal. He was a skillful, imaginative, and at times even masterful artist, and he was one of the most successful of the Bucks County painters in terms of exhibitions and awards. In the end it may be his very struggles, in addition to his obvious abilities as an artist, that draw us to admire his work. Who, after all, has not had a bout or two of depression? The fact that Spencer could rise above his illness and create so many powerful and beloved works of art is a testament to his passion and inner strength.

It's interesting to imagine what the Pennsylvania impressionist school would have looked like if Robert Spencer had remained in New York City. His ability to find beauty in the commonplace was a healthy counterpoint to the more traditional notions of beauty in the landscapes of Garber and Redfield. Spencer's paintings are perhaps the most concrete indication that the Pennsylvania impressionists did not have a monolithic style or a single worldview. His work adds depth and character to the phenomenon of Pennsylvania impressionism, and it stands as powerful evidence that there were almost as many forms of impressionism as there were impressionist artists.

Once again the James A. Michener Art Museum is proud to publish a book authored by our senior curator Brian H. Peterson, who spent more than four years studying the life and work of Robert Spencer. Brian's careful research and skillful writing help us not only to appreciate Spencer's paintings but also to understand the compelling and tragic story of the gifted artist who made them. This book is Brian's third publication about the Pennsylvania impressionists, following his monograph on William L. Lathrop (1999) and the major publication *Pennsylvania Impressionism* (2002). In addition, Michener curators have published significant books on Edward Redfield (Constance Kimmerle) as well as the Bucks County framemaking tradition and the painter Roy C. Nuse (Erika Jaeger Smith).

This growing body of work represents the intellectual foundation of the Michener Art Museum, and adds greatly to our understanding and appreciation of the art colony that flourished in New Hope in the first half of the twentieth century. Supporting original research and publications has been a core value at the Michener since its birth in 1988. It is my belief that museums must do much more than just collect and preserve objects. The museum has a responsibility to understand the significance of its collections and to share that understanding with a wide audience. Publications such as this one are one of the most important ways of fulfilling that responsibility.

BRUCE KATSIFF
Director and CEO
James A. Michener Art Museum

PROJECT FUNDERS

This book was made possible by major gifts from Louis and Carol Della Penna, Kathy and Ted Fernberger, and Carolyn Calkins Smith.

SPONSORS

Anonymous
Bonnie J. O'Boyle
Thomas and Karen Buckley
Rhoda and David Chase
Gregory and Maureen Church
Joe Conti, State Senator Tenth District, Bucks County
Lee and Barbara Maimon
Willys and Abigail Silvers

Additional support was provided by The John F. Folinsbee Art Trust, Owen Medd, Ralph S. and Bette J. Saul, Tom and Linda Tompkins, and Bill and Cathy Rieser.

Research for this project was supported by a travel grant from the Philadelphia Exhibitions Initiative, funded by The Pew Charitable Trusts and administered by The University of the Arts.

The Robert Spencer exhibition at the Michener Art Museum was sponsored by:

Acme Corrugated Box Company
Colligan's Stockton Inn
Kreischer Miller
3D Printing and Copy Center, Inc.

ACKNOWLEDGMENTS

It's easy to forget that exhibit and publication projects involving original research often are a form of story-telling. This is especially true when the project focuses on an artist like Robert Spencer, whose life had an element of tragic theater. But even with creative people who led a more ordinary existence, the work the artist made grew out of the life he or she experienced. Simply recounting the facts about that life, without attempting to uncover and communicate the story in all its drama and detail, ultimately doesn't do justice to either the life or the work.

In a much more mundane way, the exhibition project itself usually unfolds like a story. It has a beginning, middle, and end; it has elements of tension and mystery; and it has interesting and colorful characters who crop up when you least expect it. At each significant moment there are people who get involved, giving freely of their talent and knowledge, thus helping to drive the tale toward its conclusion.

The Spencer project began in 1999, when our William L. Lathrop retrospective was about to open, and I was chatting with the Michener's Director and CEO Bruce Katsiff about where we should go next with our research activities. I had already decided that I wanted to work on Spencer; Bruce was excited about the idea and gave it his full support. I continue to be grateful for his inspired leadership of our museum, as well as his enthusiasm for the research and writing that are the core of what makes this job meaningful.

In the initial stages of a project, there are two major problems: 1) Where are the pictures, and are they accessible? 2) Where are the primary source materials for information about the artist's life? Between the many private owners and institutional collections, it

was clear early on that it would not be difficult to find Spencer's paintings. But in researching the man himself, we had very little to work with at the beginning. Dr. Thomas Folk did important original research on Spencer in the early 1980s, and his work provided a foundation for our efforts. But our goal was to produce a more detailed treatment of the artist, and several people were particularly helpful as we attempted to acquire the documents, letters, interviews, articles, etc., that allowed us to piece together more fully the story of Spencer's life.

Richard Duffield, of the law firm of Duffield Young Adamson & Alfred, P.C., in Tucson, Arizona, was managing the legal affairs of the estate of Spencer's daughter Ann Spencer Simon; Mr. Duffield gave me the address of Spencer's last living relative, Shayla Spencer, and also put me in contact with Charlotte Cardon, an acquaintance of the Spencer family in Tucson. Ms. Cardon in turn informed Diana Hadley, a historian at the University of Arizona, about the project. Ms. Hadley had already done considerable research on Spencer's wife, Margaret, as part of the background research in preparation for a National Register of Historic Places nomination for the Las Lomas property in Tucson, designed by Margaret. My father and I enjoyed a sunny November afternoon in Tucson courtesy of Ms. Hadley, who gave us a guided tour of Las Lomas.

Several other people were very helpful during the early research phase. Michael Jayne, the custodian at the Michener, told me about an acquaintance of his who had done extensive research on Spencer, Michael Holt. As an outgrowth of his interest in the artist after acquiring a Spencer painting, Mr. Holt

had accumulated an enormous amount of original material, including letters from Ann Spencer Simon and a transcription of a lengthy interview with Ms. Simon. Mr. Holt kindly loaned the fruits of his research to the Michener. So even though Ann had died by the time I began to work on the project, I was able to draw on Mr. Holt's material and thus gained access to Ann's direct memories of her father.

Following the advice of Malcolm Polis, the owner of the Plymouth Meeting Gallery, I contacted Gene Mako, a gallery owner in Los Angeles who was a colleague and friend of Spencer's daughter Margaret (Tink). I traveled to Los Angeles to meet Mr. Mako, and spent a few hours in his office (actually a converted condominium), which was so full of paintings that there was barely room to sit down. Tink Spencer was especially haunted by the life and death of her father, and in the late 1960s and early '70s formed an association with Mr. Mako, with the purpose of producing a full-scale, illustrated Spencer biography. The book was never completed, but Tink—who was a serious and skillful writer—produced several rough, unfinished drafts of the manuscript. These drafts include a handwritten sketch and two partial versions of the story, one running sixteen typewritten pages and the other more than fifty pages. At some point in their association Mr. Mako purchased this and other Spencer-related material from Tink; in 2002 he kindly loaned it to the Michener Art Museum for use on this project. While Tink's manuscripts have many factual errors, she had a colorful and down-to-earth prose style, and her vivid memories of her father and mother were invaluable as I tried to figure out what life was really like in the Spencer household.

I must express my deep gratitude to Tink's daughter, Shayla Spencer, who patiently endured the presence of both myself and my wife in her house for two days. Ms. Spencer gave me complete access to all her family albums, photographs, and paintings, as well as her vivid memories of her grandmother Margaret, whom she knew very well. I also want to thank several other people who provided direct recollections of the Spencers in telephone interviews: Joan Folinsbee Cook and Beth Folinsbee Wiggins, Suzanne Hoelzl, Stephen Price Bredin, and Nora Lathrop Grimison. These people were children in New Hope when the art colony was in its heyday, and their memories of this period helped to flesh out the story as well as confirm some of the key facts.

A book like this one contains literally thousands of pieces of information, and there are few moments in the life of a curator worse than opening up his or her tome for the first time and seeing a mistake. One's own sense of chagrin is bad enough—but inevitably someone else will see the error and will not hesitate to share the discovery with the author. I'm therefore greatly indebted to three people who assisted in countless ways with the research on this project: Birgitta Bond, Mary O'Brien, and Owen Medd. Their work not only broadened the scope of the background research for this book, but also allowed me to verify many of the more esoteric minutiae such as the genealogy of Margaret Spencer (Robert's wife), the details of Solomon Spencer's life (Robert's father), and even the life story of the amorous suitor of Tink Spencer (Robert's daughter). Birgitta conducted an extensive search of both the Spencer and Charles Rosen files at the Archives of American Art, which yielded a wealth of important information. My favorite factoid—and Mary gets the prize for this one—comes in footnote 80 of the biography, where we learn that the sister of Tink Spencer's suitor was the grandmother of actress Brooke Shields.

Many other people assisted during the research phase: The Spencer/Duncan Phillips chapter of this book would not have come to fruition without the aid of Karen Schneider, the Librarian at The Phillips Collection. Other people who helped with research include Carl David of the David David Gallery in Philadelphia; the descendants of the Hendrick family; Cheryl Liebold, Archivist at the Pennsylvania Academy of the Fine Arts; Carroll Odhner, Library Director, Swedenborg Library, Bryn Athyn College; Elizabeth Botten, Interlibrary Loan Coordinator, Archives of American Art, Smithsonian Institution; Maureen McCormick, Chief Registrar, Princeton Art Museum; Betsy Rosasco,

Research Curator of Later Western Art, Princeton Art Museum; Rosemary Switzer, Seely G. Mudd Manuscript Library, Princeton University; Margaret Stenz, Andrew W. Mellon Research Associate in American Art, Brooklyn Museum of Art; Michael Jaeger Smith; Chantell Van Erbe; Susan Larkin; William H. Gerdts; William Rybolt; Lonnie Dunbier; Martha Gyllenhaal; Sandy Hoffacker; and Ellery Kurtz. Eleanore and Caleb Didrickson, who until recently were the owners of the Spencer house in New Hope, provided one of the most moving moments of the project by allowing me to visit the studio where Spencer died.

Gathering information about an artist is inevitably a highly social process, involving constant interaction with family members, researchers, collectors, etc. Consolidating all the information and ideas into readable prose is a more solitary journey, though along the way there are people who help to make the path clearer. I'm especially grateful for both the patience and skill of my wife, Helen Mirkil, who had to live with me while I labored for many months on the writing, and who edited my deathless prose when the writing was done. Bruce Katsiff and Erika Jaeger Smith also provided valuable editorial insight, as did my editor/buddy Paula Brisco, who as always managed to be insightful, sensitive, and firm at the same time. Judy Eichel helped out tremendously by transcribing the biography from my no doubt monotonous dictation.

Once the writing is done, the final stage is to make the object you are holding in your hands. This can be both exciting in its creativity and maddening in its details and deadlines, and I want to thank the folks at Marquand Books, whose professionalism and good humor made the process both enjoyable and routine: Jeff Wincapaw, Marie Weiler, Jennifer Sugden, Carrie Wicks, Marta Vinnedge, Larissa Berry, Michael Zuberbier, freelancers Matt Lechner and Sharon Vonasch, and of course fearless leader Ed Marquand.

This book simply would not exist without the generosity of the people who helped pay for it. These individuals donated significant sums toward the production of something that, until it was designed and printed, existed only in my head—a fact that never

ceases to amaze me. I am honored by their trust and share their belief in the power and necessity of books that explore the lives and life's work of deserving artists like Robert Spencer.

BRIAN H. PETERSON
Senior Curator
James A. Michener Art Museum

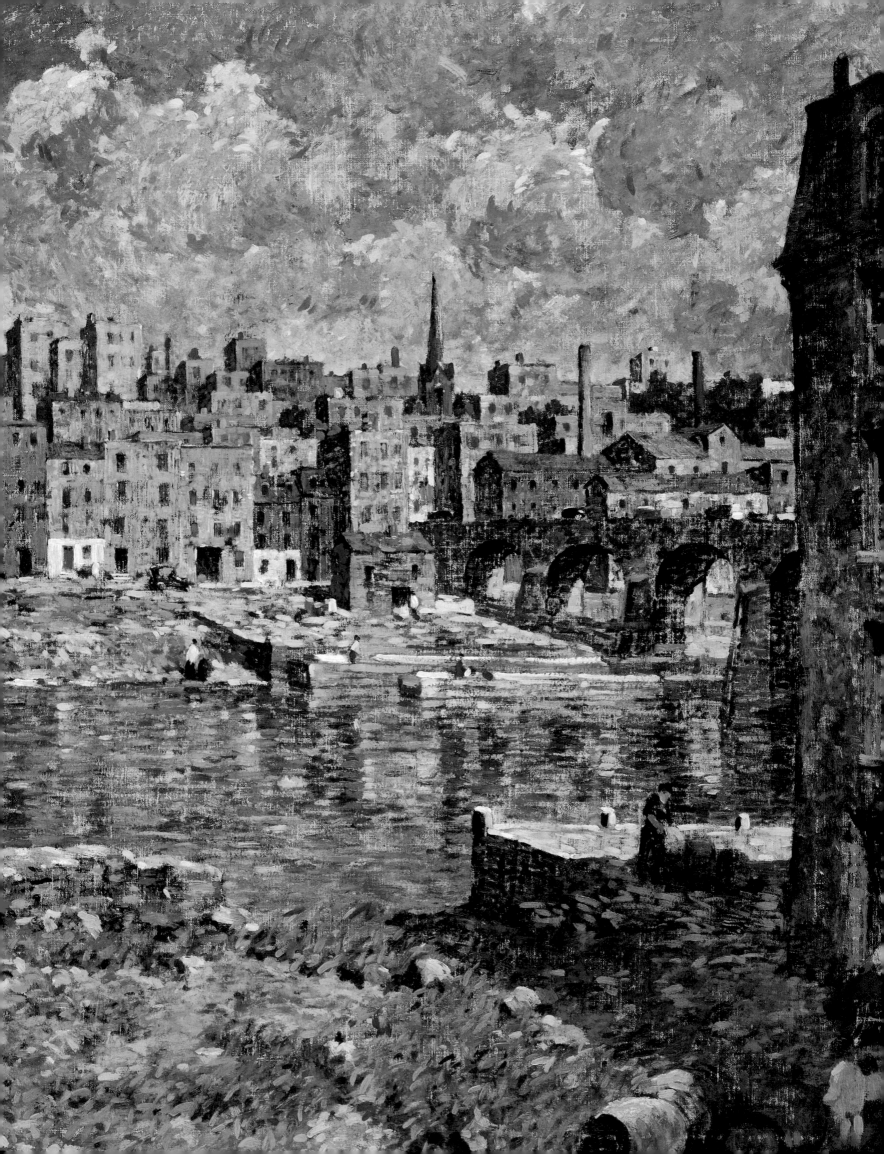

ROBERT
SPENCER

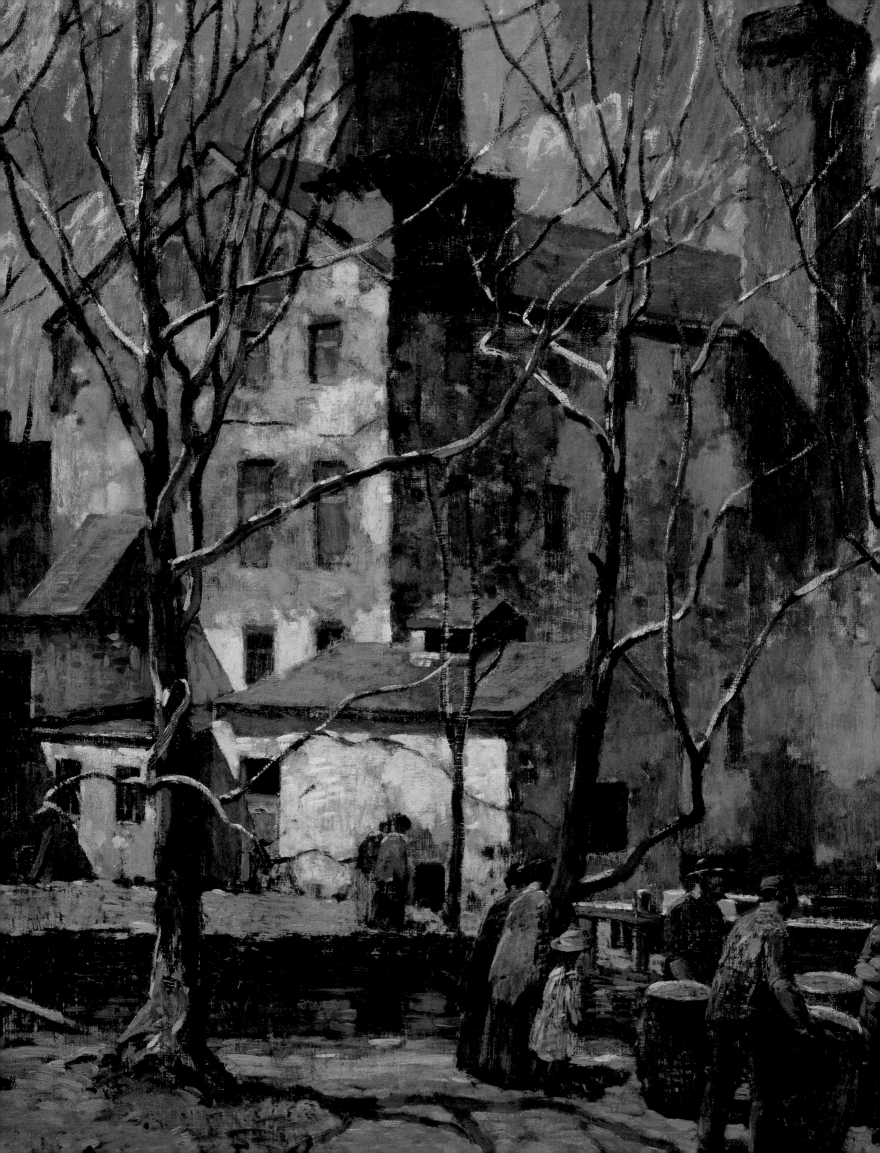

THE LIFE OF ROBERT

SPENCER

The easel was more than twelve feet high, and Spencer built it himself. He raised and lowered his paintings by turning a large crank, and steadied his contraption at the desired height by clipping a hook onto one of the dozens of horizontal wires that were strung, ladderlike, between two vertical poles. The wires were exactly one inch apart. According to his daughter Tink, "There were compartments directly under the picture support where he kept rags, turpentine, oils, and odds and ends that he wanted within hand's reach."[1]

In 1970, almost forty years after her father died, Tink finally found the bullet. It was embedded in the thick wood of his "monster" easel. She guessed that, after exiting the back of his skull, the bullet had sliced through the green velvet upholstery of his large easy chair, ricocheted off the chair's cast-iron frame, and slammed into the easel, which survived the blow unscathed.[2]

Robert Spencer didn't play around when he made something. He had built that easel to last.

If only his marriage had been as sturdy as his easel. Even their daughters had a hard time understanding the nature of the attraction between Robert and Margaret Spencer. "He had chosen a rather odd woman," said Tink, "in view of his own warmth and desire for loving. They positively thrived on battles—high-pitched, screaming tirades. . . . Peace in our family *never* lasted more than three days."[3]

Margaret's greatest desire in life was to be an architect. She studied architecture at the prestigious Massachusetts Institute of Technology— a courageous act for a woman of her era. Yet her husband, according to their younger daughter, Ann, "was no feminist, and did not feel that pursuit of a building career was appropriate for a woman."[4] Why, then, would Robert marry someone who "throughout her entire life repeated over and over, 'nothing a man can do cannot be done better by me'"?[5] The answer, said Tink, was that "he adored her."[6] And Spencer's granddaughter, who knew her grandmother well, feels very strongly that Margaret's love for her husband was just as intense, offering as evidence the fact that in the thirty-five years she lived after her husband's death Margaret did not have another serious relationship. "It was not for lack of suitors that she did not marry again after his death."[7]

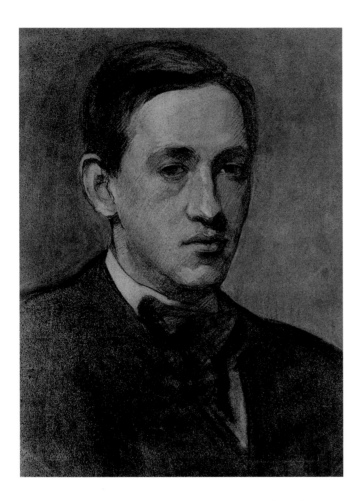

Figure 1 Robert Spencer. *Self-portrait,* 1909. Courtesy of Shayla Spencer

two children. Margaret later referred to her time in Bucks County as "the worst years of my life."[11]

Had they known what Spencer's children knew, the good people of New Hope would not have been so quick to blame his wife for his suicide. Of course it's impossible to diagnose his condition in retrospect, but he was not a well man. His daughter Ann believed that he suffered from chronic depression, and said, "His parents were always concerned about his mental health."[12] Apparently he kept this problem hidden from his brother, Joseph. When asked if Robert ever exhibited any signs of mental instability, Joseph replied, "Absolutely not. . . . I don't believe he was ever mentally ill, except perhaps something brought on by suggestion from those who did not understand his unusual temperament."[13]

Given what we now know about brain chemistry, it's difficult to conceive of the kind of debilitating depression that Robert suffered from being brought on by "suggestion." Perhaps Joseph was obliquely referring to Margaret's aggressive personality; indeed, it's hard to imagine her doing much of anything by way of suggestion. Whatever the nature of Robert's disease, and whatever or whomever triggered it, thankfully his condition did not prevent him from raising a family, building a career, and pursuing his true passion, painting.

Early Years

Late in his life Robert Spencer became a genealogy buff, and one of his favorite hobbies was exploring the graveyards of Quaker meetinghouses in search of his ancestors' tombstones. He may have been driven to this pastime by his wife, who "wanted to bring down her family tree on Rob's bowed head."[14] Margaret was a descendant of the man who perfected the steamboat's design, Robert Fulton, and two of her uncles were distinguished painters, Birge Harrison and Alexander Harrison.[15] She could also trace her lineage back to a Thomas Harrison, a major-general to the infamous seventeenth-century English politician Oliver Cromwell. Her mother was the subject of Thomas Eakins's famous painting *The Pathetic Song,* and Margaret was "raised in a world of wealth, comfort and respectability in Philadelphia."[16]

However much they loved each other, Margaret and Robert's marital problems worsened in the last few years of Robert's life. Margaret built her own studio (complete with kitchen and bedrooms) near the main house, and it was "off limits except by appointment."[8] She had the only key. Robert fled to New York City for weeks at a time, where he painted and sketched along the Harlem River waterfront. When he returned, "the battles started all over again."[9]

It was no secret that their marriage was in trouble, and when he killed himself, most of Spencer's friends blamed Margaret. She had done little to endear herself to the local community, and her flamboyant personality provided an easy target. One of their neighbors regularly referred to her as "that Amazon" when he saw her mowing the lawn.[10] The gossip after Robert's death was so fierce that she quickly left for Europe with her

To this Robert could reply that he was descended from English royalty (his family tree included an Earl of Spencer), and he was even a distant relative of both George Washington and Winston Churchill. While his noble lineage was useful when countering Margaret's teasing accusations, his favorite ancestor was in fact a pirate who terrorized the seas in the Caribbean in the service of Queen Elizabeth I. Perhaps the stories of a buccaneer in his family touched Robert's sense of romance and adventure. As Tink said, "With his dark complexion, coal-black hair, and animal-quick grace, he might have been [a pirate] himself."[17] And in his paintings he often was fascinated with far-off places and colorful stories, peopling his canvases with washerwomen, revolutionaries, prostitutes, beggars, and thieves.

Although most of Spencer's immediate ancestors were Quakers, his paternal great-grandfather earned his living in a most un-Quakerlike way, as the slave-owning master of a Virginia plantation. His father, Solomon Hogue Spencer, was an itinerant Swedenborgian clergyman, and the artist's mother, Frances Strickler Spencer, was the daughter of a buggy manufacturer. Her father also was a devout Swedenborgian, and Solomon met his future wife while preaching in Ohio.[18]

Robert Carpenter Spencer was born on December 1, 1879, in Harvard, Nebraska, where he lived for a grand total of three months. "My father changed his parish often," Spencer said, "so I never had what is called a home town."[19] From Nebraska the family moved to Henry, Illinois; Worth County, Missouri; Germantown, Pennsylvania; Ithaca, New York; Wytheville, Virginia; and finally to Yonkers, New York, where he graduated from high school in 1899.[20] According to his brother, Robert was "very sensitive and temperamental" as a boy,[21] and his family's rootless existence must have been difficult for him. But his life was anchored by a close relationship with his father, with whom he shared "a love of reading and the classics."[22]

Solomon Spencer (fig. 2) was a highly educated and literate man who studied classics at Oberlin College and Northwestern University. He began his career as a minister in a more traditional Christian church, but converted to Swedenborgianism and was trained as a

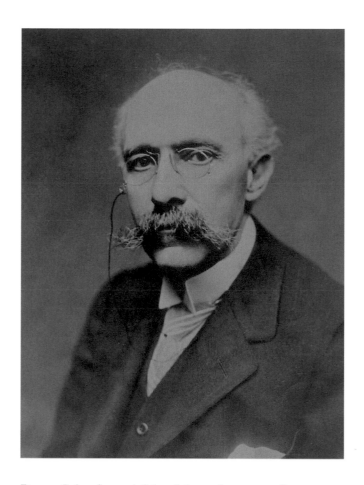

Figure 2 Robert Spencer's father, Solomon Spencer, ca. 1895. Courtesy of Shayla Spencer

minister in the faith in Cleveland. After the birth of his two children he found that he could not support his family, and he left the ministry for a few years to become a teacher. In 1884 he returned to the ministry, and a few years later became the cofounder, publisher, and editor of an influential Swedenborgian journal called *The New Christianity*. After his death in 1906, Solomon's obituary called him "a very kind and loving father, who did to the uttermost whatever he thought was for [his sons'] temporal and spiritual good."[23]

The Young Artist

The origins of Robert Spencer's interest in art are unclear. Other than his daughter Ann, there were no artists in his immediate family, and there's no record of an early mentor who helped to awaken the passion for painting. Yet his brother said Robert was "always

interested in art,"[24] and it's not hard to imagine that an artistic temperament could grow out of the intellectual environment in Solomon Spencer's household.

Robert was on the verge of entering medical school in New York City when he "suddenly decided to study art,"[25] and once he made the decision to be an artist he never looked back. As his brother worded it, Robert "would starve if necessary to paint."[26]

He received his foundation art training during a two-year stint at the National Academy of Design in New York City starting in 1899,[27] where he met a fellow painter who was to become both his friend and neighbor in Bucks County, Charles Rosen. Spencer also studied with two of the legendary figures in American painting, William Merritt Chase, at the New York School of Art, and Robert Henri, probably at the same school.[28] Apparently Chase spotted some talent in the young artist; after studying one of Spencer's canvases, the master was reported to have said, "You will make a painter, sir."[29] While Spencer no doubt appreciated this vote of confidence in his ability, he had mixed feelings about his early training in New York, saying later that "my real schooling began when I left the 'art school.'"[30]

Spencer moved to the Bucks County area in 1906, "following an unknown redheaded model in an off-again, on-again romance that left no apparent dent in his psyche."[31] His decision to uproot himself from a major city to a sleepy rural community was probably made easier because his friend Charles Rosen had moved there three years earlier. Two other well-known landscape painters, Edward Redfield and William L. Lathrop, also had lived in the New Hope area since the late 1890s, so Spencer could take comfort in the fact that he and Rosen would not be the only serious artists in the community. He lost his redheaded model to a farmer's son, but decided to stay in the area, spending the next few years living in several small towns along the Delaware River.

One of the most important events in Spencer's life occurred in the summer of 1909, when he both lived and studied with Daniel Garber at Garber's Bucks County home, Cuttalossa. Garber was actually a few months younger than Spencer, but had received a thorough schooling in figure drawing at the Penn-

sylvania Academy of the Fine Arts. Garber also had traveled and studied in Europe, and had just begun his lengthy teaching career at the academy.[32] He had much to offer his earnest young colleague. For several years Spencer's paintings showed the influence of Garber's dappled brush strokes and stable, orderly compositional habits, and it was soon after his study with Garber that Spencer finally came into his own as an artist.

Spencer's career successes in the next few years happened while his living conditions were less than ideal—though certainly colorful. For the grand sum of two dollars per month,[33] he and another artist, Charles Frederick Ramsey, rented a dilapidated building in New Hope known as the Huffnagle Mansion (fig. 3). The original structure was more than two hundred years old when the two young painters moved in. It had seen better days. Calling the house "a frayed and discolored ruin," Spencer's friend F. Newlin Price said, "Now the plaster had fallen in spots, the grounds were a riot of licentious weeds, the giant trees about it had been shattered by storms."[34]

Ramsey claimed the oak-paneled library on the second floor for his studio, while Spencer moved into the old ballroom on the main floor, which was connected to his friend's domicile by a spiral oak staircase. Their only heat in the winter came from two potbellied woodstoves that "boiled them at five feet and froze them at ten."[35] Heavy boots and overcoats served as both daily apparel and pajamas, and bodily functions were accommodated in a "two-holer" outhouse hidden away in the bushes. Always proud of his carpentry skills, Spencer built "a little swinging door in the basement so his cat could come and go from his night forays unhindered."[36]

In these lean years Spencer produced some of the canvases that he is best known for today, including three classic Bucks County mill scenes: *The Silk Mill* (1912; pl. 6), *Grey Mills* (1913; pl. 11), and *The Closing Hour* (1913; pl. 14). In 1913 he won awards at both the Art Club of Philadelphia and the National Academy of Design, and *Repairing the Bridge* (1913; pl. 15) was purchased by the Metropolitan Museum of Art the following year.

Despite these successes he was strapped for cash and sometimes fed himself by "raiding the farmers' hen coops and covertly scanning vegetable patches for stray

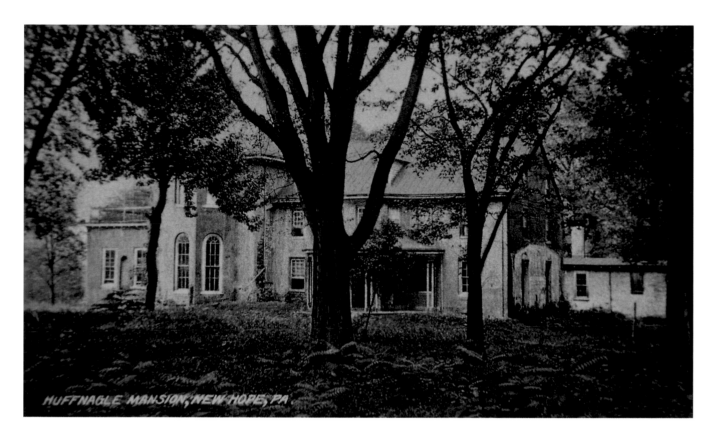

Figure 3 Huffnagle Mansion, ca. 1900–10. Collection of the Spruance Library of the Bucks County Historical Society

potatoes, corn, beans, and other succulent crops."[37] He also conceived of a rather creative way of paying his rent: painting crowd-pleasing pictures of sunsets and rainbows—what he called "potboilers"—and marketing them at department stores and other retail establishments in Philadelphia under the catchy pseudonym of "John St. John." Spencer even wrote a letter of recommendation for the illustrious Mr. St. John, under the letterhead of none other than Robert Spencer! Sources differ on the success of this scheme, but apparently at least one department store buyer proclaimed after seeing the letter that he indeed knew Robert Spencer's work very well, but that Mr. St. John's canvases were "too advanced."[38]

By the time Spencer moved into the Huffnagle Mansion, he had joined the long list of young artists who were "adopted" by William and Annie Lathrop. The Lathrops lived just north of New Hope, and their house at Phillips Mill was the favorite gathering place for numerous artists who were visiting the area or had migrated there from New York or Philadelphia. Will Lathrop was an accomplished landscape painter with a

national reputation, and for years he had been teaching informal art classes at his house. Often he would meet his students at the train station in New Hope, load them onto his "old tub of a whaleboat,"[39] and ferry them up the canal to a particularly picturesque spot where they would unfold their easels and set to work. Later they repaired to the lawn at Phillips Mill, where the English-born Annie served tea.

One of the students who took advantage of this idyllic learning environment was a talented young painter and architect named Margaret Alexina Harrison Fulton (fig. 4). Born in Philadelphia in 1882, Margaret Fulton had studied painting in New York City from 1903 to 1905 and architecture at MIT from 1907 to 1909, where she was the only woman in her class.[40] She was in her early thirties by the time she began to study painting with Lathrop. Spencer probably met Margaret in the summer of 1913 during one of his regular visits to the Lathrops' home. According to Tink, he "took one glance and announced to the rest of the community that THIS was his, hands-off, and stay the hell out of my territory."[41]

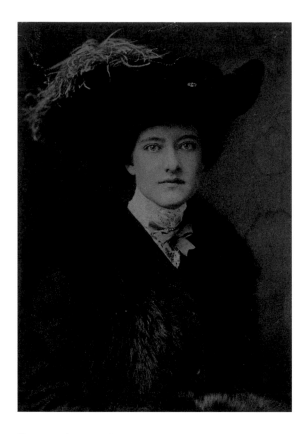

Figure 4 Margaret Alexina Harrison Fulton, ca. 1910. Courtesy of Shayla Spencer

Margaret learned of this purloined letter more than twenty years later, after both her husband and Mrs. Lathrop had died. One of the Lathrops' sons, Julian, discovered the letter and finally delivered it to its proper owner. "She never forgave the Lathrop family, even as an old woman of eighty-two," said Tink. "She brought it up to me a week before she died."[44]

Given Margaret's genteel Philadelphia upbringing, it would have been natural for her to have a fancy church wedding with all the trimmings. Ever the iconoclast, however, she opted for a short civil service at Phillips Mill, delightfully observed by the fourteen-year-old Elizabeth Lathrop:

Miss Fulton got so disgusted when she looked in the Ladies Home Journal and saw the fashions for some of the wedding gowns that she said she would never wear such awful things, so they thought they would get married in our house and they did. They were married Friday afternoon, the 27th of February. . . . Daddy gave her away, Mr. Colt was best man and I was the bridesmaid. . . . The service only lasted for about three minutes, then all of the neighbors came in and congratulated them.

Oh! I forgot to tell you that when they were just married, Miss Fulton said, "Now I've got you at last" to Mr. Spencer.[45]

It was a happy occasion—though at least one member of the family eventually developed bad feelings about that day. In a photo album under a picture of Robert and Margaret on their wedding day (fig. 5), someone later wrote the following cryptic message: "A chill wind . . ."[46]

Life in the Art Colony

Robert's wedding, of necessity, involved a change of address. "Margaret was damned if she was going to move her inherited antiques into the old Huffnagle Mansion along with Ramsey and the bats."[47] The young couple first lived in an apartment above the fire station across the river in Lambertville, New Jersey. While his marriage to Margaret ultimately proved to be unhappy, it certainly improved his life in one crucial respect: financially. Within a year or two, Robert went from an old woodstove and an outhouse at the Huffnagle Mansion to being the happy resident of a brand-new house—designed, built, and

Spencer had some competition for Margaret's hand, however, in the form of a well-to-do admirer from Philadelphia. Spencer's daughters' versions of this story differ slightly in the details, but both agree that Margaret's Philadelphia suitor sent her an important letter that dealt with the details of their wedding or at the very least an important meeting. Margaret must have been living with the Lathrops because the letter was addressed to them. The Lathrops were "very fond"[42] of Spencer, had observed how smitten he was with Margaret, and were interested in advancing his cause. So they intercepted the letter and hid it away. Thinking she had been scorned by her fiancé, Margaret "in a pique" decided to marry Spencer instead. "True to the code of the gentleman then in vogue, her jilted [Philadelphia] fiancé rose to the occasion and presented her with a wedding gift, a dining room set in mahogany complete with elaborately carved sideboard. Then with this last noble gesture he proceeded to die."[43]

paid for by his architect wife. From their Lambert-
ville apartment, the young couple loved to walk across
the bridge over the Delaware River and through New
Hope to the lot where they planned to build their
"dream home." The deeds for the land list Margaret
Spencer as the sole owner.[48]

Located about a half-mile above the village and a
mile below the Lathrops, the place had been an apple
orchard for many years. It looked down on a small
brook (Rabbit Run) as well as the broad expanse of
the Delaware and the forested hills on the other side.
"The brook ran about as smoothly as the household,"
said Tink, "sometimes flooding and sometimes a
dry run."[49]

They named the house Willow Brook Hill (fig. 6).
In addition to an ancient fireplace and other antiques
they collected, "there were many gardens and two
fish ponds and pretty outbuildings on the property."[50]
Robert's studio was a large, two-story-high room with
a staircase leading to a balcony that overlooked the
studio space. The entire north side was almost all win-
dows. He lined the walls with his own paintings, and
placed his easel, chair, and etching table strategically
around the room. He also built a toolroom adjacent
to the studio that he could access through a large glass-
paned door.

Occasionally Margaret had to deal with unwelcome
visitors at their new home:

*Possibly a hint of my mother's personality was her reaction to
the marauding hens from the farm next door. Outraged at this
invasion of her flower beds, she grabbed the family pistol and
shot off one of [the chickens'] tail feathers. The retort from the
gun was so powerful that it threw her back on her behind.
However, I do not recall any further invasion of poultry.*[51]

For their water the Spencers drilled a well, and
Margaret cleverly disguised the two-story pump house as
a gazebo. One afternoon when visitors were expected,
Robert disappeared for several hours. Finally, as dark-
ness was falling, his wife became worried and began to
search for him. Suddenly he emerged from the pump
house, carrying "a cushion, a book, an oil lamp and
a step ladder. He had lifted the cover off the well,
dropped the step ladder down, pulled the cover over
his head, and perched there over three feet of water

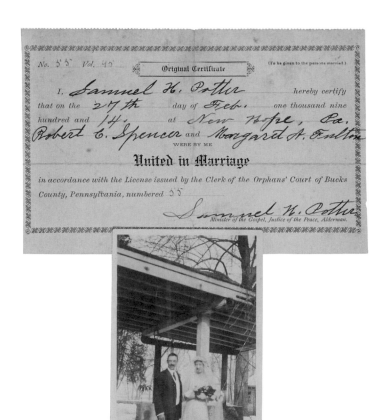

Figure 5 A page from a Spencer family scrapbook showing Robert
and Margaret's marriage certificate and a wedding-day photograph.
Courtesy of Shayla Spencer

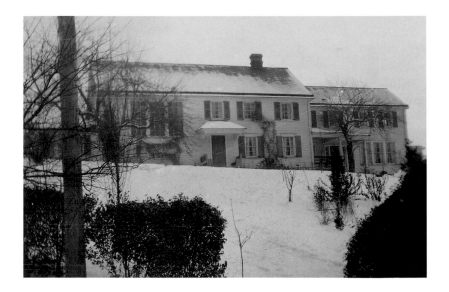

Figure 6 The Spencers' house, Willow Brook Hill, ca. 1920.
Courtesy of Michael Holt

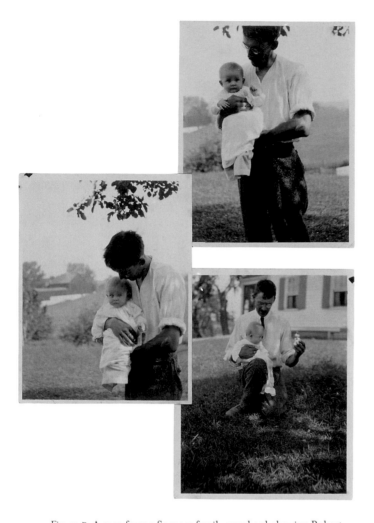

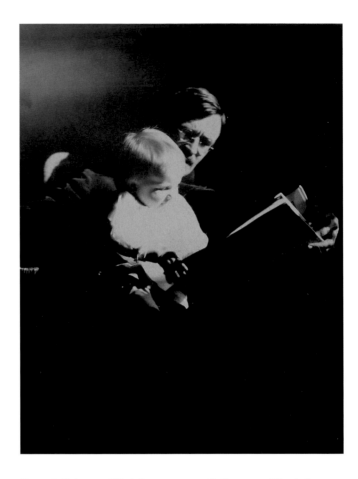

Figure 7 A page from a Spencer family scrapbook showing Robert with his newborn daughter Margaret (Tink) Spencer, 1915. Courtesy of Shayla Spencer

Figure 8 Robert and Tink Spencer, ca. 1916. Courtesy of Shayla Spencer

while [the visitors] trooped overhead. And he'd forgotten all about the time, so only came up when he had finished his book."[52]

With his marriage, new home, and early career successes, Robert seemed to have found his way in life. Within a few years his daughters had been born (figs. 7–10)—Margaret (nicknamed "Tink") in 1915, and Ann in 1918[53]—and he settled into a period of steady creativity and increasing acclaim for his work. In 1915 he was awarded a gold medal at the Panama-Pacific International Exposition in San Francisco, and the next year he was one of six prominent Bucks County painters who formed the New Hope Group, an informal organization that exhibited together at several prestigious venues around the country. Margaret Spencer served as secretary for the group.[54]

These were the peak years of the New Hope art colony, and the Spencer family became active participants in the everyday life of the community (fig. 11). Most of the activities that held the colony together were centered around the Lathrop family, as colorfully described by Tink Spencer:

The Lathrop house, separated from its grist mill by this curving dirt road [River Road], housed more and more young pupils of William Lathrop's school in its upper rooms. The charm of the neighborhood came partly from the fact that both artists and farming families drew together at the square dances and farm suppers held in the Lathrops' mill, huge enough to hold a hundred dancing couples. Their chaperoning elders sat on benches against the walls, dunking homemade doughnuts in hot cider in the winter, drinking iced springwater tea and lemonade in the summer. . . .

Figure 9 The front and back of the Spencer family Christmas card, 1918.
Courtesy of Shayla Spencer

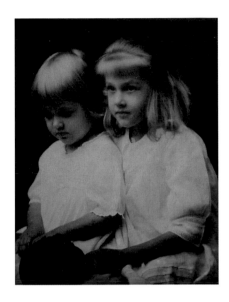

Figure 10 Ann and Tink Spencer, ca. 1920.
Courtesy of Shayla Spencer

Weddings, and subsequent christenings, took place either in the green glen below the mill, with its rushing trout stream bordered by blue forget-me-nots, or on the Lathrop lawn, which ran smoothly green from the long wide-stone terrace to the edge of the canal and its huge weeping willow trees. . . . More and more people flocked to the Lathrop afternoon tea gatherings—painters, writers, sculptors swarming even into the kitchen and halfway up the staircase.[55]

The Lathrops were not the only people in New Hope who could throw a good party. Some artists' families rented mule-drawn canal barges in the summer, eating both their lunch and supper on board as they floated to the Garbers' home a few miles up the canal. The Spencers had built a large cellar beneath their home, and Robert loved to grow large edible mushrooms down there as well as brew great quantities of beer and saki. His concoctions were not always successful. The corks on his bottles often blew off, causing his wife great distress as the smell of beer permeated the house. He loved to organize "home brew" parties attended by his artist friends and a few of his favorite relatives. He also became an excellent golfer, playing regularly on a small private course off River Road as well as with the pros on East Hampton, Long Island, while visiting family members who lived there.

By all accounts Robert was an attentive and loving father. Tink attributed his parenting skills to an innocence that he had retained from his childhood. There was "something undestroyed by his own growing up and he seemed to understand and love all that went through his young daughters' heads."[56] In the winter he would haul his kids on a sled to artist Rae Sloan

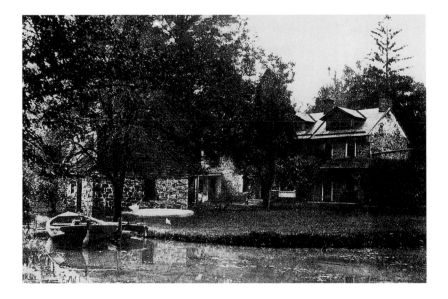

Figure 11 The Lathrop residence at Phillips Mill, the de facto home of the New Hope art colony, ca. 1918. Courtesy of the Lathrop family

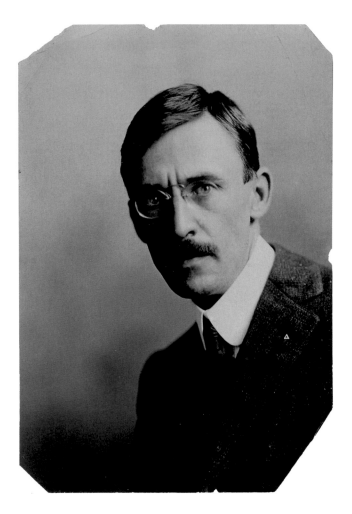

Figure 12 Robert Spencer, ca. 1920. Courtesy of Shayla Spencer

The May 1927 issue, with "Vol. 1, No. 2" gracing the masthead, contains a two-stanza ode to spring by the ten-year-old Barbara Bredin, as well as a charming poem by the seven-year-old Joan Folinsbee entitled "Flowers All the Day":

Flowers in the morning
Flowers all the day
Nodding in the sunlight
In the month of May. [59]

But in the Spencer household there was a dark side to this idyllic life of parties, fishing on the canal, and schoolgirl innocence. There's no doubt that Robert and Margaret Spencer loved each other intensely, but it was like the love between the ingredients of gunpowder: Mix them together and the slightest spark will set off an explosion. The Spencers not only fought with each other in private, they fought at the dinner table when guests were present. Joan and Beth Folinsbee frequently were asked to stay for dinner, and both remember how uncomfortable they felt when Robert and Margaret launched into one of their regular battles. [60]

In addition to experiencing tension in his marriage, Robert began to exhibit signs of mental instability. Although his problem almost certainly started much earlier, the first documented discussion of it was in 1923, in an article by F. Newlin Price in the magazine *International Studio*. Price mentions Spencer's recent nervous breakdown "that for the time stopped his painting," and goes on to quote the artist himself on the subject: "Cézanne was sick and did not know it; I am sick and I know I'm sick." [61] A few years later Spencer brought up the subject in a letter to his friend Duncan Phillips, the renowned collector who founded The Phillips Collection in Washington, D.C. Referring to his recent inability to paint, Spencer says, "These last two years I have literally lived in hell." [62]

Most likely he suffered from what we now call bipolar disorder or manic-depression. [63] Even in today's medical environment it can be difficult to recognize and treat this illness, but in the 1920s little or nothing could be done. Nevertheless, the family tried. Ann Spencer Simon said that her father "suffered several mental breakdowns in his lifetime," and remembered the "frequent visits" of Dr. Leon Salmon, a local

Bredin's nearby house, where they would skate on the canal then build a bonfire and toast marshmallows. In the summer he would fish for catfish in the canal with his daughters, and hunt with them for mushrooms in cow pastures and old apple orchards. He was not above the occasional spanking. "My father looked upon this as a lugubrious but necessary duty," said Ann, "and tried to comfort us afterwards with lumps of sugar. We never held it against him, whether it was the sugar lumps or the contrite attitude after it was all over." [57]

Two of Robert's closest artist friends were Bredin and John Folinsbee, and by an odd coincidence the three painters each had two daughters who were around the same age. [58] These six girls became the best of friends; they formed a little sorority that they called the "Rabbit's Run Club" and published an amateur literary magazine called the *The Rabbits' Writings.*

general practitioner who specialized in broken bones and delivering babies.[64]

European Travels

In Spencer's day, travel to Europe was more or less a prerequisite for the well-educated artist. Most painters made their European pilgrimages in their twenties, usually following the end of their formal education. One can only speculate about why Spencer waited until he was forty-five before he made his first journey across the Atlantic. Most likely it wasn't for lack of funds; while he sometimes had lean periods, his wife's inheritance combined with his own income from the sale of his work allowed for a comfortable middle-class existence. Perhaps the real reason was that for many years Spencer was perfectly content to paint scenes of Bucks County and New York. He acquired his wanderlust at roughly the same time he was growing increasingly restless in his creative life, and his travels provided the subject matter for much of his later work.

His first trip to Europe was in the summer of 1925, when he visited France, Spain, and Italy (fig. 13). He journeyed to France briefly in 1927, and in 1929 went there again, this time staying for a year and a half.[65] Spencer was assisted financially on these trips by the Hendrick family, who were distant cousins of Margaret Spencer. Josephine P. Hendrick often gave Spencer the use of her chauffeured car in New York City, thus enabling the artist to sketch and paint at the New York docks. Her son, James P. Hendrick, was one of Spencer's closest friends (James named his second son Robert, in honor of Spencer), and both James and Josephine accompanied Spencer on at least one of his European journeys. Mrs. Hendrick also provided her car for Spencer during his visits to France.

Josephine Hendrick left behind a moving memoir of her friendship with Spencer in which she discusses the artist's state of mind at various points in his life: "That his life was a most difficult one was a foregone conclusion. Margaret [Tink], the older of his two children, has told me, with bitterness and fear, of the frightful quarrels and of her father's desperate unhappiness." On the subject of their European trip, Mrs. Hendrick says, "It was a glorious holiday. We

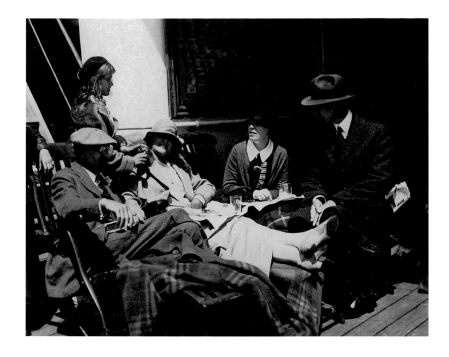

Figure 13 The Spencer family on a ship, traveling to Europe. From left to right: Robert Spencer, Tink Spencer, Margaret Spencer, unknown couple, ca. 1925. Courtesy of Michael Holt

would take long walks through the enchanting towns. Rob loved best of all to wander along riverfronts by busy quays and shipping. Being good walkers, we would stay out late in the evenings, seeing sights, hearing sounds that were magical. I think Rob's unhappiness deepened his sympathy and understanding of people.

"As I think of him," Mrs. Hendrick concludes, "it is with a wishful longing that he might have been spared the tragedy of his life and death."[66]

Despite his underlying psychological problems, Robert Spencer clearly relished his European travels—that is, if his weight was any indication! For most of his life he was almost pathologically skinny. Once as a young man he went swimming in a river and emerged, dripping wet, to the sight of his weeping aunt. When he asked her why she was upset, she reportedly replied, "Oh, Bob, you are so thin."[67] According to Tink, he returned home from a tour of Europe "with an actual fat paunch—healthy as all get out and sporting a Dalí mustache."[68]

Tink went with him on at least one of these trips. Her vivid memories of her time with her father provide a poignant portrait of the artist in his element—particularly his love of the everyday life of people:

*They seemed to talk to Spencer, the Italian and French Rivi-
eras, with the groups of grape pickers in the vineyards, bare-
foot, stamping the grapes to wine juice . . . warmth of sun and
people, gathering of peasants at a café table, dances on the
square. They all meant life to Spencer. The happiest expression
I ever saw upon his face was on a warm Mediterranean night.
. . . He joined the dancers on the market square and, leaving me
on the arm of a hefty, [smelly] peasant, grabbed a silk stock-
inged petite from the fray and was madly waltzing her around
to cheers of "O l'americain!"[69]*

Though he was the son of a minister, Spencer was
never an openly religious man, and he completely
rejected his father's Swedenborgian faith: "Angels
were quite prominent in their creed," said Robert's
daughter Ann, "and my father would have nothing
to do with their sexless, unsensual ways."[70] Yet the
European countryside seemed to bring out his latent
religious feelings:

*Driving through a section of the Pyrenees one late afternoon
when the sun was just setting and his mood was very low due to
a family row, he and I came to the top of a hill and looked
down over a winding road to a town built down the hillside
across from us. The sun's red glow was just striking its lowest
house and we sat for a while in silence, enthralled by the beauty
and the quiet. And Dad suddenly curved his arm around the
whole valley, and said with tears in his voice, "God must be
there. It looks so happy."[71]*

The ancient French cathedrals also elicited these
same religious yearnings:

*He loved the beauty and quiet peace of the old cathedrals in
France. For he said you came close to yourself and, through
yourself, to God when you entered them. He often said that if
he were to become a convert to any religion he would choose the
Roman Catholic.[72]*

The Final Years

Spencer returned from his European journeys not
only physically and emotionally refreshed, but full of
ideas and experiences that fueled his creative energy.
Most of the more experimental canvases that he
painted in the last few years of his life have European
subjects, and the freedom and self-confidence in

these works may have grown out of the rich emotional
atmosphere of his travels. But inevitably he would
end up back in New Hope, where once again he had
to confront both his inner demons and his increas-
ingly unhappy marriage. As Tink put it, he came back
"to the old battles of hearth and home."[73] Relations
with his wife had become so strained that Margaret
would retreat for days at a time to her private studio
near the house, where she would write lengthy poems
about flowers and paint portraits of her daughters.

Because Robert's journals and personal records
were lost to fire,[74] one can only speculate about his
mind-set in his last years. There are a few clues in a
long and rambling letter he wrote a few months before
he died to his friend Duncan Phillips. Spencer gave
this letter his full attention—there are both handwrit-
ten and typed drafts that survive—and he used it to
vent his rage at what he thought of as the sterility and
godlessness of modern culture.[75] Speaking of his joy
at seeing a bust by Renoir, Spencer says:

*It gave me a great thrill. Such a wonderful appreciation of a
live thing, a living woman, a lovely animal; painted for the
love of youth, the love of pulsating, living flesh, the love of a
thing created by God, as opposed to a thing manufactured by
man. . . . Then I found Matisse—one of his typical women, a
thing of brush strokes and intellect; and Picasso, he left me bit-
terer yet; not because of painting doctrine, but because if
Matisse and Picasso represent life—if that is how wine and
food and life should taste—the world for me is dead![76]*

Spencer expresses an intense nostalgia for the past
in this letter and refers to modern art as "the Franken-
stein of today—an unloved, unlovable, distorted
machine."

*Has man so completely forgotten God and God's purpose, the
world and its normal fecundity, that nothing not made by a
machine is of value? Is life worthwhile when a pill takes the
place of a full dinner? Or a distorted mannequin the place of a
fine woman? . . . It would seem to me that there is a balance;
the balance of spirit and matter, of brain and animal. Go too
far one way, too far the other, the result is trouble, and life is
bitter in one's mouth![77]*

Spencer probably hoped that Phillips would join
him in his diatribe, but Phillips's response to this let-

ter was measured and rational. It's almost as if Phillips was gently admonishing his tormented friend, encouraging Spencer to be more open to the humanity and creativity of modern culture:

> I have read and re-read your letter many times and I keep it in my pocket to remind me to answer it at the earliest moment that there is leisure. . . . Of course I agree with you as to the inhumanity of any art which tries to divorce itself from life and all relations with it, and yet the unanswerable argument of the Modernists is that they are [as] entitled to be [respected] as architects or musicians [are] and equally justified in using abstractions. We do not complain of the inhumanity of a building nor of a sonata, and both are capable of expressing the individual taste and even the emotion of their maker. . . . Respect for the individual and deep concern for the sanctity of human life are the two things closest to my heart.[78]

There's a tone of bitterness in Spencer's letter to Phillips, as well as the vague sense of a man who has withdrawn from life, who sees life as dark and hopeless. Two phrases are particularly troubling: "The world for me is dead" and "Life is bitter in one's mouth." Equally revealing is Tink's description of her father's habit of playing the piano, and how he stopped not long before he died:

> Although he could not read a note of music, had no ear for harmony, he often sat for hours at the piano pressing out great crescendoing chords and passionate single-noted melodies. And at other times—with soft, retaining, and loud pedals all to the floor—he made queer, haunting music blow through the house making time forgotten. He said it made him paint better and that he could get, from the music in his head, the substance and the shape and the color of what he wanted to put on canvas. . . . But whatever his mood, when he played those hour-on-hour improvisations of the symphonies within his head, I'd tiptoe through my bedroom door and sit, huddled in a bed quilt, against the corner of the balcony until my feet were ice and my eyes swam with the cold. . . .
>
> Why he stopped his playing I don't know. Except that the last few years before he died seemed to have so much of sadness in them that he could not bring himself to letting out such feelings with his notes.[79]

Things got so bad in the Spencer house that finally there was open talk of divorce. Both daughters recalled that their parents' final argument was over Tink and her future. A young Italian man of noble lineage, a student at the nearby Solebury School named Alessandro Torlonia, was actively courting Tink—who was all of sixteen years old at the time.[80] Margaret, with her society upbringing in Philadelphia, was starstruck at the presence of nobility, and supported the idea. Robert, on the other hand, "didn't want that man seducing his daughter,"[81] and actually threw the young prince out of the house.

The Spencers must have argued ferociously the night Robert died because he started to drink, in great quantities, the red wine that a bootlegger delivered every month to the back door of his studio. Ann remembered that her mother had locked the door of the workshop adjacent to Robert's studio, and he cut his hand when he broke the glass in the door so he could get in. "Tink bandaged his cuts and I went to bed."[82]

Tink, who was clearly her father's favorite, had more detailed memories of that evening because she stayed up longer and spoke with him while he sat in the chair in the middle of his studio. Some thirty-eight years later, she recalled the "low murmur" of his voice telling her, "You've inherited my hands, long and thin. Remember that. When you grow to be a woman they will be beautiful, and they'll outlast your face."[83]

He told his daughter about the possibility of divorce, and said, "I only hope that someday you'll understand. Your old dad can't live with her and can't live without her. I'd ask you to come and live with me. We'd have fun together. No, that's not fair. Your mother is a much better person to bring up you and your sister."[84]

Tink recalled that her father crumpled up an empty pack of cigarettes and tossed it onto a nearby table, where it happened to knock over the king on a chessboard. "That's the way it goes, Tinker. The queen reigns supreme."[85]

The young woman finally went upstairs, blew her father a kiss from the balcony, and crawled into bed "with a forbidden stage magazine."[86] Sometime later, on that evening of July 10, 1931, Robert Spencer put his revolver in his mouth and pulled the trigger. He was fifty-one. According to the obituaries, Margaret heard the shot, ran into the studio, and discovered

Robert's lifeless body—still sitting in the chair. Apparently he left a note, though reports conflict about its contents.[87] Ann slept through the night, but when she woke up the next morning she saw the neighbors' cars in the driveway. Her sister came to the door of Ann's room and said, "Dad shot himself last night."[88]

Neither woman left behind any detailed recollections of what the next few days were like. Ann summed it up by saying, "There was a great quietness, a stillness in the house after his death."[89]

The shock of what happened that night reverberated throughout the New Hope community, and went as far south as Washington, D.C., and as far north as Maine. Duncan Phillips wrote to Margaret:

We appreciated so much the fine and profoundly understanding letter of your daughter thanking us for the flowers we sent. It is hard to write to you all what we feel about Robert's death. We were very fond of him and are stunned and bereaved by his death. For you and your children the loss must be terrible. I fear that he worked beyond his physical powers of endurance bringing on that nervous exhaustion to which all of us who are sensitive are subject.[90]

Phillips reminded Margaret that he had hoped to have Spencer paint portraits of both himself and Mrs. Phillips, and said, "He loved life with a zest and a beautiful responsiveness to its tones and flavors."[91]

John Folinsbee was summering in Maine when he learned by telegram of Spencer's death. Folinsbee was deeply saddened by the loss of his friend—but he was not completely surprised. He told his daughter Beth that he had heard Spencer talk of suicide on more than one occasion. Folinsbee also recalled that Spencer had always taken his imposing revolver along when he and Folinsbee painted landscapes together. Folinsbee was so disturbed by this habit that he told Spencer on more than one occasion to "put the gun away." Spencer even was known to sleep with the gun under his pillow.[92]

When all the bills were paid, Spencer's estate was valued at less than $3,000. He was cremated, and his ashes were scattered in the Delaware River near his home.

Aftermath

When something tragic happens, people usually need to blame someone. It's a handy way of convincing ourselves that the tragedy could never happen to us. Whether justified or not, who else to blame in this case but Margaret? She was a flamboyant, passionate, outspoken woman who was determined to have a professional career, and her personality did not fit in with the more genteel, conservative atmosphere of New Hope. Both of her daughters were aware of the gossip. Speaking of her father's suicide, Ann remarked, "Doctor described the cause as melancholia. Others were not so kind."[93] Tink was more direct: "The suicide upset the entire community, so we took off for Europe, the West, anyplace away from the reproach of Dad's friends."[94]

Margaret rented out the house and took her daughters to Europe for two years. When they returned, she inspected the property and came to the conclusion that

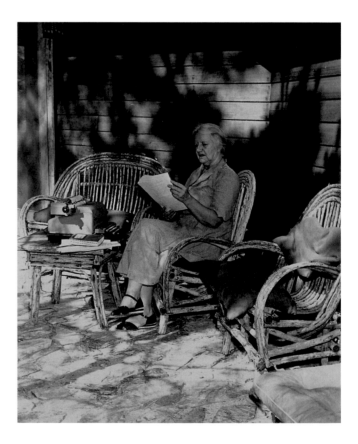

Figure 14 Margaret Spencer at the Las Lomas property, Tucson, Arizona, ca. 1960. Courtesy of Shayla Spencer

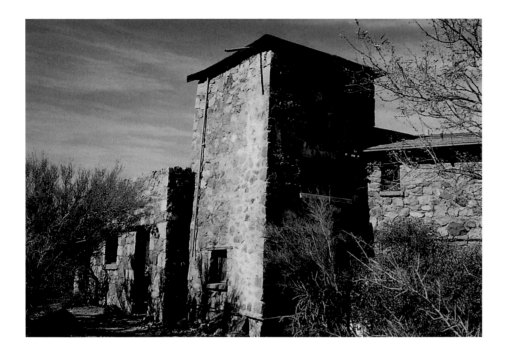

Figure 15 A building at Las Lomas, 2001.
Courtesy of the James A. Michener Art
Museum Library and Archives

some items were missing. So she promptly sued the tenants. At the trial, Mrs. Folinsbee was called as a witness. When asked if Mrs. Spencer had a "reputation for veracity," Mrs. Folinsbee—who was under oath—felt she had no choice but to say what she thought was the truth. "Not the best," she replied.[95] Margaret never spoke with the Folinsbees again after that, and forbade her two daughters from seeing the Folinsbee girls. So the Rabbit's Run Club had a sad end, another victim of Spencer's suicide. Eventually the girls renewed their friendship, but only after Ann and Tink grew up and were no longer living with their mother.

Soon Margaret moved permanently to Tucson, Arizona, where finally she was able to practice architecture with relative freedom. Her most notable accomplishment was a group of fifteen buildings called Rancho de Las Lomas (figs. 14, 15), which for a few years was run as a dude ranch and is now separate houses and apartments. Margaret never forgave the people of New Hope for what she believed had been done to her, and she "seethed for years over what she called the platitudes, placidities and self-satisfied sanctities"[96] of the artist colony.

Is it ever possible to determine a single reason why someone commits suicide? In Spencer's case, the most important factor had to be his underlying medical condition. Suicide is still a common outcome

of acute depression, and no doubt the problem was worse in Spencer's day, when both chemical and psychotherapeutic treatments were either unavailable or nonexistent. His unhappy marriage certainly didn't help matters. The constant battles with his wife probably wore him down, adding to his sense of desperation at the end.[97] And there is plenty of evidence in his letters, in the memories of his daughters, and even in his work that he was increasingly desperate. People who have survived acute depression and written about it report that the feelings of hopelessness and despair are totally overwhelming and ultimately indescribable.[98]

The tragedy of Spencer's death was not only that it permanently scarred the lives of his wife and daughters and wounded the community that loved him. He was also beginning to find a new confidence and maturity in his work. In the last years of his life he was starting to experiment with new ideas and new techniques, and there were signs of the kind of freedom and mastery that the best artists possess. In the end, the effect on his work might be the greatest tragedy of his suicide. His wife and daughters eventually recovered from their grief and had productive lives. His community moved on, and the memory of his sad story soon faded. But we will never know how his life's creative adventure might have turned out had he not pulled the trigger on that warm summer night.

NOTES

The following abbreviations will be used for the source material that came from Robert Spencer's daughters:

Tink Spencer 1: Margaret (Tink) Spencer, unfinished handwritten draft manuscript of Robert Spencer biography, unpaginated, ca. 1969.

Tink Spencer 2: Margaret (Tink) Spencer, unfinished typed draft manuscript of Robert Spencer biography, fifty-two pages plus additional notes and sketches, ca. 1969.

Tink Spencer 3: Margaret (Tink) Spencer, "Slow Burns the Genius," unfinished typed draft manuscript of Robert Spencer biography, sixteen pages, August 1969.

Tink Spencer 4: Margaret (Tink) Spencer, "Robert C. Spencer," typed draft manuscript, six pages, unpaginated, undated.

Ann Spencer Simon 1: Transcribed telephone interview with Ann Spencer Simon conducted by Michael Holt on January 20, 1995, three pages, unpaginated.

Ann Spencer Simon 2: Letter from Ann Spencer Simon to Michael Holt, January 22, 1995.

1. Tink Spencer 2, p. 15.

2. Tink Spencer 3, p. 1.

3. Tink Spencer 4.

4. Letter from Ann Spencer Simon to the Michener Art Museum library in response to a request for information about her mother, February 29, 1996.

5. Tink Spencer 4.

6. Tink Spencer 4.

7. E-mail from Shayla Spencer to Brian Peterson, December 13, 2002.

8. Tink Spencer 4.

9. Tink Spencer 1.

10. Ann Spencer Simon 2. The neighbor who said this was Julian Lathrop, son of William L. Lathrop.

11. Margaret (Tink) Spencer, "Mother Was a Problem: From Bucks County to Bedlam," unpublished manuscript about the life of Margaret (Mrs. Robert) Spencer, unpaginated synopsis.

12. Ann Spencer Simon 1.

13. From a typewritten questionnaire prepared by Tink Spencer, with handwritten responses from Joseph Spencer, n.d.

14. Tink Spencer 4.

15. Lovell Birge Harrison (1854–1928) was born in Philadelphia and studied at the Pennsylvania Academy of the Fine Arts and in Paris at the École des Beaux-Arts. He traveled and painted throughout the world, eventually settling in Woodstock, New York, where he was one of the founding members of the Woodstock art colony and also helped to create the Art Students League Summer School there. He is primarily associated with the moody, poetic landscape style known as tonalism. Thomas Alexander Harrison (1853–1930) also was born in Philadelphia and studied at the Pennsylvania Academy. He traveled to California in the mid-1870s as an employee of the U.S. Coastal Survey, and eventually moved to France where he was well known for his marine paintings.

16. Diana Hadley, "A Brief History of Las Lomas," unpublished manuscript, p. 1. Margaret's immediate family history was confirmed through an extensive genealogical search. Her maternal grandparents were Apollas and Margaret L. Harrison, and the 1850 census for the Germantown section of Philadelphia lists Apollas (age 30) and Margaret (age 25) living at the same residence. The 1860 census lists Apollas (age 39) and Margaret L. (age 35) Harrison also living at the same residence in Germantown, along with Margaret (9), Thomas A. (7), and Lovell B. (5). This confirms the birthdate of Margaret Spencer's mother (also named Margaret Harrison) as approximately 1851; she was married in 1881, and Margaret Spencer (whose birthname was Margaret Alexina Harrison Fulton) was born in 1882. Her parents eventually moved to Santa Barbara, California, where the 1920 census lists Robert (71) and Margaret (68) Fulton living in the same residence. The connection between Margaret Spencer's father and the Robert Fulton of steamship fame could not be confirmed, though both of her daughters mention it, and it was an accepted element of the Spencer family history.

17. Tink Spencer 2, p. 1.

18. According to the Web site of the Swedenborgian Church of North America, Swedenborgianism is "a community of faith based on the Bible as illuminated by the teachings of Emanuel Swedenborg (1688–1772)." Swedenborg was a Swedish scientist who also authored thirty volumes of theological and philosophical thought, including explications of Genesis, Exodus, and Revelations. He abandoned such traditional Christian ideas as the Trinity, original sin, and eternal punishment and reward, instead asserting that "the Second Coming has taken place—and in fact still is taking place," a continually occurring process that enables "a new perception of the Word of God." In the Swedenborgian universe, "we live in a world of spirit as well as in the material world. . . . With death we become conscious in the

spiritual world, where our personal identity is retained and we are revealed as the person we inwardly are." Quotations are from the Swedenborgian Web site.

19. Robert Spencer, from an undated handwritten personal history in the Dewitt McClelland Lockman Papers, Archives of American Art, ca. 1925–30.

20. Information on the Spencer family's travels was obtained from a typewritten questionnaire prepared by Tink Spencer, with handwritten responses from Joseph Spencer, n.d.

21. Ibid.

22. From an unidentified and undated newspaper obituary, probably the *Philadelphia Public Ledger,* in the archives of the Pennsylvania Academy of the Fine Arts, Philadelphia.

23. From an unattributed obituary in the Swedenborgian publication *New-Church Messenger* (April 18, 1906): 246–47.

24. From a typewritten questionnaire prepared by Tink Spencer, with handwritten responses from Joseph Spencer, n.d.

25. Robert Spencer, from an undated handwritten personal history in the Dewitt McClelland Lockman Papers, Archives of American Art, ca. 1925–30.

26. From a typewritten questionnaire prepared by Tink Spencer, with handwritten responses from Joseph Spencer, n.d.

27. The student records for the National Academy in this period no longer exist. However, Spencer himself says that he began his study at the academy in 1899 and studied there for two years. The source of this information is the undated personal history now in the collection of the Dewitt McClelland Lockman Papers in the Archives of American Art.

28. This school began its existence as the Chase School of Art in 1896 and changed its name to the New York School of Art in 1898. Robert Henri taught at the school from 1902 to 1908, a period that overlaps with the period when Spencer was most likely to have studied there. Students at the school probably still called it by its initial name; in the handwritten personal biography in the Lockman Papers, Archives of American Art, Spencer says he "went to the Chase school for a year or so." Unfortunately the records of this school have been lost, so it's impossible to confirm absolutely that Spencer studied with Henri. However, in a list of honors and awards that he compiled for the Boston art critic and gallery director Sidney C. Woodward, Spencer says he was a "pupil of Chase, DuMond, Henri and Garber." Also, the program for a 1938 Spencer exhibition at Ferargil Galleries in New York City says, "Pupil of Frances Jones, William M. Chase, Robert Henri, Frank Vincent DuMond, and Daniel Garber." This program was probably put together by Spencer's friend F. Newlin Price, who was the director of Ferargil Galleries, so it is a reasonably reliable source. Frances Jones may be the Canadian painter Frances M. Jones Bannerman (1855–1944); Frank Vincent DuMond (1865–1961) was a well-known Connecticut impressionist painter who taught principally at the Art Students League in New York City. The Woodward reference can be found in the Archives of American Art, Smithsonian Institution Archives and Manuscripts Catalog, Sidney C. Woodward papers.

29. F. Newlin Price, "Spencer—and Romance," *International Studio* 76 (March 1923): 485.

30. Robert Spencer, from an undated handwritten personal history in the Dewitt McClelland Lockman Papers, Archives of American Art, ca. 1925–30.

31. Tink Spencer 3, p. 2.

32. For more information on Daniel Garber and the other New Hope painters, see Brian H. Peterson, editor, *Pennsylvania Impressionism* (Doylestown, Pa.: James A. Michener Art Museum; Philadelphia: University of Pennsylvania Press, 2002).

33. F. Newlin Price says the rent at the Huffnagle Mansion was two dollars a month; Tink Spencer fixes the monthly tariff at fifteen dollars. Since Price's essay on Spencer was written less than ten years after Spencer moved out of the mansion (Tink's material was written roughly forty-five years later), he is perhaps more likely to be correct, though there is no way to confirm this directly.

34. Price, pp. 485–86.

35. Tink Spencer 2, p. 4.

36. Ann Spencer Simon 2.

37. Tink Spencer 3, p. 9.

38. Price, p. 486. Tink Spencer also has a version of the "John St. John" story; she remembered that the scheme was at least marginally successful, while Price says it was not. None of the paintings are known to have survived.

39. Tink Spencer 2, p. 5.

40. Diana Hadley, "A Brief History of Las Lomas," unpublished manuscript, p. 1.

41. Tink Spencer 3, p. 10.

42. Ann Spencer Simon 2.

43. Ann Spencer Simon 2. One can't help but wonder whether the Lathrops eventually regretted their decision to play matchmaker, since Margaret—justifiably or unjustifiably—was blamed by so many for Robert's suicide.

44. Tink Spencer 4.

45. Elizabeth Lathrop, letter to her brother Julian Lathrop, March 6, 1914. Letter is in the possession of Nora Lathrop Grimison.

46. The album is in the possession of Shayla Spencer. Robert and Margaret's marriage license was issued on February 24, 1914. On the application Robert lists his residence as Lambertville, New Jersey, probably because he had already moved out of the Huffnagle Mansion in anticipation of his marriage. He lists his occupation as "artist." Margaret lists her birthplace as "Germantown, Phila., Pa.," her parents' residence as "California," and surprisingly states her occupation as "singer."

47. Tink Spencer 3, p. 10.

48. The Spencer property was acquired in two land purchases. The first deed was recorded at the Bucks County Courthouse on October 7, 1914, from Elizabeth P. Magill to Margaret F. Spencer. On April 9, 1924, Margaret bought another parcel of land, contiguous with the original purchase, from Chester A. Magill and his wife, Avis Magill. Margaret sold the property to Gilbert W. Mead on March 4, 1946.

49. Tink Spencer 3, p. 10.

50. Ann Spencer Simon 1.

51. Ann Spencer Simon 2.

52. Tink Spencer 2, p. 23.

53. There apparently was a tradition among the women of the Harrison family to name their firstborn daughters Margaret; Tink's great-grandmother, grandmother, and mother all were named Margaret.

54. Previous studies have said that the New Hope Group exhibited together for approximately two years starting in 1916. As part of the background research for the Spencer exhibition and publication, we examined the Charles Rosen Papers of the Archives of American Art, Smithsonian Institution. To our surprise we discovered no less than thirteen exhibitions listed for the New Hope Group, from 1916 to 1926, at such prestigious institutions as the Memorial Art Gallery, Rochester, New York (1916); the Cincinnati Art Museum, Cincinatti (1916); the Detroit Institute of Art, Detroit (1917); the Cleveland Museum of Art, Cleveland (1917); the Albright-Knox Art Gallery, Buffalo, New York (1918); the Rosenbach Gallery, Philadelphia, (1919); and again at the Albright-Knox Art Gallery, Buffalo (1926).

55. Tink Spencer 3, p. 8.

56. Tink Spencer 2, p. 9.

57. Ann Spencer Simon 2.

58. Bredin also had a son, Stephen Price Bredin.

59. A photocopy of the first page of this publication is in the archives of the Michener Art Museum. Information on the Rabbit's Run Club and the friendship between the three artists' daughters was obtained in a telephone interview with Beth Folinsbee Wiggins on December 3, 2002.

60. From telephone interviews with Joan Folinsbee Cook (November 25, 2002) and Beth Folinsbee Wiggins (December 3, 2002).

61. Price, p. 489.

62. Letter from Robert Spencer to Duncan Phillips, November 7, 1928. Letter is in the library of The Phillips Collection, Washington, D.C.

63. Spencer's granddaughter recalls family stories suggesting that in addition to the documented instances of debilitating depression, the artist was known to be the "life of the party," and also exhibited signs of the more active or "manic" phase of the disease. From a telephone interview with Shayla Spencer on January 10, 2003.

64. Ann Spencer Simon 1. Dr. Leon T. Salmon appears in the United States Census of 1930 and was recalled as the local general practitioner by both Beth Folinsbee Wiggins and Joan Folinsbee Cook. Dr. Salmon is also listed in the artist's estate records as the attending physician at Spencer's death.

65. Spencer occasionally corresponded with officials at the Pennsylvania Academy to make arrangements for their periodic studio visits. In a December 8, 1930, letter he says, "We had a fine time the year and a half we spent in France—but find many changes on our return. New Hope is almost a second Woodstock. I don't like it!" Letter is in the Archives of the Pennsylvania Academy of the Fine Arts, Philadelphia.

66. From an unpublished memoir by Josephine P. Hendrick, in the possession of Hendrick family descendants.

67. Price, p. 486.

68. Tink Spencer 1.

69. Tink Spencer 2, p. 25.

70. Ann Spencer Simon 2.

71. Tink Spencer 2, p. 24.

72. Ibid.

73. Tink Spencer 1.

74. There were two fires that destroyed both personal papers and paintings of Spencer's: in 1971 in Tucson, and also at the Gene Mako Galleries in Los Angeles in the 1970s.

75. It's intriguing that the final copy of this letter in the library of The Phillips Collection is handwritten, even though a

typed draft also exists. Apparently Spencer wanted to get the letter right, but also wanted it to appear spontaneous.

76. Letter from Robert Spencer to Duncan Phillips, April 27, 1931. Letter is in the possession of Gene Mako, currently on loan to the Michener Art Museum.

77. Ibid.

78. Letter from Duncan Phillips to Robert Spencer, May 19, 1931. Letter is in the possession of Gene Mako, currently on loan to the Michener Art Museum.

79. Tink Spencer 2, p. 32.

80. Don Alessandro Torlonia (1911–1986) was the Fifth Prince of Civitella-Cesi. The Solebury School lists him as a student in 1931, when he was nineteen years old. In 1935 he married the Infanta Beatriz of Spain, thus becoming the son-in-law of King Alfonso of Spain, whose abdication of the throne in 1931 was one of the factors that led to the Spanish Civil War. According to a January 10, 1935, wedding notice in the *Charleston Daily Mail,* Torlonia's American mother, Elsie Moore, was "the daughter of a wealthy Brooklyn banker." As a New Yorker, she may have been familiar with nearby Bucks County, which could explain why her son was going to school there. In September 1940 Torlonia was arrested by Mussolini because he was suspected of "anti-Fascist" tendencies. Torlonia's sister, Donna Marina, was the grandmother of actress Brooke Shields.

81. Ann Spencer Simon 1.

82. Ann Spencer Simon 1.

83. Tink Spencer 3, p. 1.

84. Ibid.

85. Ibid.

86. Tink Spencer 3, p. 2.

87. An obituary in the Lambertville newspaper states that he left behind "a brief note asking his friends to pause and remember him." Another obituary says he "left a note last night saying that he was tired of living."

88. Ann Spencer Simon 1.

89. Ibid.

90. Undated letter from Duncan Phillips to Margaret Spencer. Letter is in the possession of Gene Mako, currently on loan to the Michener Art Museum.

91. Ibid.

92. From a telephone interview with Beth Folinsbee Wiggins on December 3, 2002.

93. Ann Spencer Simon, from an unpublished chronology and personal history in the possession of Shayla Spencer.

94. Tink Spencer 2, from an unpaginated autobiographical sketch at the end of the manuscript.

95. From a telephone interview with Beth Folinsbee Wiggins on December 3, 2002.

96. Margaret (Tink) Spencer, "Mother Was a Problem: From Bucks County to Bedlam," unpublished manuscript about the life of Margaret (Mrs. Robert) Spencer, pp. 12–13.

97. Suicide is the eleventh leading cause of death in the United States, and eighty-three percent of gun-related deaths in the home are the result of suicide. Between sixty and ninety percent of suicides in America are caused by mental illness. "[Suicide] starts with an underlying biological risk," but "life experience, acute stress and psychological factors each play a part." From Carol Ezzell, "Why? The Neuroscience of Suicide," *Scientific American* (February 2003): 46–51. Thus Spencer's situation— a genetic brain disorder (manic-

depression) combined with stress brought on by his failing marriage —conforms with the current scientific understanding of the causes of suicide.

98. Two of the best-known and most eloquent accounts of bipolar disorder and acute depression are *An Unquiet Mind,* by Kay Redfield Jamison (Random House, 1997), and *Darkness Visible: A Memoir of Madness,* by William Styron (Vintage Books, 1992).

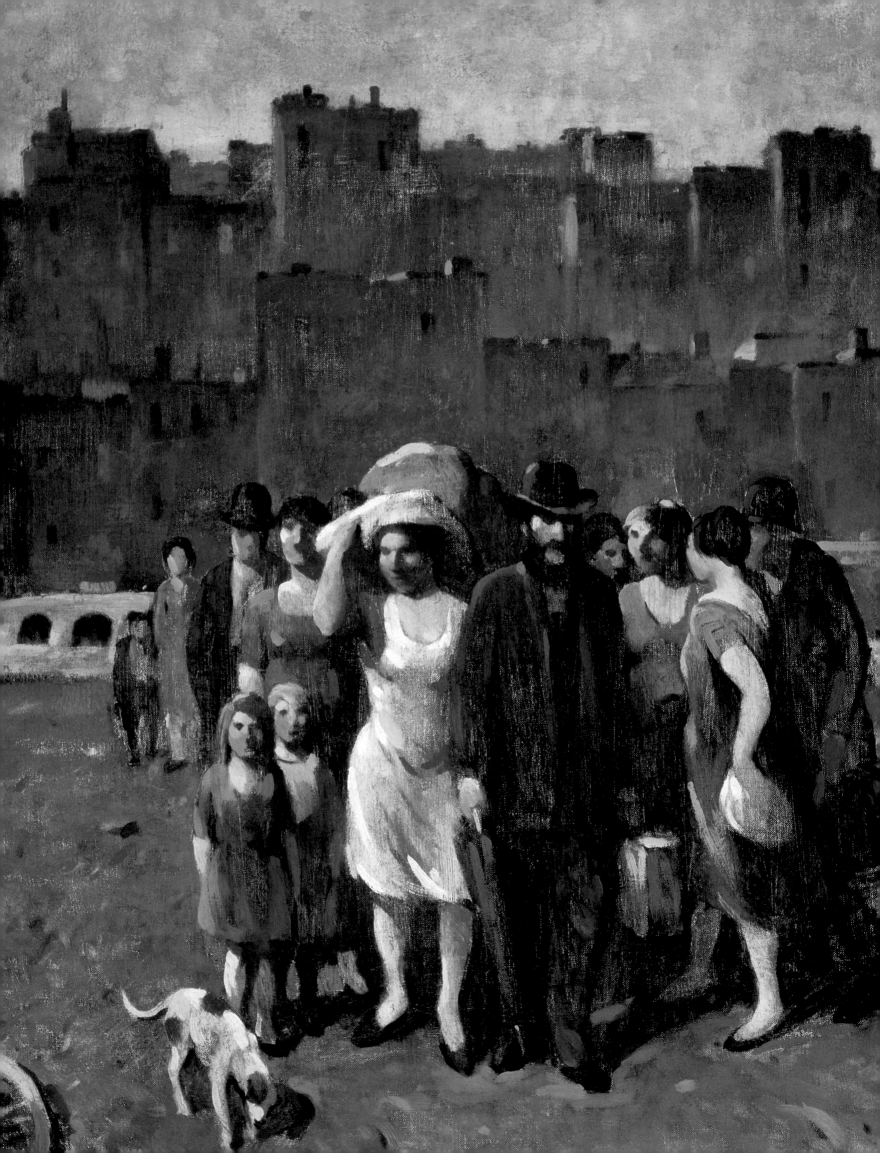

THE PAINTINGS OF ROBERT

SPENCER

Introduction

"A landscape without a building or a figure is a very lonely picture to me."[1]
ROBERT SPENCER

For many American painters the words *landscape* and *building* would form
an uneasy marriage, if not an outright contradiction in terms. Think
of all those gorgeous waterfalls, mountains, and sunsets depicted by
Frederic Church, Albert Bierstadt, and numerous other nineteenth-
century painters associated with the Hudson River school: hardly a
building to be found, and very few people as well. It's true that build-
ings occur with some regularity in the cheerful canvases of American
impressionist painters, as well as in the darker, more moody landscapes
of the impressionists' brethren of the brush, the tonalists. But other
than the occasional parade scene or cityscape, the buildings in both the
impressionists' and tonalists' pictures usually are isolated tokens of a
human presence in an otherwise unspoiled natural environment, or
charming decorations in picturesque fantasies of rural life.

If Robert Spencer had been magically transported to Yosemite, the
Canadian Rockies, or the Connecticut coastline, he would have ignored
the scenery and made a mad rush to the nearest mill or tenement. It was
buildings, as well as the people who lived and worked in them, that cap-
tured his imagination as a young painter and continued to inspire him
almost every day of his tragically foreshortened life.

Of course there are many different kinds of buildings and people, and
Spencer was particular about which kinds he liked to paint. You will not
find a single soaring New York skyscraper or stern-faced, larger-than-life
captain of industry in his entire life's work. Spencer liked things that were
old, beat-up, abandoned. He often painted the back of a building instead
of the front; poor, working people instead of the upper crust; bare-armed,
bulky washerwomen instead of delicate, tea-sipping ladies; thieves and
prostitutes instead of wispy dancers and genteel picnickers.

Given that so many other successful artists of his day were making pleas-
ant landscapes peopled with the wives and children of wealthy patrons, what

could have motivated Spencer to turn his eye so single-mindedly to the other side of the tracks? Perhaps he was some sort of pioneering, socially conscious "lefty" who, even in the teens and Roaring Twenties, was trying to change the world with his canvas and brush. But Spencer adamantly rejected any obvious political interpretations of his work:

Many people have made the mistake of thinking me socialistic —a friend of the working man and all that sort of thing. Not at all. Socialism spells destruction to me. . . . It is man, and not man's theories that I'm interested in—and it is immaterial if the man lives on Fifth Avenue or over on Baxter Street. I'll admit I find Baxter Street, for the time being, a bit more interesting— but that is not the point.[2]

While Spencer's daughter Ann believed that her father sympathized with the working man, he also "exhibited at times some very patrician attitudes."

Seen in a contemporary light, would my father's classification as an artist of the working man be something of an anomaly? . . . I suspect that his approach to workers and menials was essentially southern, both familiar and distant at once. I think he may have romanticized the working man in the Wordsworthian sense. I wonder if it is significant that his mill scenes showed the workers all homeward bound to wife, bairns and bucket of beer—the simple pleasures of the poor. . . .

On the other hand his violent resentment of the industrial era may have been in part because it demeaned the worker, and I am sure he was sympathetic to their plight.[3]

Could it be that Spencer was motivated more by love than anger? Maybe he simply loved the feel of the weathered surfaces of old buildings, and found the flotsam and jetsam in people's backyards oddly beautiful. He was drawn to the environments that ordinary people create for themselves, and he enjoyed the everyday things that ordinary folks do: talking with friends on the front porch of the house, washing clothes, picking up trash in a vacant lot. He was a student of the human animal, and observed and recorded the subtleties of gesture and body language as people interacted with each other.

To Spencer, there was something about the idealized world of the traditional landscape painter that felt unreal and vaguely dishonest. As his friend F. Newlin Price put it:

Back-yards—well, a back-yard may mean the fine, full naked arms of a woman washing clothes near a gray wall and a glorious elm tree. It may mean the place where men and women and children put off the clothes of pride and put on their own transparently healthy, courageous kind, and are spontaneous. It is the intimate side of life, the half-dressed side, where beings are themselves. Back-yards are genuine, unpretentious.[4]

Figure 1
Charles Meryon (1821–1868)
L'Abside de Notre-Dame de Paris
1850–61
etching (proof impression)
image: 148 × 288 mm
Spencer Museum of Art,
The University of Kansas:
Museum purchase: C. Z. Offin
Art Fund; T. Maupin M. Fund;
L. C. Walker Fund

Figure 2
Robert Henri (1865–1929)
Cumulus Clouds, East River 1901–02
oil on canvas
25¾ × 32 inches
Smithsonian American Art Museum.
Partial and promised gift of Mrs. Daniel
Fraad in memory of her husband

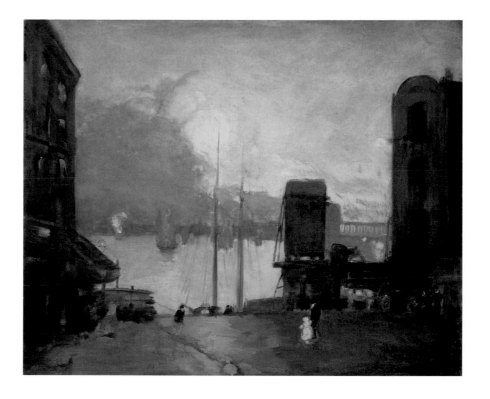

Spencer wasn't the first artist to see the world this way. By the time he matured as a painter in the second decade of the twentieth century, he could draw on a long tradition of humanistic artists in both the literary and visual arts. He was particularly fond of Charles Dickens, who lovingly portrayed the life of lower-class England. High on the list of Spencer's painterly ancestors were Rembrandt, who could turn a lowly housemaid into a timeless icon; Francisco Goya, with his passionate depictions of the effects of war on ordinary people; and Honoré Daumier, the nineteenth-century French painter who regularly found beauty and pathos in the street life of Paris, as well as Daumier's contemporary Charles Meryon (fig. 1), who was known for his evocative etchings of the buildings and bridges of Paris.[5]

The most obvious influence on Spencer was Robert Henri (fig. 2) and the New York–based group of artists Henri led known as The Eight or the Ashcan school. Henri and some of his colleagues injected a kind of unsentimental yet loving realism into American painting. Instead of filling their canvases with idealized peasants and maidens or hackneyed scenes from history and literature, the Ashcan school painters often depicted the back alleys, barrooms, and bums of New York City.

Henri's rebellious realism was rooted in his years of study at the Pennsylvania Academy of the Fine Arts, where he was steeped in the hard-nosed pedagogy of Thomas Eakins, the master painter who trained his students to ground their work in careful observation of the visual universe.

Spencer studied with Henri, though it's not certain when or for how long.[6] But Spencer certainly absorbed Henri's ideas. Because of Spencer's choice of subject matter he has often been called Bucks County's Ashcan school painter. He also has been associated with the Depression-era movement that flowered shortly after his death, social realism. But Spencer's work resists this kind of easy pigeonholing. There's often a gritty, "in your face" quality to the realism of the Ashcan painters that would have been foreign to Spencer, who felt a kind of romance in his canal scenes and pictures of anonymous New York dockworkers. And there's an ardent, "storm the barricades" mentality in the social realist depictions of unemployed workers and homeless immigrants that would have offended Spencer's more aristocratic sensibilities.

While his basic subject matter—buildings and people—remained constant, he was not content simply to crank

out pleasant mill scenes throughout his roughly twenty-five years of serious painting. By the end of his life he was experimenting with a looser, more spontaneous drawing style in which only the vague outlines of buildings were recognizable. So much for Henri's gritty realism! In his last years Spencer also made a number of paintings that were odd combinations of fantasy and historical events, with ironic commentaries on modern life and his unhappy marriage thrown in as well. While they have a definite point of view, there's not much evidence of flagrant left-wing politics—or right-wing, for that matter—in those canvases.

There isn't the slightest hint of impressionism in the late paintings either, which leads to the unavoidable question: Even though he lived and worked in an art colony associated with impressionism, and often has been lumped together with the American impressionist movement, was he even remotely an impressionist painter? The definitive answer is, yes and no.

Impressionism was characterized by a bright palette; rapid, broken brushwork and a rougher, less detailed painting surface; a fascination with the effects of light on the things of the world; and an underlying realism that manifested itself in the conviction that the best work happened outdoors, in direct physical contact with nature. Some of Spencer's earlier paintings have the bright colors and dappled brushwork of impressionism,[7] but for every one of these canvases there is another one with a darker palette and more detailed surface. And even though Spencer based many of his paintings on real places, and both sketched and painted outdoors like the impressionists, he was a studio painter at heart: a careful, meditative worker who in general valued precision over speed.

Spencer certainly assimilated the impressionist ethos, and there are many paintings from his early and mid-thirties that fit loosely under the impressionist umbrella. But as he matured he grew restless, and in his forties he was making pictures that lived in an entirely different universe. If one were forced to cram him into a particular stylistic classification, he would have to be placed with the mostly nineteenth-century artists known as genre painters, who celebrated ordinary moments in the lives of common folk—a movement that reached its low point, perhaps, in those ubiquitous renditions of dogs playing poker and its high point in van Gogh's deeply felt peasant scenes. F. Newlin Price was convinced that Spencer fit best into this category, though Price voiced this opinion several years before his friend's later, more experimental phase:

> Although catalogued as a landscapist, Spencer really is a genre painter [emphasis Price's]. It is the intimate, daily, romantic life of the people that he is interested in; never in the political life, or in the fashion of the day. . . . Art, for him, has no period. It is daily life.[8]

Terms like impressionism, social realism, and genre painting can legitimately connect artists to some of the larger notions about art that flow through the culture. But ultimately such categories are useful only if they also shed light on what particular artists were trying to accomplish in their work. Like all good painters, Spencer absorbed many different styles and was nourished by many different creative minds. But what came out was his way of seeing and experiencing the world. As his life unfolded he grew more and more confident of both his craftsmanship and his ideas, and he cared less and less about what other artists were doing.

NOTES

1. Robert Spencer, from an undated handwritten personal history in the Dewitt McClelland Lockman Papers, Archives of American Art, ca. 1925–30.

2. Ibid.

3. From an unpublished short manuscript by Ann Spencer Simon, in the possession of Shayla Spencer.

4. F. Newlin Price, "Spencer—and Romance," *International Studio* 76 (March 1923): 490.

5. Spencer's predilections for writers and painters are found in the undated handwritten personal history in the Dewitt McClelland Lockman Papers, Archives of American Art, ca. 1925–30.

6. See the Spencer biography, footnote 28, for the documentation of Spencer's study with Henri.

7. Most of these apparently impressionist traits are directly attributable to the influence of Daniel Garber, with whom Spencer both lived and studied in the summer of 1909.

8. Price, pp. 489–90.

BEGINNINGS

Spencer was nineteen when he began his serious study of painting at the National Academy of Design, and he finished his schooling ten years later, in 1909, when he studied privately with Daniel Garber. He must have made many paintings in this period, but almost none survive. Unlike some artists who indiscriminately flood the market with their pictures, Spencer was mindful of what he exhibited and sold.[1] Because he was so meticulous about how his paintings were presented to the world, it's reasonably safe to assume that he destroyed most of his early work.[2]

It's understandable that he wouldn't want his reputation to be diminished by paintings that didn't live up to the standards he set for himself later in life. But the confidence and ease that he eventually found didn't happen by accident. The few early canvases that do survive provide some clues about how hard he had to work in order to get where he wanted to be.

There are four paintings in this book that were made before Spencer hit his stride as an artist, and only three of these were definitely made by Spencer: *Roadside* (ca. 1909; pl. 2), *The Mill Yard* (1910; pl. 3), and *Tohickon Valley, Point Pleasant, Pennsylvania* (1910; pl. 4).[3] *The Mill Yard*, especially, has some of the fingerprints of his mature style. The subject matter is archetypal Spencer: the back of an old mill and a horse-drawn cart, surrounded by trees and sky. The haphazardly strewn logs and boulders in the foreground, as well as the three white chickens searching for seeds, give the painting that typical Spencer sense of ordinariness. This is not a grand moment grandly conceived, but a humble, everyday scene that is also oddly beautiful.

One of the signs of youth in a painter can be a certain carefulness, a lack of freedom. When compared to his later work, *The Mill Yard* is cautious and somehow "safe." The paint is applied slowly and precisely, the colors are somewhat flat, and the composition is relatively predictable. This is a perfectly acceptable and pleasant painting, and even has a tangible poetic atmosphere—but it's a canvas that Spencer himself might later have described as displaying some elements of "school-academy" work.[4]

Roadside is one of the rare Spencers with neither a building nor a figure present. As in *The Mill Yard*, the paint application is detailed and unspontaneous, and the colors are relatively monochromatic. These qualities, along with a vague resemblance to some of Daniel Garber's early landscapes, suggest that this picture comes from a time when Spencer was still unsure of himself. Paintings done just a year or two later were clearly made by the same artist, but it was an artist who had figured out exactly what he wanted to sing about.

1. During our research on this project we were unable to discover a single instance where Spencer repeated the title of a painting exactly. This suggests that he kept excellent year-by-year accounts of his work.

2. As noted previously, Spencer's records were destroyed in a fire at the Las Lomas property in Tucson. The nearly complete list of Spencer paintings compiled by his daughter Tink from the artist's records begins in 1909; you would think from this list that he never made a painting in his student years! Because the list is generally so accurate, Tink most likely created it before the fire from the artist's journals and records.

3. The fourth early painting (*Untitled*, pl. 1), while signed, has uncertain provenance and can't be definitely attributed to Spencer. While in many respects it is radically different from his mature style, its subject matter, figure drawing, and somewhat distant point of view are all suggestive of his later habits, and the painting is most likely an early Spencer canvas.

4. Spencer uses this term in an undated, handwritten personal history in the Dewitt McClelland Lockman Papers, Archives of American Art, ca. 1925–30.

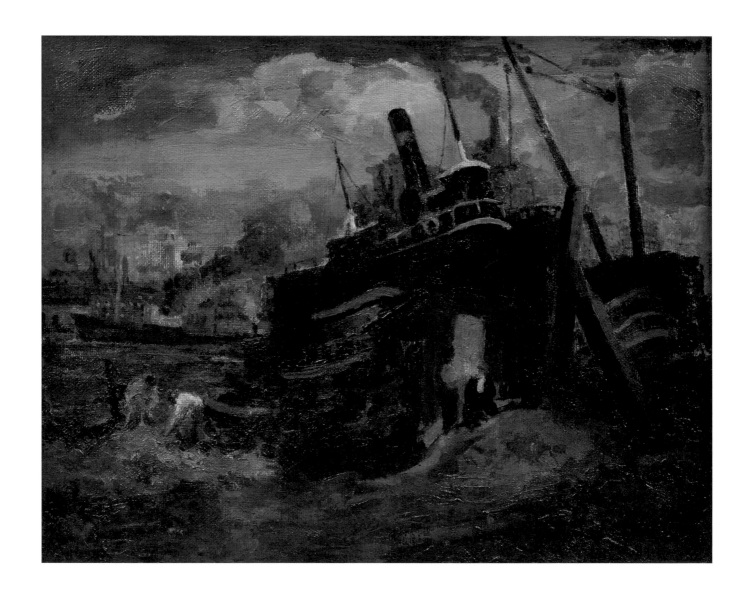

Attributed to Robert Spencer

PLATE I *Untitled* 1908

oil on canvas mounted on board
16 × 20 inches
Collection of Owen Medd

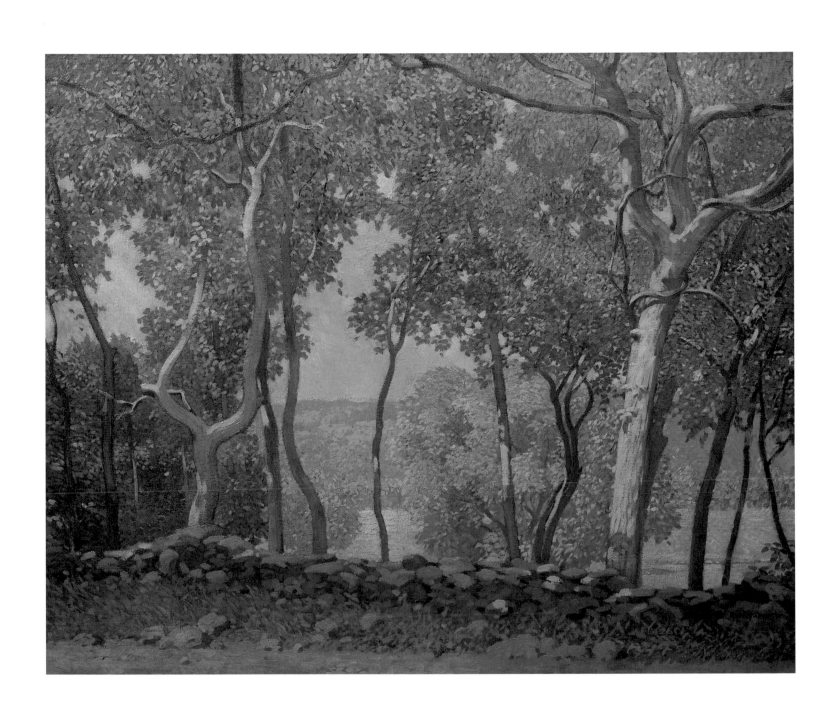

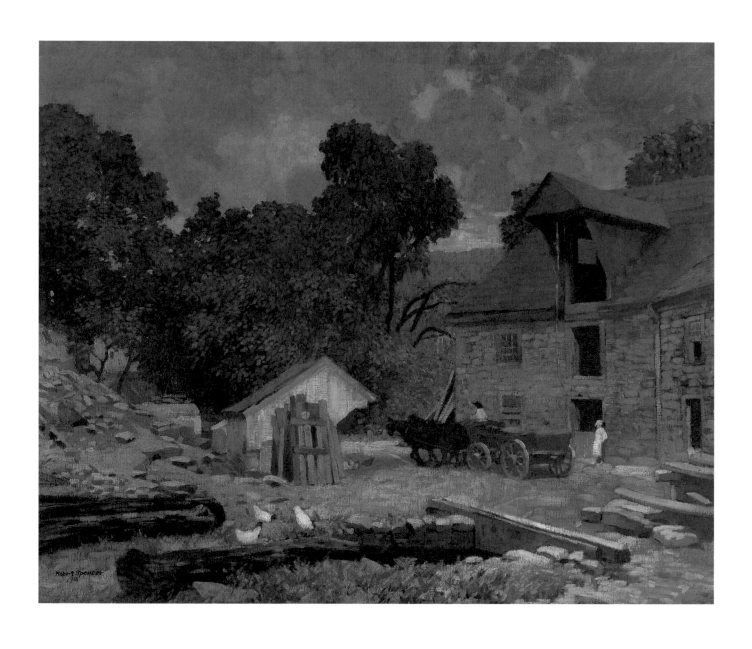

PLATE 3 *The Mill Yard* 1910

oil on canvas
25 × 30 inches
private collection

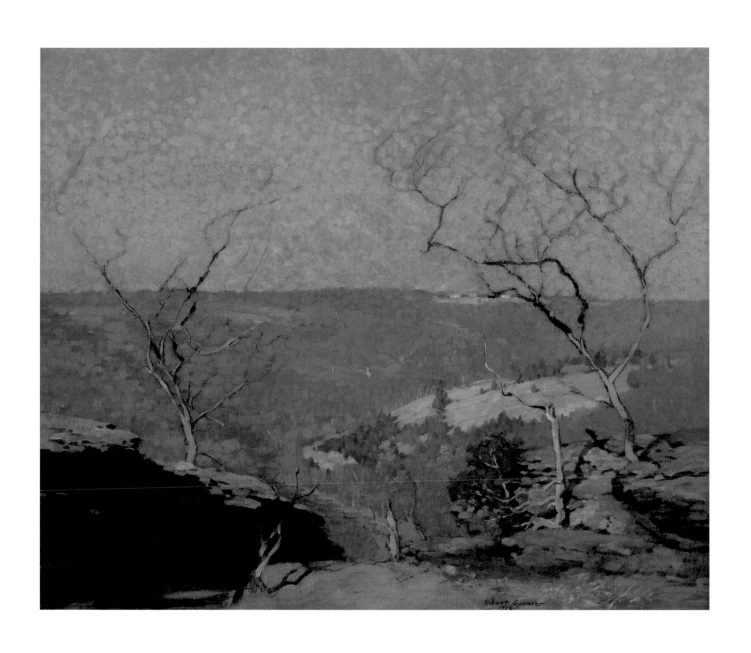

PLATE 4 *Tohickon Valley, Point Pleasant, Pennsylvania* 1910
oil on canvas
25 × 30 inches
Collection of Ellen and John Vreeland

FINDING HIS VOICE

The word *breakthrough* is often used by artists to describe moments of intense and unexpected growth. There are many kinds of breakthroughs: Sometimes, after a period of searching and dissatisfaction, a radically new idea takes hold of an artist's mind, and the work moves in a completely different direction. But a breakthrough also can be more like an arrival than a departure. The young painter gropes around in a fog, unsure of what's solid and what isn't, but occasionally bumping into things that seem real. Suddenly the fog lifts and the shape of the terrain becomes clear. To put it another way, the artist tries on all sorts of clothes, some of which don't fit at all, some of which fit pretty well. Then, almost by accident, just the right combination is found in which all the different elements mesh perfectly, and it looks as if he or she was born with those clothes on.

It may seem imprecise and intellectually lazy to describe this latter kind of breakthrough metaphorically. But this congealing process of the soul is inherently mysterious, and the language of poetry actually may be the most precise way of talking about it. There are also peculiar connections here with the language of religion, as well as, oddly enough, sports. A golfer or baseball player who, after a period of struggle, suddenly finds that sweet, perfect swing may not be very different from an artist like Spencer whose work unexpectedly comes together, seemingly without effort. In the religious arena, the state of grace is usually spoken of as a mysterious and inexplicable gift, yet it often follows a time of great effort and great uncertainty.[1] To use another metaphor: If the artist learns her name—if she begins to know, in her bones, who she is—how could this knowledge *not* be reflected in her work?

Although a number of technical changes occurred in Robert Spencer's paintings around 1910, perhaps the best way of describing the difference between *The Mill Yard* (1910; pl. 3) and *The Marble Shop* (ca. 1910; pl. 5) is that the latter painting was made by an artist who knew his own name.

The Marble Shop has a deceptively casual quality. The brushwork is loose and not excessively detailed. Daubs of paint are laid on quickly, with tufts of brown grass brought to life by single strokes, and entire chickens created from a few rapid touches of white, red, and black. Similarly, the composition is simple and unforced: a row of dilapidated buildings with a relatively empty foreground that quietly leads the eye between the two groups of chickens, past the white fence and figures on the right, to the main character—the central wooden structure with its broken windows and randomly stacked gravestones (presumably the "marbles" of the title). While the building appears to have

stood for decades, the picture itself has a momentary, evanescent atmosphere, as if Spencer just happened to be walking by this place with his hands in his pockets. Glancing up, he saw the nondescript little scene, recorded it in his memory, went home to his studio, and in a few minutes transferred it to canvas.

Of course it was not that easy, but Spencer makes it look easy, the same way a virtuoso saxophone player doesn't force you to think about the years and years of practice that went into the spontaneous execution of a complex solo riff. Spencer himself made the connection between painting and music when he talked about technique:

> A thorough knowledge of the technical side is just as necessary to the painter as to the musician. Until one knows his palette and his drawing well enough to forget them, his expression is as much hampered as a public speaker would be by stammering.[2]

The key word in Spencer's statement is *forget*. The point of technique is not to draw attention to it self-consciously, but to get so incredibly comfortable with drawing, color, surface, and design that the artist actually forgets that he's using advanced technical skills to say what he wants to say in a picture. The magic of what happened to Spencer with *The Marble Shop* (as well as to countless other artists of all persuasions who have a similar breakthrough) is that this sudden leap in the technical area occurred at roughly the same time he figured out exactly what subject matter and which ideas he wanted to pursue. In other words, after a long period of trial and error, he came to know who he was as an artist *and* a man, and the technique he needed to express his ideas was there, in his eye and hand, ready and waiting.

Spencer *earned* what he found in *The Marble Shop* through hard work, study, and years of simply living with himself, getting to know his own habits and proclivities. But hard work alone doesn't explain what happened, and therein lies the mystery of how artists find their voices.[3]

Within a few years Spencer had firmly established the beachhead he created with *The Marble Shop,* and 1913 was arguably the best year of his life as a painter. In that year he made at least seven major canvases,[4] five of which are among the works he is best known for today:

Grey Mills (pl. 11), *Five O'clock June* (pl. 13), *The Closing Hour* (pl. 14), *Repairing the Bridge* (pl. 15), and *The White Tenement* (pl. 16). As with *The Marble Shop,* each of these pictures has all of the identifying features or "fingerprints" that make Spencer's work so easy to spot: The subject matter is buildings (usually mills) and people. There is movement and life set against the backdrop of ancient, decaying structures that have as much or more character as the workers. The people are closely observed in terms of clothing and gesture, yet also are distant and anonymous, with facial expressions barely discernible. The colors are somewhat muted, yet never monochromatic, with individual areas enlivened by an active, dappled surface that blends several colors.[5] The design is relatively flat, dominated by the vertical buildings (which are the real protagonists) and small horizontal strips in the foreground and sky.

The breakthrough that happened around 1910 was the defining moment of Spencer's creative life. His subject matter eventually moved beyond Bucks County to New York and Europe, and he expanded his conceptual horizon to include intimate vignettes of street scenes and family life, grand and enigmatic histories and biblical tableaux, and a flirtation with a few of the more rarefied and experimental ideas associated with early twentieth-century modernism. But every picture he made in the next twenty-one years was grounded in the simplicity, spontaneity, and self-awareness that he found in these early paintings.

1. Two classics of spiritual literature that describe this process are *The Confessions of St. Augustine* and Thomas Merton's *The Seven Storey Mountain,* both of which speak of long periods of restlessness, experimentation, and doubt that preceded moments of awakening. Spencer, like most artists, probably would have been uneasy with this direct comparison between artistic and spiritual growth, yet there are many underlying similarities in the language and experience.

2. Robert Spencer, from an undated handwritten personal history in the Dewitt McClelland Lockman Papers, Archives of American Art, ca. 1925–30.

3. On the one hand this process is no more mysterious than an artist learning that she likes tuna sandwiches better than roast beef. After years of living with herself, she gradually learns how to be comfortable with the idiosyncrasies and habits that are most her own. She grows into herself. Yet this still doesn't fully explain the rather sudden congealing of idea and technique that Spencer and so many serious artists experience.

4. The three most common sizes of Spencer's paintings are 12 by 14, 25 by 30, and 30 by 36 inches. He generally reserved the latter size for his major, bravura canvases, such as *The Closing Hour.*

5. Much has been made of the fact that Spencer's early work was strongly influenced by his study with Daniel Garber, particularly the dappled, impressionistic brushwork. But Spencer's use of *color* in these paintings is even more "Garberesque," especially the complex blendings of separate tonalities that combine to give a single impression of color in a given area.

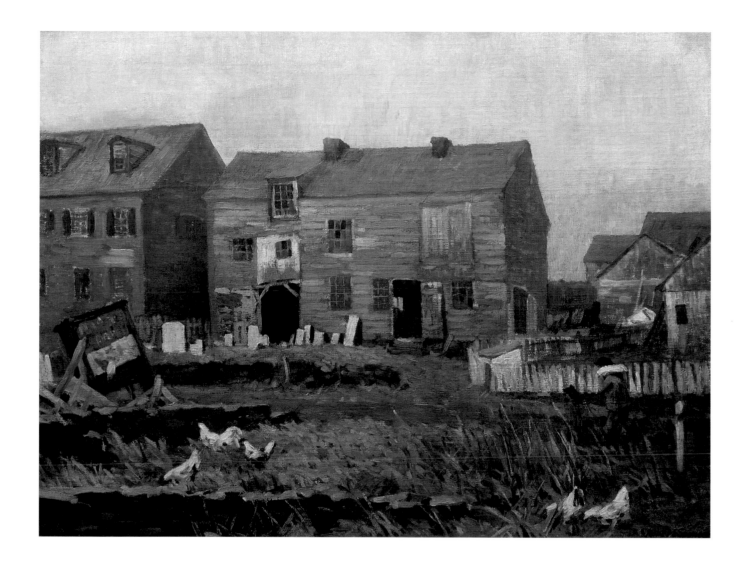

"No one intimately acquainted with the ways of pigment could fail to observe the affection
of his delicate craftsmanship. He weaves a fabric-like lace—lace in which are caught little
primitive patterns of life among laborers."

THE NEW YORK TIMES, 1920, AUTHOR UNKNOWN

PLATE 5 *The Marble Shop* ca. 1910

oil on canvas
18 × 24 inches
private collection

"*Spencer seems to visualize his mills and his people as inseparable. He imparts to the mills the impress of the people who have dwelt within their walls. They partake of the dignity of human beings' work.*"

UNKNOWN NEWSPAPER, 1923, AUTHOR UNKNOWN

PLATE 6 *The Silk Mill* 1912

oil on canvas
30 × 36 inches
Collection of Walter and
Lucille Rubin. Photograph
courtesy of the Boca Raton
Museum of Art

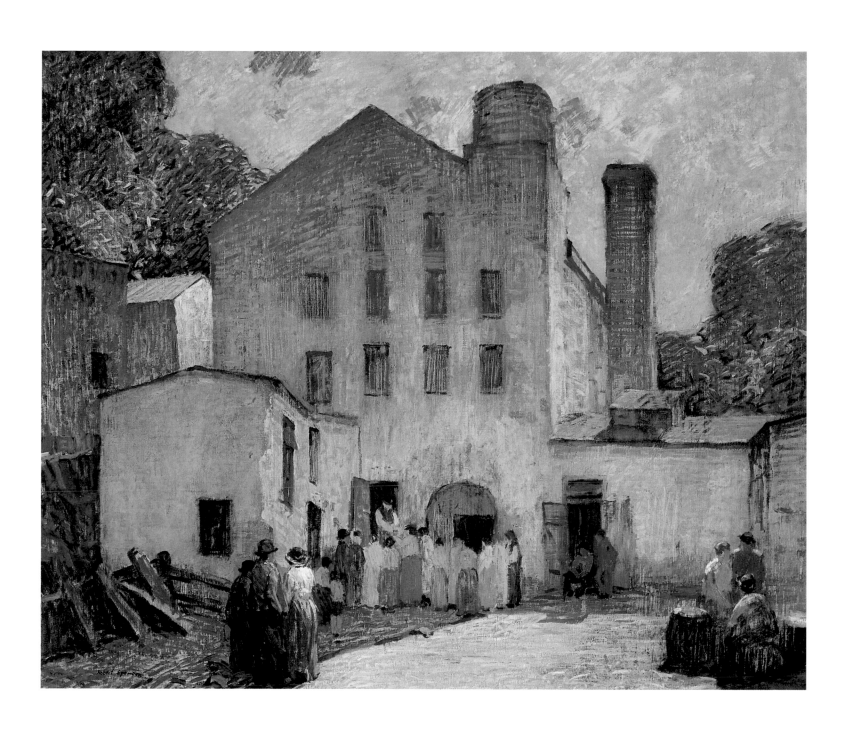

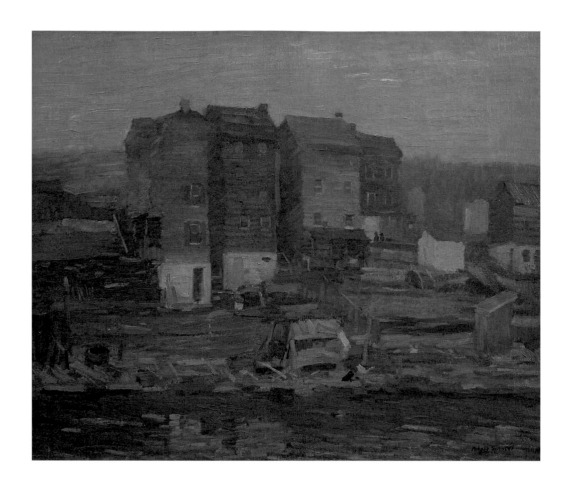

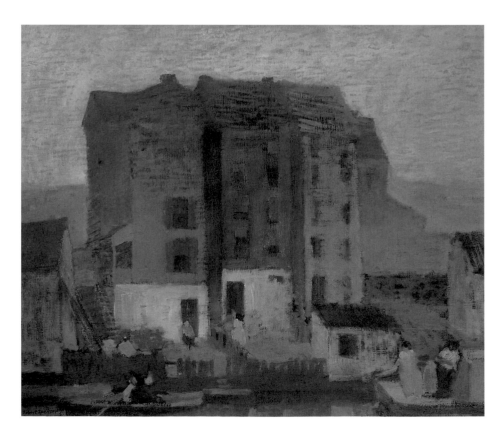

PLATE 7 *A Gray Day* 1912

> oil on canvas
> 20 × 24 inches
> In trust to the James A.
> Michener Art Museum from
> Marguerite and Gerry Lenfest

PLATE 8 *Misty Evening* 1911

> oil on canvas
> 20 × 24 inches
> Collection of Kathy
> and Ted Fernberger

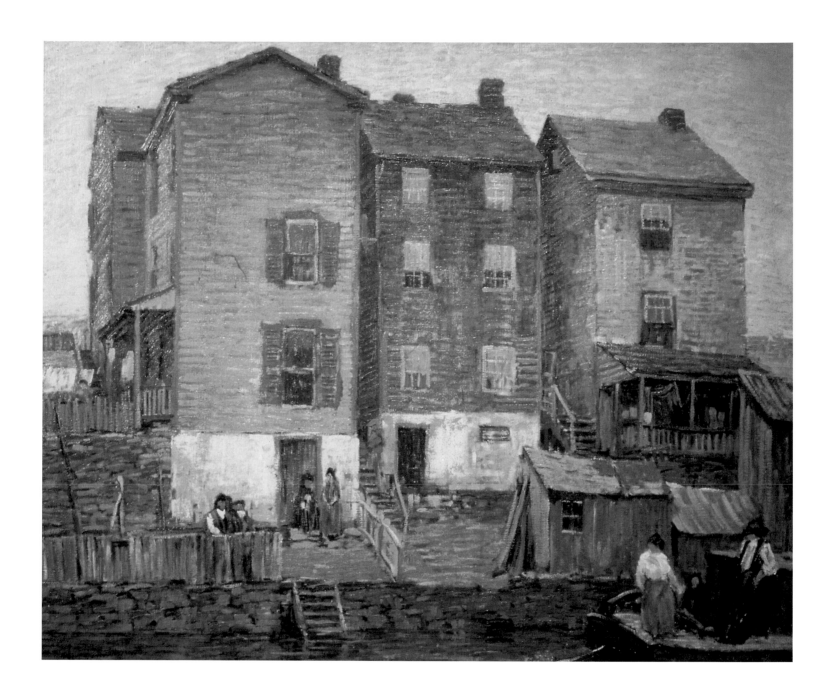

"Three Houses *is an example in which the artist's skill has depicted simply and with singular fidelity the varying wear of weather on tenements of the same age ranged along the bank of a canal.*"

NEW YORK WORLD, 1916, AUTHOR UNKNOWN

PLATE **9** *Three Houses* 1911

oil on canvas
30 × 36 inches
Courtesy of the Huntington Library,
Art Collections and Botanical Gardens,
San Marino, California

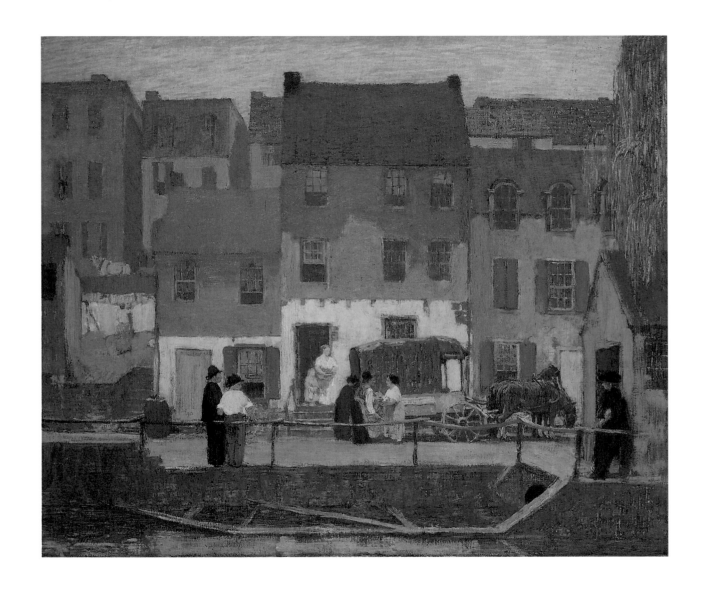

PLATE 10 *The Huckster Cart* ca. 1912

oil on canvas
30 × 36 inches
The Art Institute of Chicago. Friends
of American Art Collection, 1916.440.
Reproduction, The Art Institute of Chicago

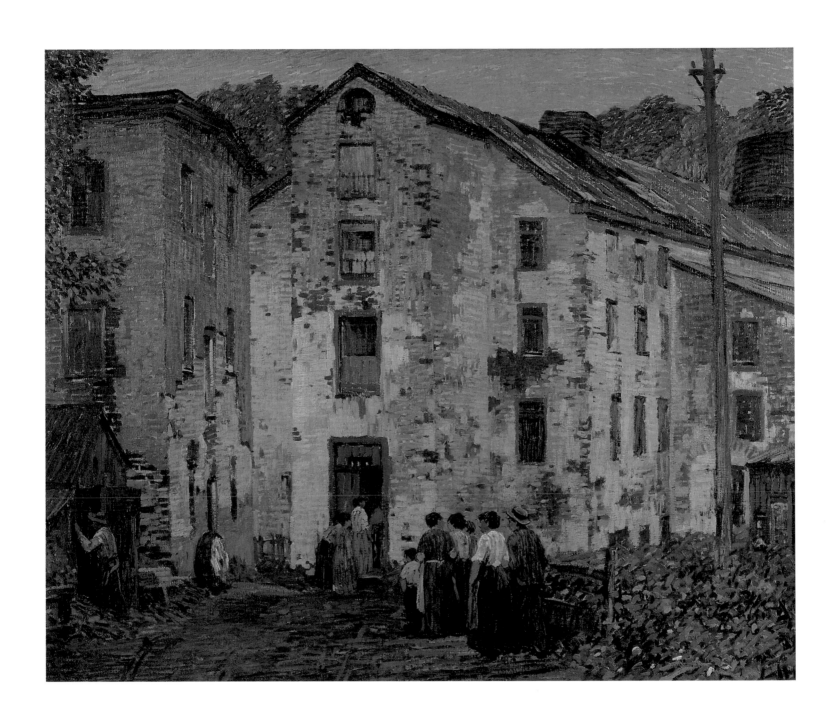

PLATE I I *Grey Mills* 1913

oil on canvas
30 × 36 inches
Widener University Art Collection,
Gift of A. Carson Simpson and
Mrs. Peggy Simpson Carpenter, 1953

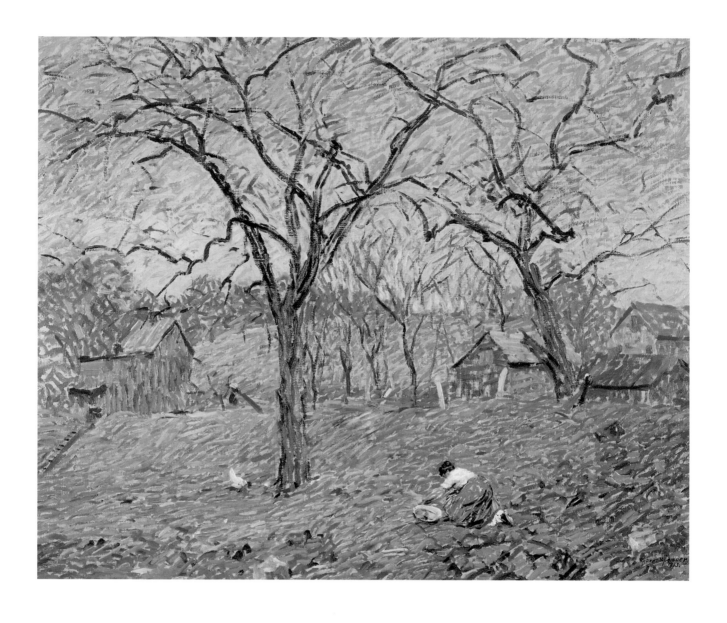

PLATE 12 *Gathering Greens* 1913

 oil on canvas
 25 × 30 inches
 Collection of Rhoda and David Chase

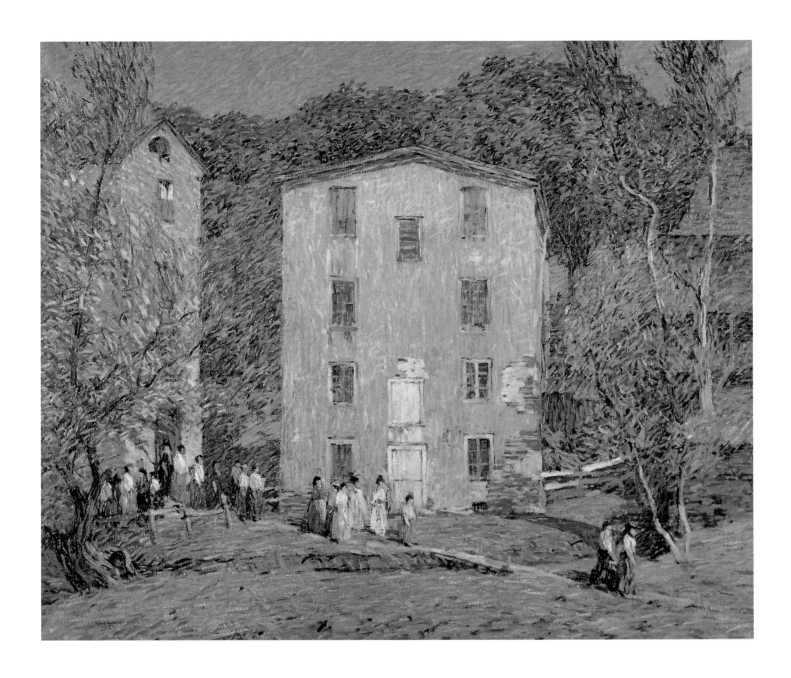

"[Spencer's] composition Five O'clock June, for instance, has a certain lyrical, almost joyous quality, with its brilliant sunlight, its warm green foliage and its groups of gaily-clad operatives, despite the fact that the subject represents nothing more romantic than the closing time at a factory."

UNKNOWN ST. LOUIS NEWSPAPER, FEBRUARY 11, 1917, AUTHOR UNKNOWN

PLATE 13 *Five O'clock June* 1913

oil on canvas
30 × 36 inches
Collection of Richard and Mary Radcliffe

"[Spencer] makes us feel the pathos and drabness of mill life. Even the brick walls tell their story. They are old, worn, chipped, with the paint blistered and peeling off—the walls of the earlier factories of America which have been used for years and years."

UNKNOWN NEWSPAPER, UNDATED, AUTHOR UNKNOWN

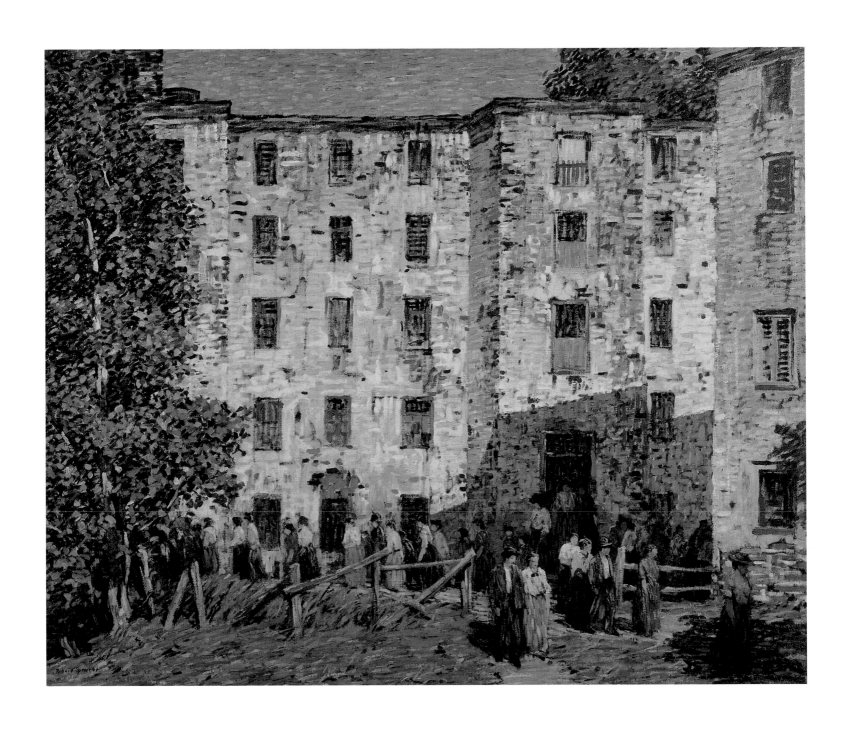

PLATE 14 *The Closing Hour* 1913

oil on canvas
30 × 36 inches
private collection

45

"[Spencer] approaches his rectangular brick buildings in an idyllic mood, caressing their flat, weather–worn surfaces with a tender brush."

THE PHILADELPHIA PUBLIC LEDGER, NOVEMBER 19, 1916, AUTHOR UNKNOWN

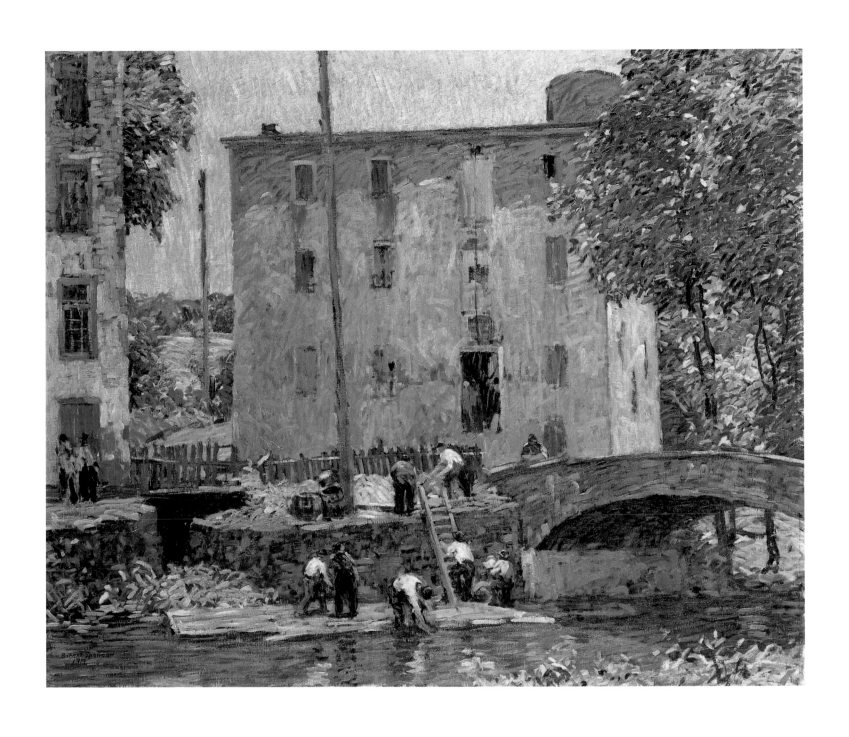

PLATE 15 *Repairing the Bridge* 1913

oil on canvas
29⅞ × 35⅝ inches
The Metropolitan Museum of
Art, George A. Hearn Fund, 1914.
(14.21) Photograph © 2001 The
Metropolitan Museum of Art

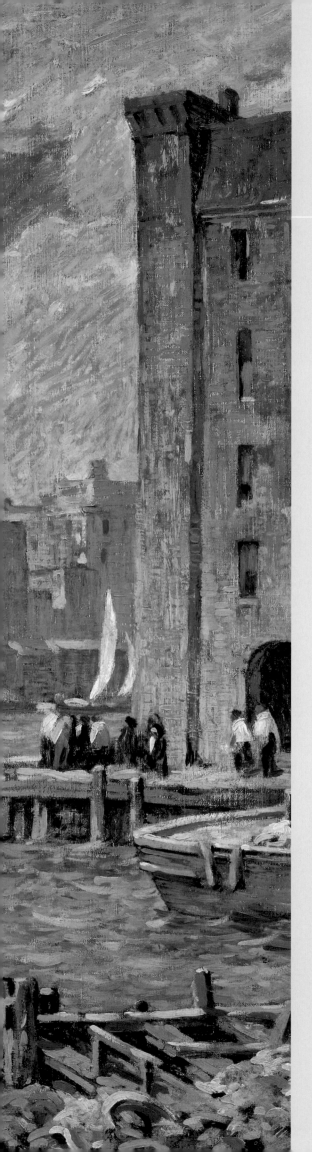

THE CITIES, THE TOWNS, THE CROWDS

In Spencer's breakthrough years of 1910 to 1913/14, he both discovered and planted his flag in the territory where he would make his creative home. In subsequent years he set about the pleasurable task of exploring that territory.

In the teens his subject matter was almost exclusively Bucks County scenes, and he didn't limit himself to the mills and mill workers for which he is best known. There are large-scale views of the Delaware River, with snow or grass in the foreground and bridges and villages lying peacefully beneath the hills on the other side. There also are intimate scenes of courtyards and tenements, with clusters of people talking, observing, and milling about. He was particularly drawn to the Delaware Canal, and loved to paint views of barges as they floated lazily up and down the canal, surrounded by buildings, trees, and stone walls.

In the late teens and early twenties Spencer must have begun to feel that he had seen all Bucks County had to offer. He continued to paint buildings and figures, but shifted his attention to New York City's rivers and harbors. Eventually he abandoned America altogether for the canals, bridges, and dockworkers of Europe. His work also began to evolve in ways beyond the change in location, as he became increasingly less interested in basing his pictures on observation alone.

The White Tenement (1913; pl. 16) is a classic example of Spencer's earlier, Bucks County period. Although the subject matter isn't typical of impressionism, the picture clearly was made by an artist who was working under the impressionist umbrella.[1] The painting has a bright palette, in Spencer's universe at least. There's a relaxed and cheerful atmosphere in this depiction of an old apartment building above the canal on a sunny spring day: Long rows of clothes hang loosely on clotheslines, and even the run-down tenement looks downright festive, surrounded as it is by a radiant blue sky and deep green bushes and trees. The dappled brushwork has a decidedly impressionistic feel, and there's a sense that the artist had fallen in love with a real place that he tried to depict realistically, even though he almost certainly changed elements of the scene to enhance its picturesqueness. Despite Spencer's attention to detail in this canvas, the picture also conveys his appreciation for the poetry of a building with so much character. As his friend F. Newlin Price said:

> To Spencer castles are not half so romantic as are factories or mills or tenements. Every brick, every angle, every opening in a mill means something, has its history, especially if the mill

be old. The stains on the walls, the broken places are landmarks
of battles with storm and sunshine, with man-made machines,
with time. Every workman, every year leaves some impression
of himself or itself, . . . each succeeding family leaving its mark,
until the very structure becomes human and fits into the moods
of the town.[2]

These humanized structures were the "meat and
potatoes" of Spencer's paintings, but the way he ren-
dered them began to change in the late teens and early
twenties. *The Red Boat* (ca. 1918; pl. 30), for example,
depicts a canal boat floating peacefully between several
buildings, probably in New Hope. Spencer renders
these structures, along with the trees and sky surround-
ing them, with even greater detail and precision than
he applied to *The White Tenement* of 1913 or to the mills
he painted in his other major canvases of 1913. The
only remnant of the dappled, impressionistic brush
strokes is found in the grassy area along the canal.
The Red Boat has a rustic simplicity, a feeling that the
painting is still grounded in the impressionist desire
to convey the tactile, sensory qualities of a particular
place.

Spencer's daughter Tink believed that these canal
scenes were at the heart of her father's vision of life
in Bucks County, though the paintings are a bit more
tranquil than her colorful description:

> *All life was deeply paintable if it was strong enough, and his*
> *back yards and his scenes of life on the canal boats drawn by*
> *mules up and down the Delaware Canal, with their tough*
> *bargemen and their fighting, hair-pulling, eye-spitting women,*
> *their drunken brawls and their singular life, were certainly*
> *strong enough material for his brush. [The canals] are gone*
> *now . . . but once they were full of life, and the tales told and*
> *the pictures created by their romance will live on, part of the*
> *saga of America.*[3]

In the 1920s the impressionist need for realism
was gradually overtaken by Spencer's increasing em-
phasis on the romantic and even legendary aspects of
urban life. *Wharves* (1925; pl. 39) retains the impres-
sionistic brushwork in the foreground and especially
in the water, where the short, rhythmic strokes look
like gently lapping waves. As with *The Red Boat*, the
buildings are rendered with greater detail than was

typical of Spencer's earlier, most impressionist work.
But there has been a subtle shift in the emotional
tone. The shift comes in part from the change in sub-
ject matter (from the pastoral charm of Bucks County
to the more dynamic, cosmopolitan energy of New
York's East River), and in part from a larger-than-
life quality that has crept into the way Spencer sees
the world.

In *Wharves*, this quality is most noticeable in the
placement of the large structure that dominates the
composition. Not only is it in the exact center of
the scene but the angle of view is upward and the left
foreground is relatively empty, giving the building
a dramatic power that's enhanced by the sunlight
sweeping across its surface. Even the people in the
painting appear archetypal: a cluster of workers,
children playing, a group of ladies looking on. This
painting still depicts an actual place, but the scene
is also the kind of muscular urban tableau that poets

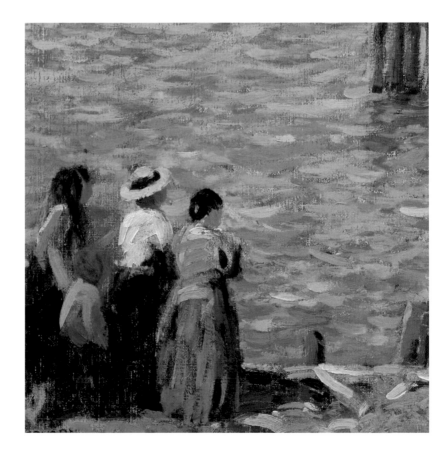

Figure 1 Detail of *Wharves*, plate 39

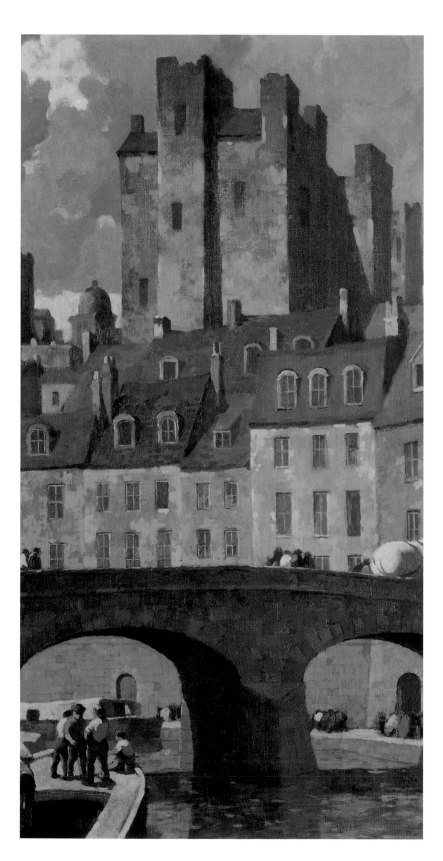

Figure 2 Detail of *The Old City*, plate 42

and songwriters celebrated in more innocent times, as in this excerpt from Carl Sandburg's famous 1916 poem "Chicago":

> Come and show me another city with lifted head singing so
> proud to be alive and coarse and strong and cunning.
> Flinging magnetic curses amid the toil of piling job on job, here
> is a tall bold slugger set vivid against the little soft cities...[4]

This mythic quality is more pronounced in one of the last paintings Spencer made, *The Old City* (1931; pl. 42), which is dominated by a dramatic central building that looms heroically over the ancient stone bridge and canal. The pleasant impressionistic brushwork has completely disappeared, and the charming Bucks County mills and tenements of the earlier paintings have been replaced by the complex and overpowering architecture of Europe, probably Paris. Spencer felt an intense love for such primal scenes of the life and dynamism of cities, as Tink recalled in this beautiful description of his fascination with bridges:

> I remember a night in Paris when I was fifteen. We'd been
> walking all afternoon in a half sunny mist... and we stopped
> on each bridge while Dad went back over time and his imagi-
> nation to the things that had, or might have, happened on each
> one. The riots and the battles, saints and philosophers watching
> over the parapets, the lovers meeting in their folds, the suicides
> who used to leap from them into the River Seine. Dad said the
> bridges were the veins of Paris, for they flowed life into the
> streets and buildings built on either side.[5]

The most revealing word in Tink's reminiscence is *imagination*. In his last years, Spencer was less and less constrained by the hard facts in his work, and more and more comfortable with an imaginative appreciation of the history and romance of places and people. As he worded it, "When we are all weary, tired of facts, tired of efficiencies, we turn to Romance, and we find it . . . in pictures, in literature, in music."[6]

1. See the Introduction for a brief discussion of the impressionist mind-set.

2. F. Newlin Price, "Spencer—and Romance," *International Studio* 76 (March 1923): 490.

3. Margaret (Tink) Spencer, unfinished typed draft manuscript of Robert Spencer biography, fifty-two pages plus additional notes and sketches, ca. 1969, p. 13.

4. Carl Sandburg, *Harvest Poems 1910–1960* (New York: Harcourt, Brace and World, 1960), 35.

5. Margaret (Tink) Spencer, p. 26.

6. From a letter from Robert Spencer to an unknown recipient named "Barrie," April 22, 1931; letter is in the possession of Gene Mako, on loan to the Michener Art Museum. The man to whom this letter was addressed was most likely the director of the Grand Central Galleries in New York City.

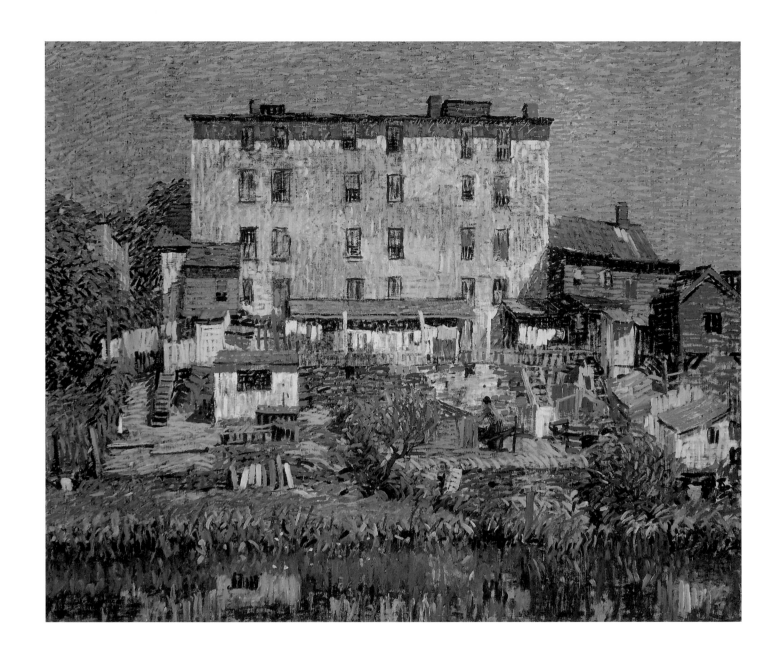

"[Spencer] sees the quiet, poverty-stricken life as might some young poet of the people. The everyday scenes are not seen in caricature as an outsider would see them. Even a tumbling tenement, with its scrambling humanity, is painted with this rare quality of sympathetic understanding."

UNKNOWN NEW YORK CITY NEWSPAPER, MARCH 6, 1920, AUTHOR UNKNOWN

PLATE 16 *The White Tenement* 1913

oil on canvas
30 × 36³⁄₁₆ inches
Brooklyn Museum of Art. John B.
Woodward Memorial Fund 25.761

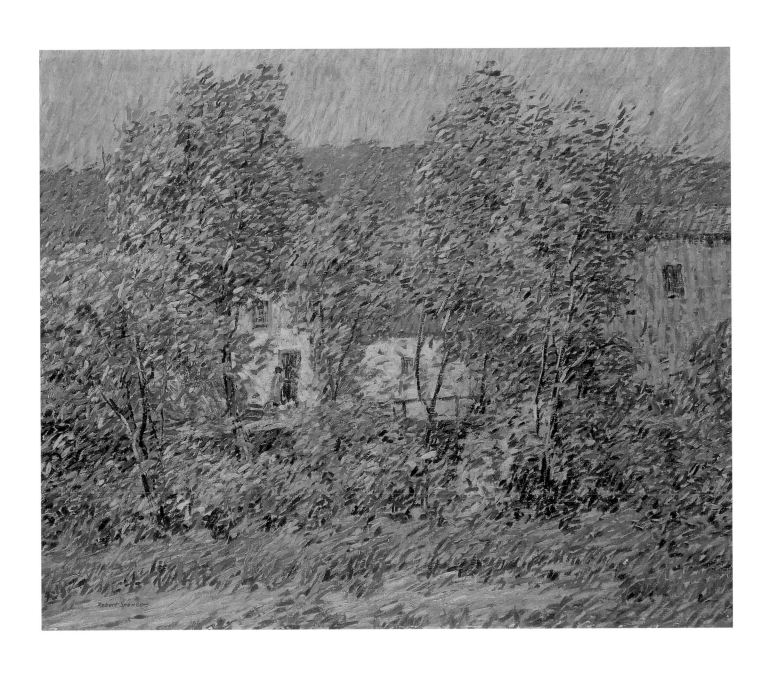

PLATE **17** *May Breezes* 1914

oil on canvas
25 × 30 inches
White House Historical Association
(White House Collection)

53

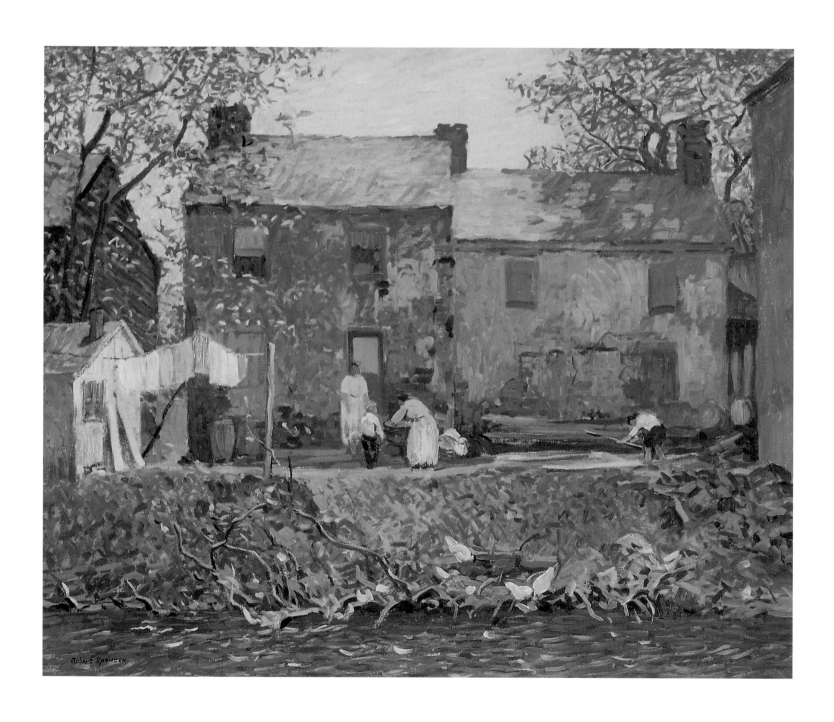

PLATE 18 *Summertime* ca. 1915–20

 oil on canvas
 25 × 30 inches
 In trust to the James A. Michener
 Art Museum from Marguerite and
 Gerry Lenfest

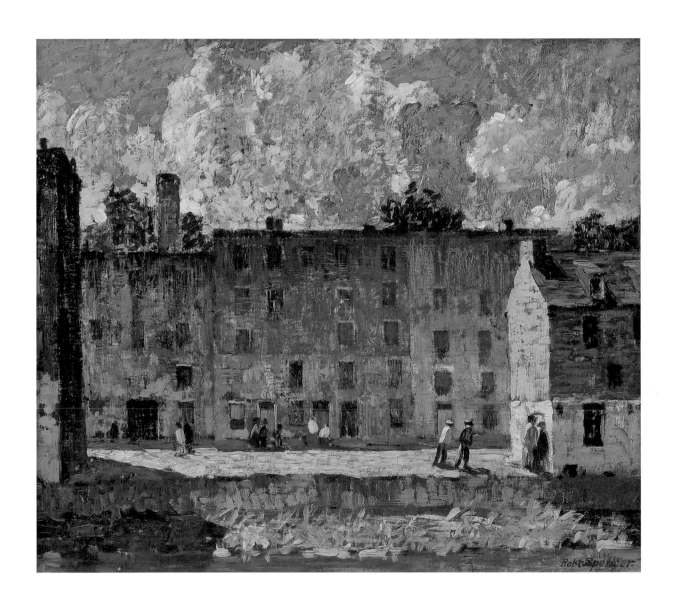

PLATE 19 *A Row of Tenements* 1915

oil on canvas
12 × 14 inches
private collection

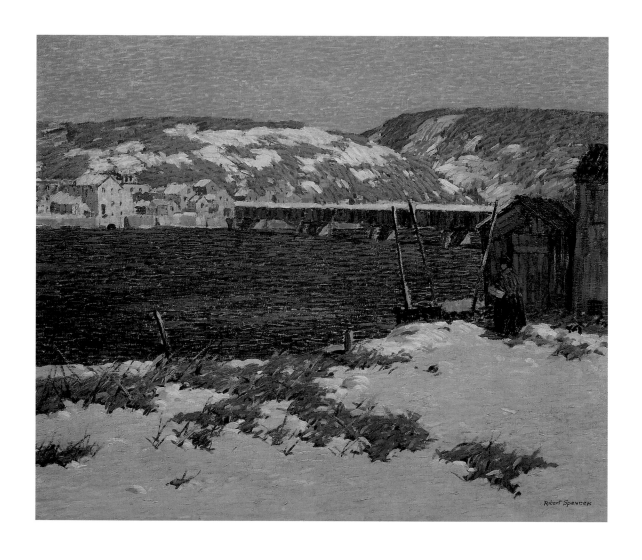

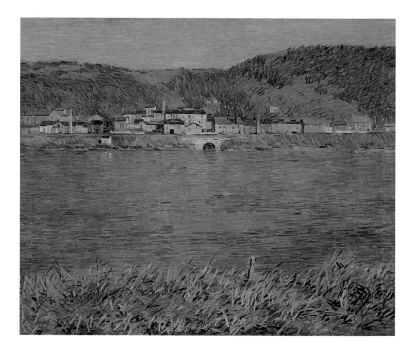

PLATE **20** *The Two Shores* 1915

 oil on canvas
 25 × 30 inches
 private collection

PLATE **21** *The River, March* 1916

 oil on canvas
 30 × 36 inches
 Courtesy of the Reading Public
 Museum, Reading, Pennsylvania

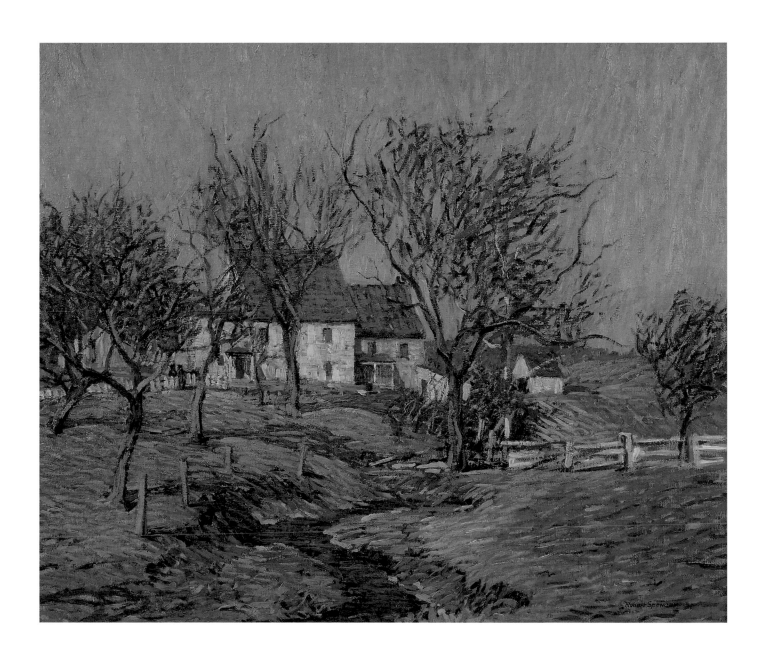

PLATE 22 *The Brook* 1915

 oil on canvas
 25 × 30 inches
 Collection of Ellen and John Vreeland

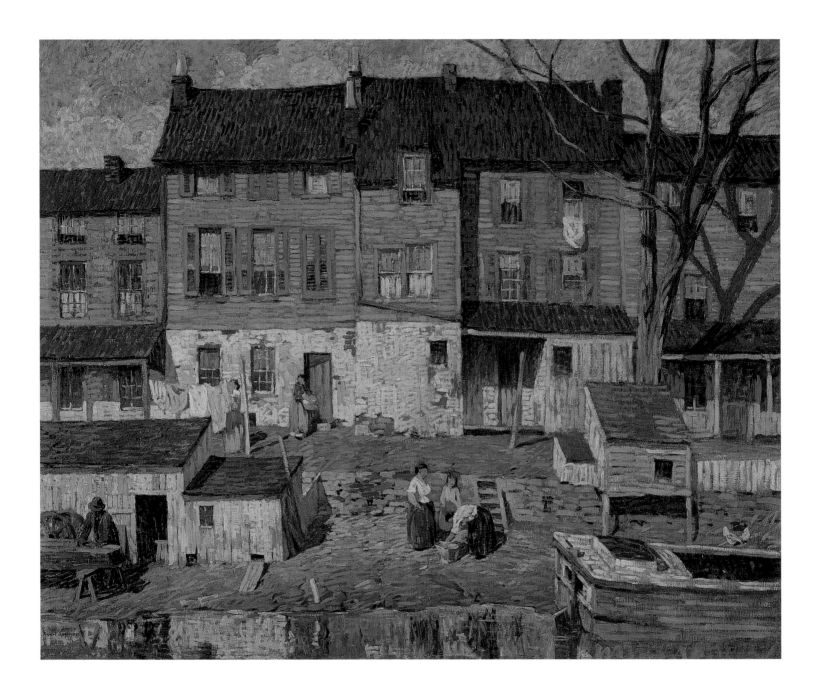

"*What his pictures say, in effect, is that ugly dwellings and the life and labor that center in them have in the scheme of things fully as great a beauty and dignity as any other phase of nature, and offer to the artist just as fine an opportunity to express himself in color and line and form.*"

THE DEMOCRAT CHRONICLE, ROCHESTER, NEW YORK, APRIL 15, 1917, AUTHOR UNKNOWN

PLATE 23 *On the Canal, New Hope* 1916

oil on canvas
30 × 36 inches
The Detroit Institute of Arts.
Gift of Miss Julia E. Peck.
Photograph © 2002 The
Detroit Institute of Arts

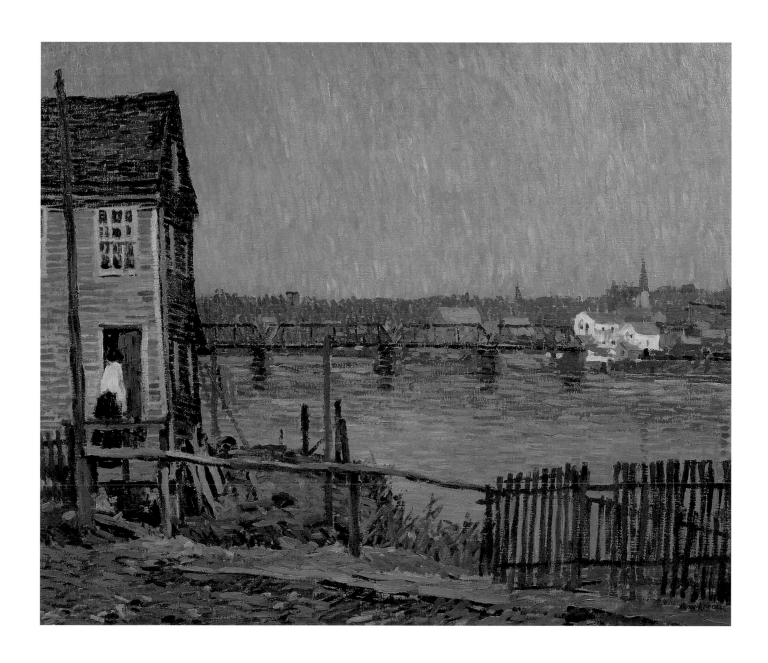

"There are passages of painting in some of his views of workmen's houses that vie with the greatest of modern work in quality, in addition to which they are marked with a grave kind of beauty that gives them a place apart from most contemporary American art."

NEW YORK CITY EVENING MAIL, NOVEMBER 1916, AUTHOR UNKNOWN

PLATE 24 *A Fisherman's House* 1917

oil on canvas
25 × 30 inches
Collection of the New Hope
Museum of Art

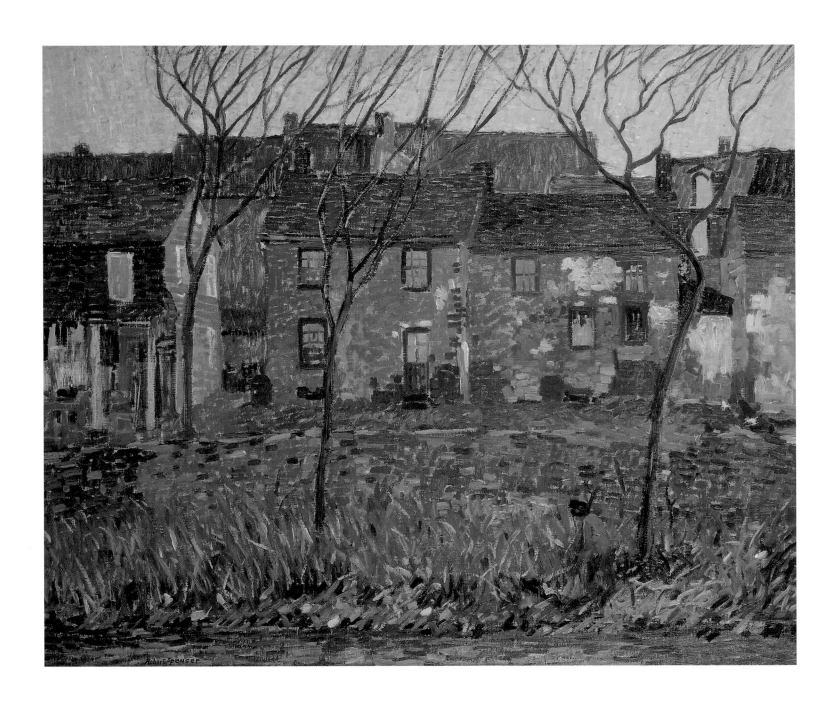

PLATE **25** *Waterloo Row* 1917

 oil on canvas
 25 × 30 inches
 Collection of Amy and Robert Charles

PLATE **26** *Waterloo Place* 1917

 oil on canvas
 30 × 25 inches
 Collection of Thomas and Karen Buckley

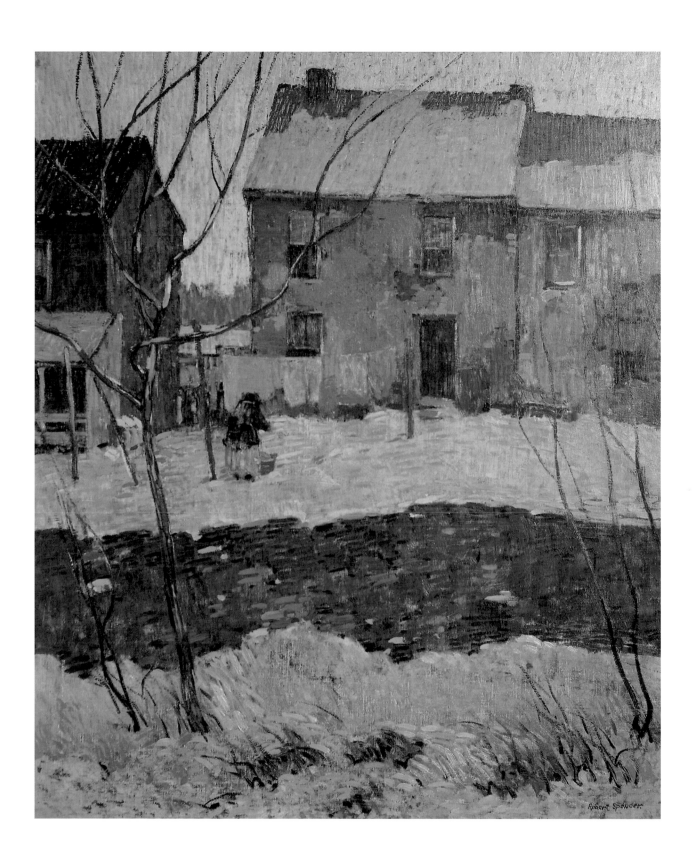

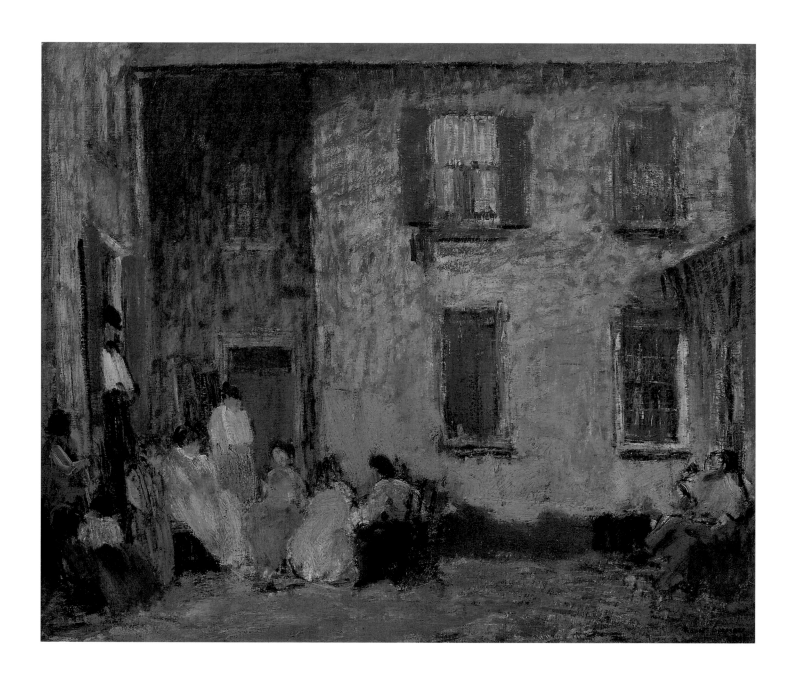

PLATE **27** *Untitled* n.d.

(possible title: *Hour of Dusk* 1917)
oil on canvas
20 × 24 inches
Collection of Lee and Barbara Maimon

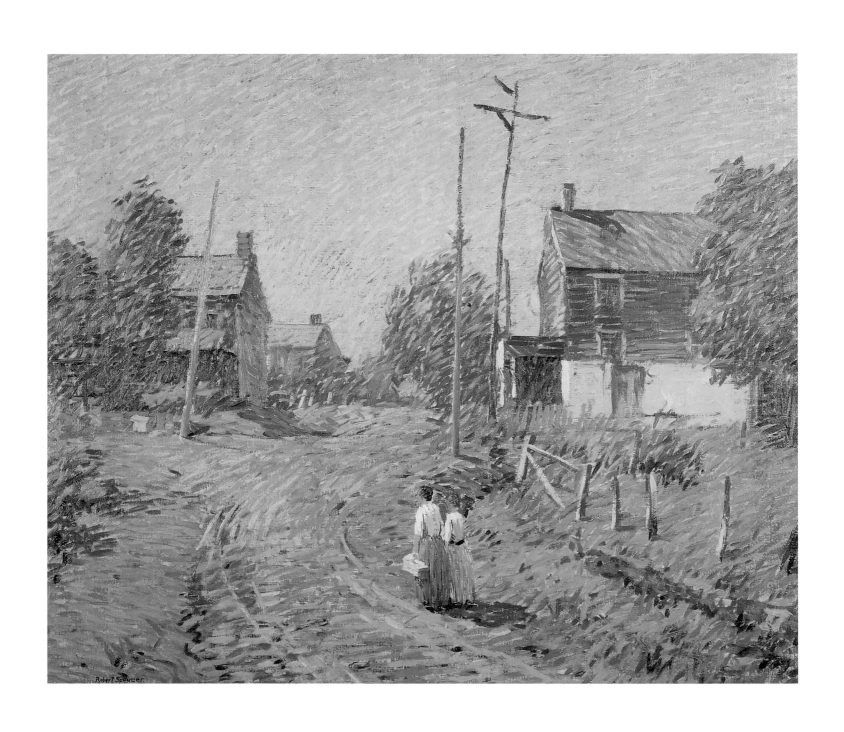

PLATE **28** *Crossroad* 1918

oil on canvas
25 × 30 inches
Sheldon Memorial Art Gallery
and Sculpture Garden, Uni-
versity of Nebraska Lincoln,
UNL-F. M. Hall Collection

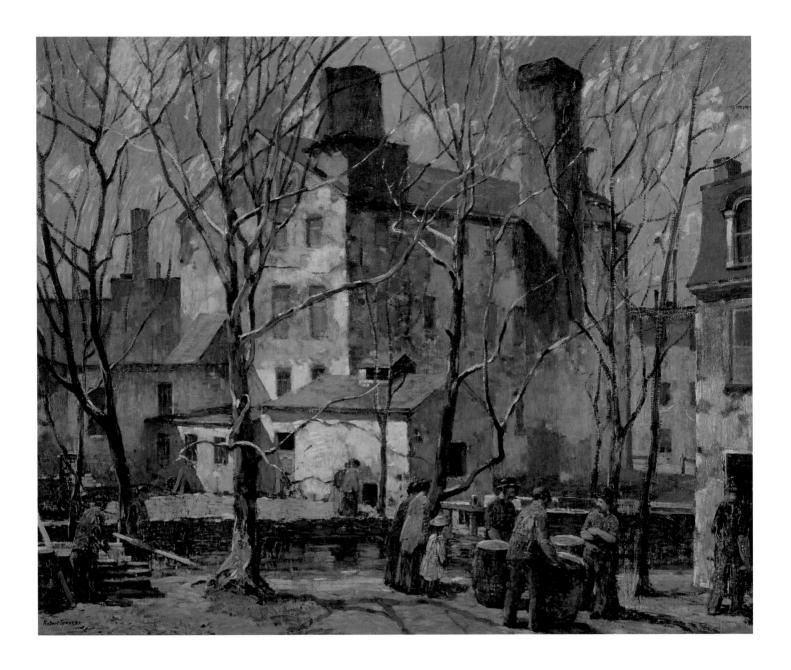

"There is little merit, Spencer seems to say to himself, in being cheerful and happy when all's going well; but watch me when I am surrounded by gloom and shadows and squalor and ugliness! There's nothing so hopeless, so repulsive, but I can make it smile with a touch of the sunlight, or bring out some latent charm and interest in its local color."

UNKNOWN BOSTON NEWSPAPER, UNDATED, AUTHOR UNKNOWN

PLATE 29 *A Day in March* ca. 1918

(alternate title: *Mills*)
oil on canvas
30 × 36 inches
Private collection of Jim's Antiques
Fine Art Gallery

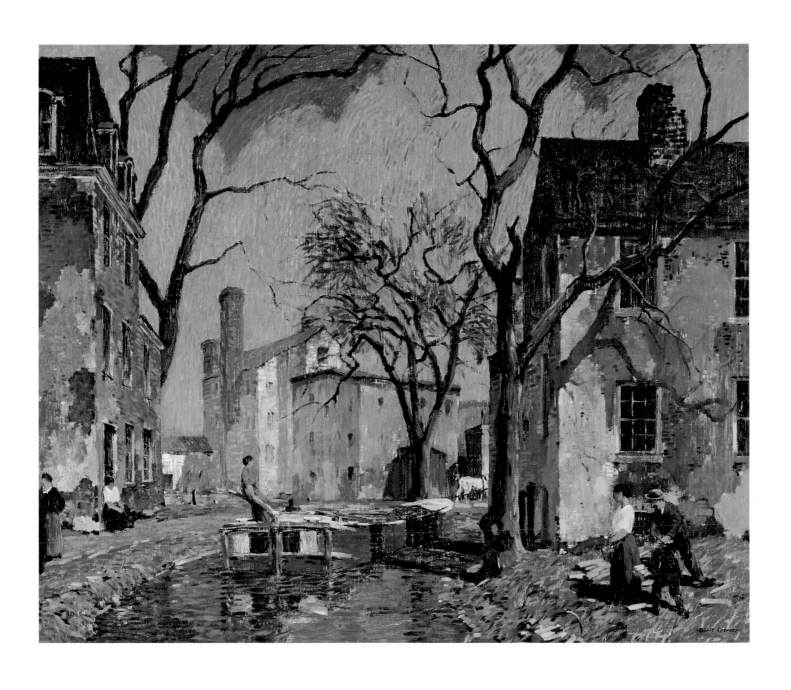

PLATE 30 *The Red Boat* ca. 1918

 oil on canvas
 30³⁄₁₆ × 36³⁄₁₆ inches
 In the collection of The Corcoran
 Gallery of Art, Museum Purchase,
 Gallery Fund

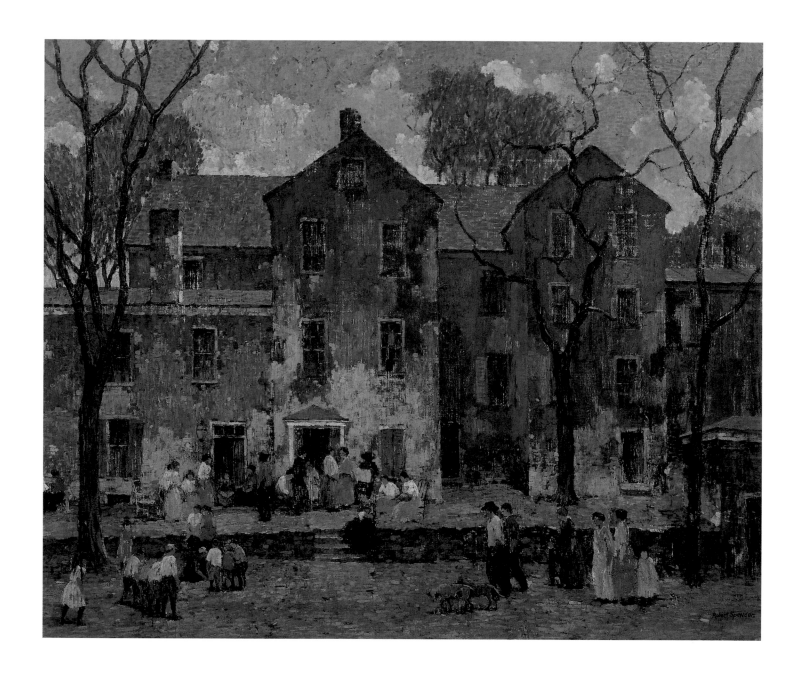

"Spencer tries to catch the varying beauties of nature, remembering that trees and clouds and sunshine no more stand still for their portraits than do the shifting groups of factory workers, who unconsciously make kaleidoscopic patterns of changing color and fantastic shadow."

UNKNOWN NEW YORK CITY NEWSPAPER, UNDATED, AUTHOR UNKNOWN

PLATE 3I *The Barracks* 1919

oil on canvas
30 × 36 inches
Collection of the New Hope
Museum of Art

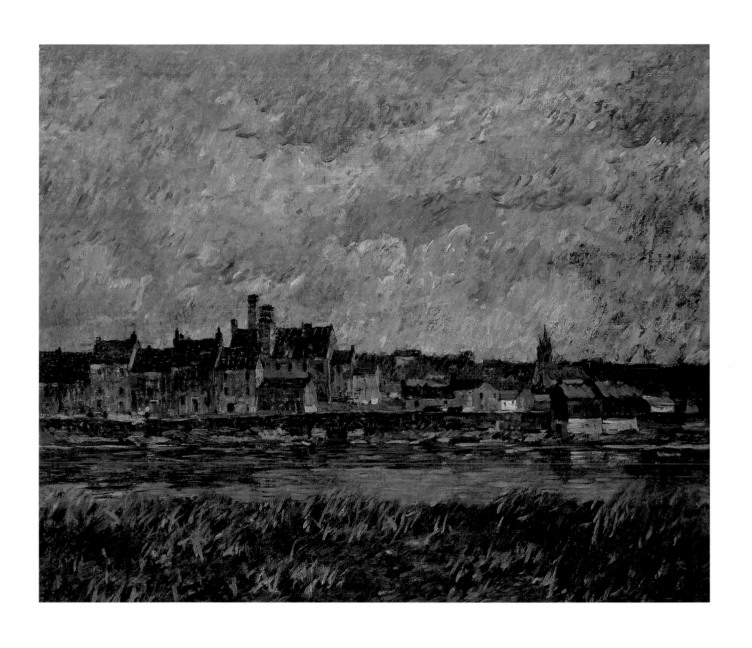

PLATE **32** *Gray Day in Spring* ca. 1915–20

oil on canvas
25 × 30 inches
Collection of Louis and
Carol Della Penna

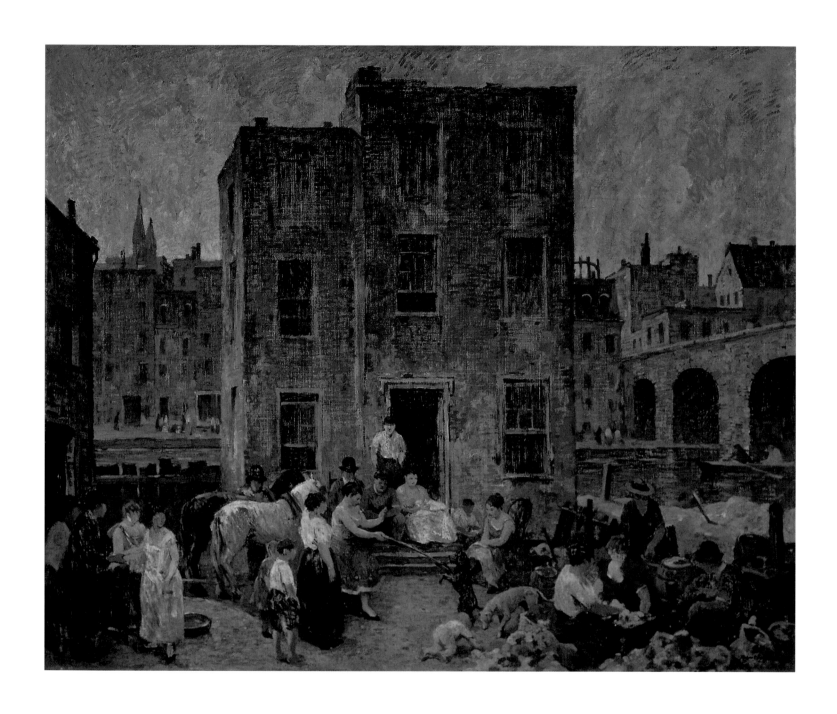

"[Spencer] is in the full vigor of his talent, which is great. His art does not resemble European art, a rare fact in America."

PIERRE BONNARD, QUOTED IN AN UNKNOWN
FRENCH NEWSPAPER, 1926, AUTHOR UNKNOWN

PLATE **33** *Mountebanks and Thieves* 1923

oil on canvas
30 × 36 inches
The Phillips Collection,
Washington, D.C.

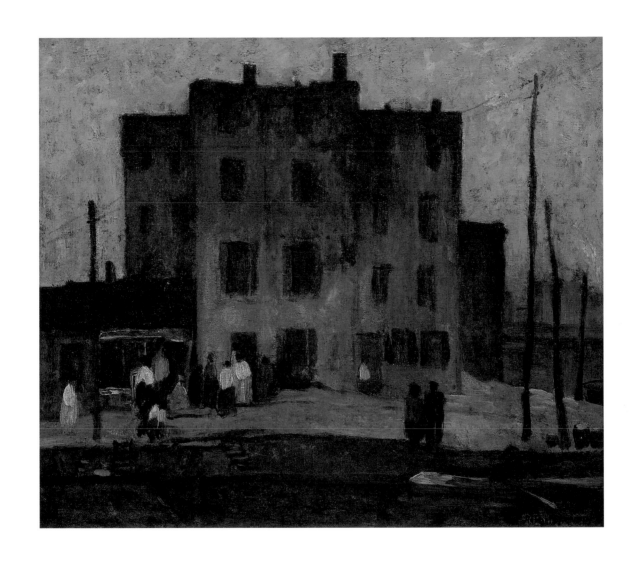

PLATE **34** *Jack's Castle* 1921

oil on canvas
12 × 14 inches
Collection of Ellen and
John Vreeland

"Out of the grime and smoke and deadly commonplace of the mills, the ugliness of the tenement houses, the sickening squalor of a row of unpainted shacks lining the farther side of a canal, [Spencer] manages to extract the 'fleur du mal,' the blossom of beauty emerging from the slime of the gutter."

UNKNOWN BOSTON NEWSPAPER, UNDATED, AUTHOR UNKNOWN

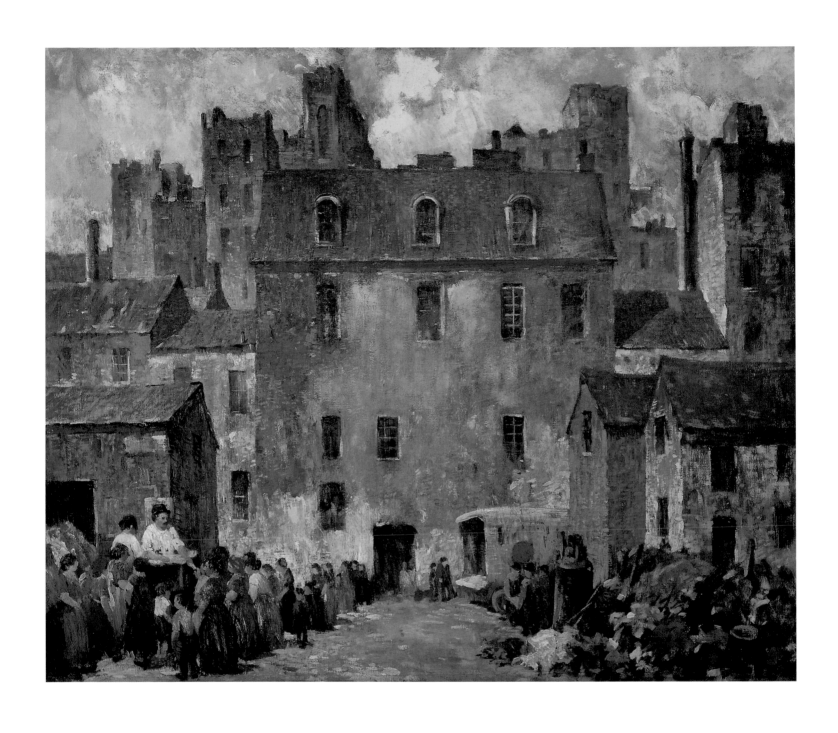

PLATE 35 *The Rug Pickers* 1921

oil on canvas
30 × 36 inches
Collection of the Union
League Club of Chicago

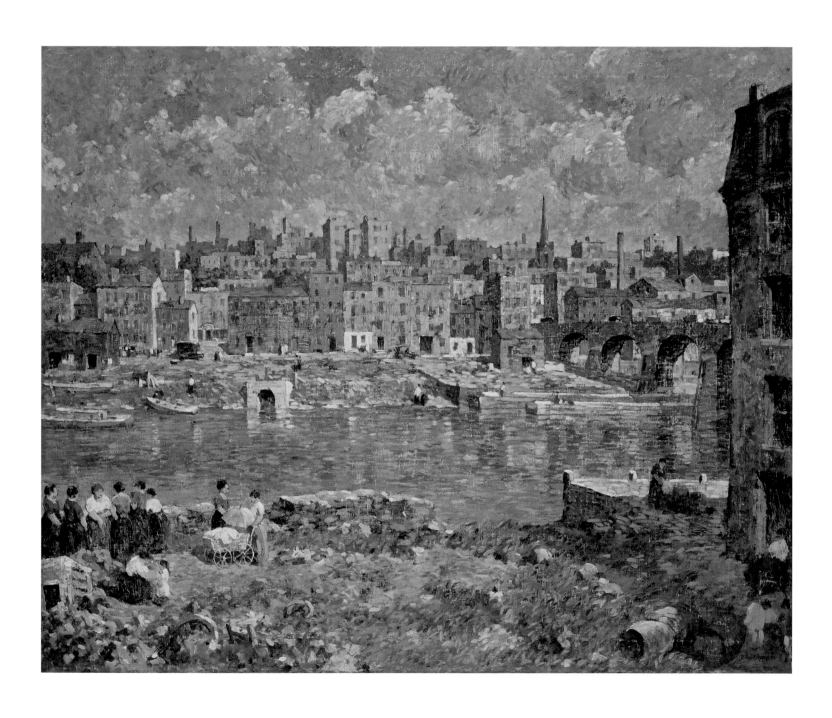

"There is no other painter, not John Sloan nor even Edward Hopper,
more pungently American in expression."

FROM A COLLECTION IN THE MAKING, 1926, BY DUNCAN PHILLIPS

PLATE 36 *The Other Shore* 1923

oil on canvas
30 × 36⅛ inches
Smithsonian American Art Museum.
Bequest of Henry Ward Ranger through
the National Academy of Design

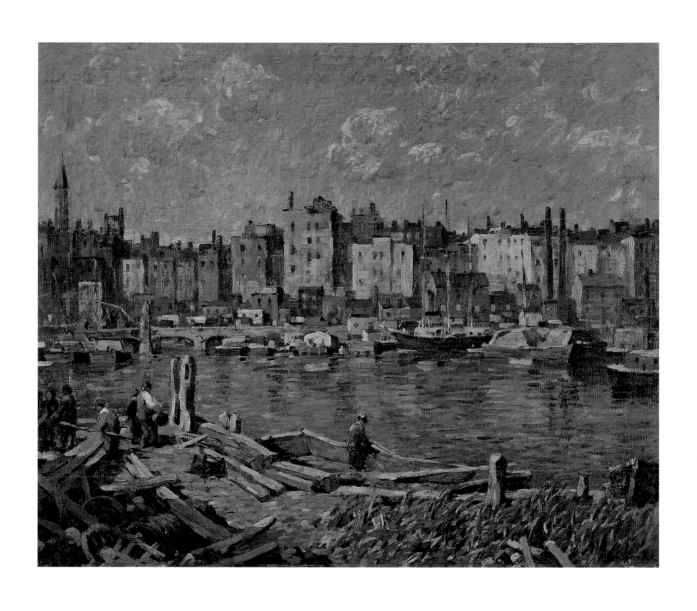

PLATE **37** *Harlem River* 1924

 oil on canvas
 20 × 24 inches
 Collection of Philip
 and Dianna Betsch

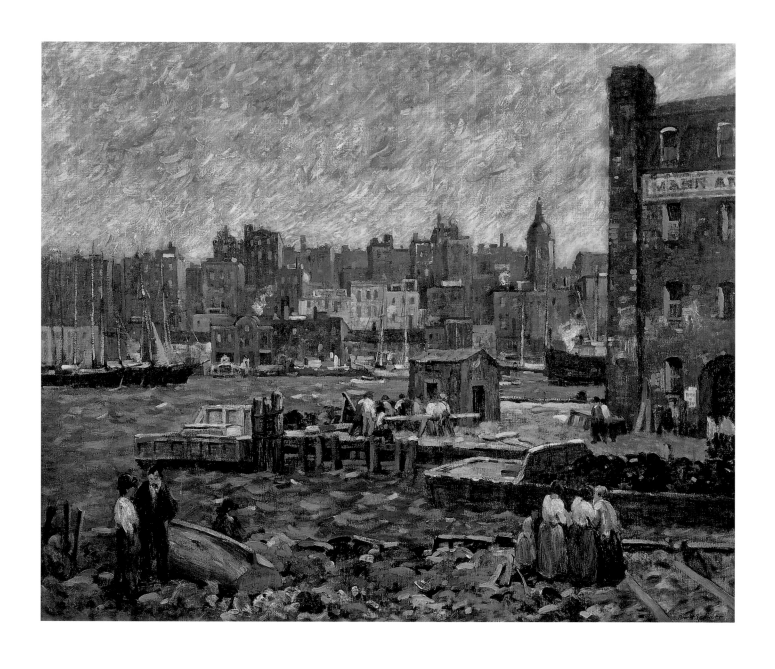

PLATE 38 *Weather* 1925

 oil on canvas
 30 × 36 inches
 Collection of the New Hope
 Museum of Art

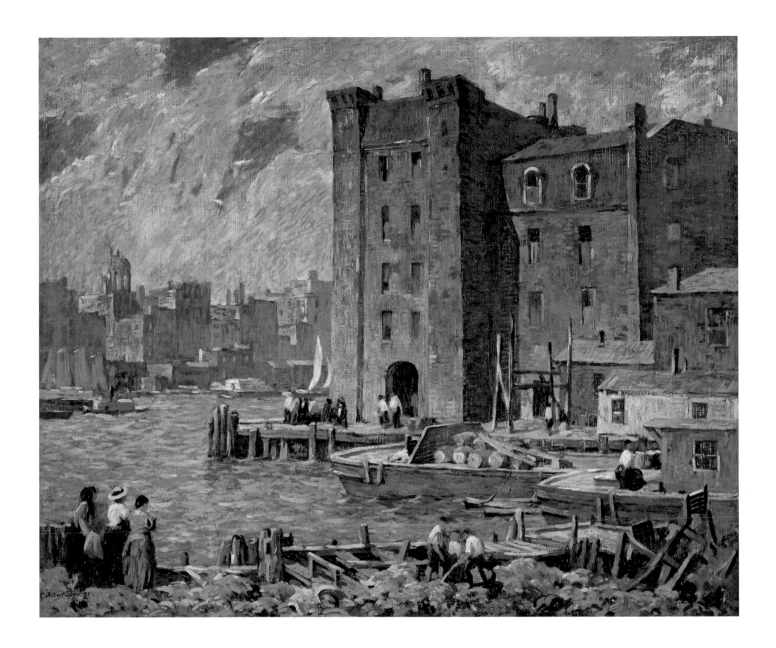

"[Spencer's] canvases abound in rectangles—flat facades, as of old mills or deserted warehouses, with many windows shallowly placed—and yet he so paints them that one seems to be going around a corner with the artist and suddenly coming upon them in a territory that one only enters when the light is just right or the vision slips into some nook that fits between the known dimensions and another."

THE NEW YORK HERALD, UNDATED, AUTHOR UNKNOWN

PLATE 39 *Wharves* 1925

(alternate title: *East River Wharves*)
oil on canvas
30 × 36 inches
private collection

"In such a picture as Ship Chandler's Row, *every inch of the surface and every contour of form are delectable in themselves. . . . Harmonies of shell blue, shell violet, shell pink, bone color and black, with repetitions of shapes, fuse into a subtle symphony."*

FROM *A COLLECTION IN THE MAKING*, 1926, BY DUNCAN PHILLIPS

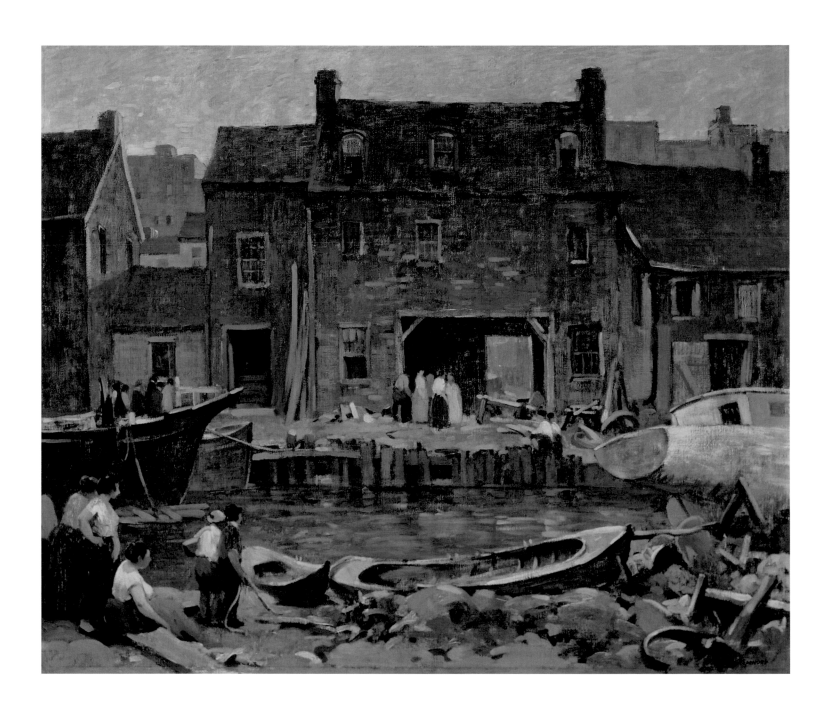

PLATE 4O *Ship Chandler's Row* 1926

oil on canvas
30 × 36 inches
The Phillips Collection,
Washington, D.C.

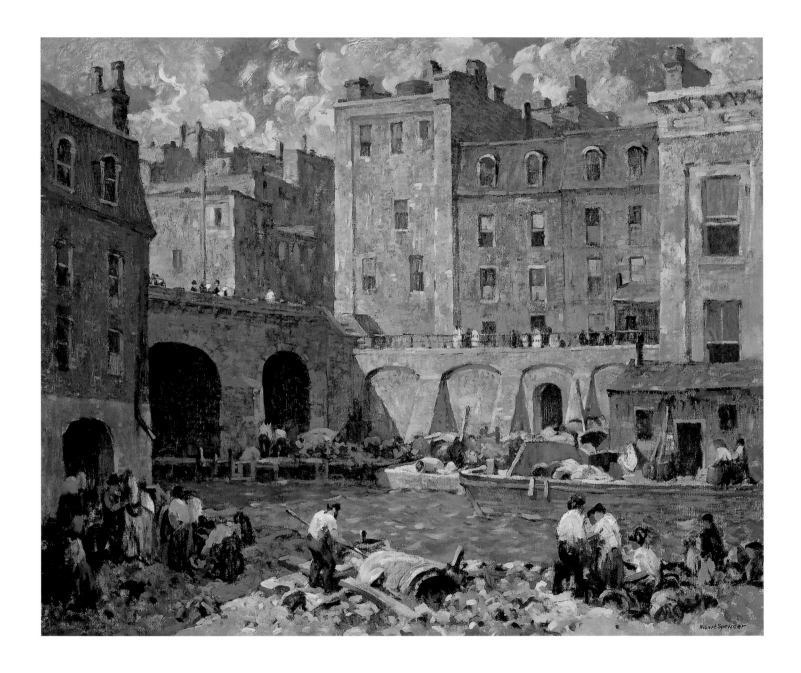

"[Spencer] lives in a world of his own, takes a house from here and a bridge from there
and reconstructs a picture amazingly full of reality. These places that the artist has built
exist because they exist in his imagination. There is a little touch of Dickens in them."

THE NEW YORK TIMES, APRIL 1925, AUTHOR UNKNOWN

PLATE 41 *The Crowding City* 1925

oil on canvas
30 × 36 inches
Delaware Art Museum, Special Purchase
Fund raised by popular subscription, 1929.
DAM#1929-1

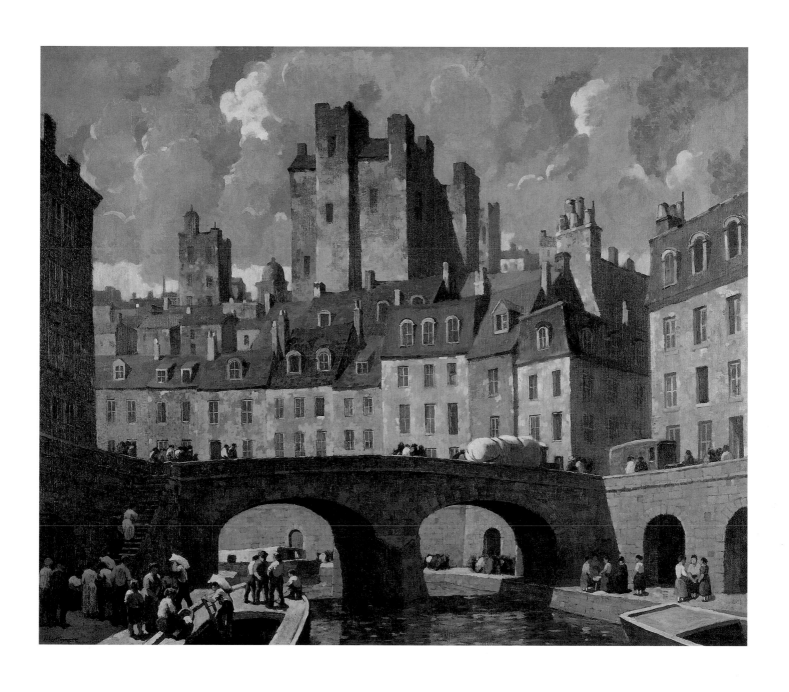

PLATE 42 *The Old City* 1931

oil on canvas
30 × 36 inches
Sheldon Memorial Art Gallery
and Sculpture Garden, Uni-
versity of Nebraska—Lincoln,
UNL-F. M. Hall Collection

VIGNETTES

Spencer's fascination with the romantic, larger-than-life aspects of city life usually caused him to stand back from his subjects. He loved the grand view, in which the hustle and bustle of daily living was interwoven with expressive architecture that dominated the scene. But there was another side to his personality. Almost as an antidote to the more distant perspective of his weightier canvases, he sometimes moved closer, casting his eye on domestic life and informal street scenes. Most of these canvases are small—12 by 14 inches is the typical size—and the scenes depicted are "small" as well: simple observations and quick studies of people engaged in everyday activities. Such ordinary moments were as close to his heart as the large-scale mills and tenements. As he worded it, "The intimate contact with man is essential to me."[1]

If Spencer had been completely honest, he might have substituted "woman" for "man" in the previous sentence. "A man like Spencer," said his daughter Tink, "could not live in a womanless world."[2] Many of these painterly vignettes depict women—often his wife—doing stereotypically female things: washing clothes, ironing, bathing. There also are colorful, close-up views of street life: peasants lounging on steps, city folk eating lunch and, in one remarkable painting, well-dressed gentlemen greeting prostitutes in a Parisian doorway. Spencer's vignettes also include revealing, almost bitter scenes of life in his own household, and he used these latter paintings to exact a not-so-subtle revenge on his not-so-demure wife.

Spencer's feelings about what he thought of as the soulless mechanization of modern culture provide an interesting backdrop to his domestic scenes of women. As he grew older, he was increasingly troubled by the sins of the Industrial Revolution, which to him caused daily life to lose much of its flavor:

For all our great mechanical progress we do not appear to sleep better, enjoy our food more, our life contains no new happiness. There is a kind of inhuman quality about modern art and modern life that I cannot get the value of; I cannot see the point.[3]

In his paintings, Spencer expressed these ideas not by literally depicting what he hated—the evil machine—but by celebrating what he loved. Thus the subject matter of these domestic vignettes is self-consciously, even militantly, low-tech. There's no sign of a washing machine in *Woman Hanging Out Clothes* (1917; pl. 48), for example. Even an old-fashioned clothes wringer would be out of place in this innocent vision of a young woman pinning garments

on a clothesline. Spencer has deliberately removed most references to place and time; the scene has an archetypal quality, as if he is saying, "This is what life should be like. The beauty and substance in such simple daily activities are lost in our frantic, mechanized world." Of course, this is a romanticized view of labor. He conveniently stays far enough away from his subject to keep the viewer from seeing the calluses on her fingers.

The Bath (ca. 1915–18; pl. 47) has a similar innocence, as does *Woman Washing* (1917; pl. 46). Both paintings deal with a classic and well-explored aspect of female domestic life, yet for Spencer the subject is more personal: his wife, washing her hands in a basin.[4] *The Bath*, especially, has a quality of loving innocence; Margaret looks curiously childlike and vulnerable in her nakedness. With her clothes draped casually on a nearby chair and the rumpled bed in the background, this picture probably depicts Margaret just moments after waking up in the morning, when she had a daily ritual of washing herself. The titles of these two paintings make no mention of Margaret, suggesting that Spencer again wanted to emphasize the universal nature of the scenes. Yet there's a tender, unconscious beauty to the gestures. These are moments that only a husband or lover would be privileged to see. One has only to look at these paintings to confirm what his granddaughter says: Robert Spencer was deeply in love with his wife.[5]

The obvious affection for Margaret in these two domestic scenes makes another painting all the more shocking. It strains the imagination to think that *The Bath* and *Happy Family* (pl. 53) were made by the same artist and depict the same woman. A comparison of these pictures provides graphic evidence that, while their marriage was founded on a genuine attraction, Robert and Margaret were literally at each other's throats. Unfortunately, *Happy Family* is not dated. Assuming the painting was made around the time this battle occurred, the age of the crying baby would place the work sometime between 1916 and 1919 (their children were born in 1915 and 1918), or roughly the same period as both *The Bath* and *Woman Washing!* However, the freedom and spontaneity present in the way Spencer drew the two combatants suggest his more confident style of the late

1920s, and in similar paintings done in that period Margaret appears to wear the same nightgown.

One of these canvases is *Alarm Clock* (1928; pl. 54), which shows a rather groggy looking Robert apparently being awakened and dragged out of bed by Margaret. A small alarm clock sits on the corner of the table near the bed. As with *Happy Family,* the title adds an ironic, even caustic punch to the scene. An obvious question is asked by *Alarm Clock:* Is the alarm clock Margaret, or the clock itself? At least in this painting Margaret isn't gouging his eyes out!

The larger point here is that possibly as early as the mid- to late teens, Robert was occasionally using his work as a vehicle for gallows humor about his marriage. This habit continued into the late twenties, when his caustic commentary moved from his vignettes into some of the ambitious and enigmatic canvases he made in the last few years of his life.[6]

Spencer didn't limit his attention to domestic scenes in these vignettes. As his universe expanded beyond Bucks County in the late twenties, he occasionally produced small, informal observations of European street life such as *On the Quai* (1929; pl. 56) and *Dejeuner* (1930; pl. 55). Perhaps the most haunting of these scenes is *Night Life* (1931; pl. 58), which depicts two ladies of the evening greeting their clients in a dimly lit Parisian doorway, with what appears to be an elderly "madam" looking on. The heavy makeup, harsh light from a single overhead bulb, and Spencer's strange, angular drawing style combine to give the two prostitutes an inhuman, animal-like quality.[7] The sinister atmosphere is enhanced by the nearly faceless rendering of the men and the expressionless, almost skull-like head of the elderly woman. Spencer made this picture at most a few months before he killed himself, and one can't help but wonder if its dark tone reflects his mood at that time.

1. Robert Spencer, from an undated handwritten personal history in the Dewitt McClelland Lockman Papers, Archives of American Art, ca. 1925–30.

2. Margaret (Tink) Spencer, "Robert C. Spencer," typed draft manuscript, six pages, unpaginated, undated. Manuscript is in the possession of Michael Holt.

3. Letter from Robert Spencer to Duncan Phillips, April 27, 1931. Letter is in the possession of Gene Mako, currently on loan to the Michener Art Museum.

4. Note that the pitcher and basin appear to be the same in these two canvases, as do the clothes. It's possible that *The Bath* was made not long after Robert and Margaret were married, perhaps in their Lambertville, New Jersey, apartment, while *Woman Washing* was probably made in the home they built together north of New Hope.

5. See the biography of Robert Spencer earlier in this book for further discussion of the Spencers' complex marriage.

6. See the chapter entitled "Histories, Fantasies, and Ironies" for a discussion of these allegorical paintings.

7. Spencer disliked almost all modernist painting, especially the work of Pablo Picasso. It's therefore odd that the animal-like rendering of the two women's faces is distinctly reminiscent of Picasso's female figures. Perhaps Spencer consciously utilized the hated Picasso's style because it expressed his discomfort with what he was depicting in this painting.

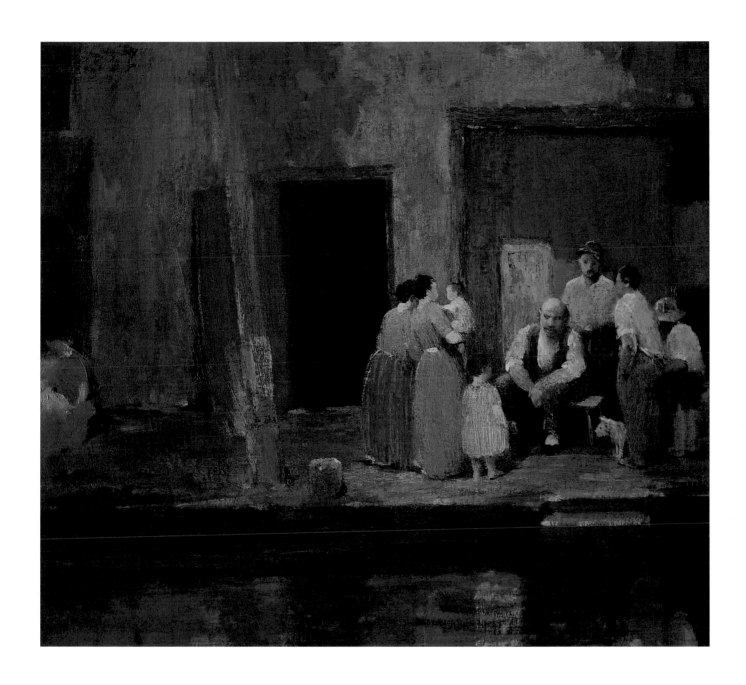

"[Spencer] has become the philosopher and the laureate of the little American industrial village, painting again and again its old houses, its mysterious factories, its 'types' coming out of the mill at the noon whistle."

FROM *A COLLECTION IN THE MAKING*, 1926, BY DUNCAN PHILLIPS

PLATE 43 *Near the Blacksmith's Shop* 1914

(alternate title: *Canal People*)
oil on canvas
16 × 18 inches
Collection of Thomas and
Karen Buckley

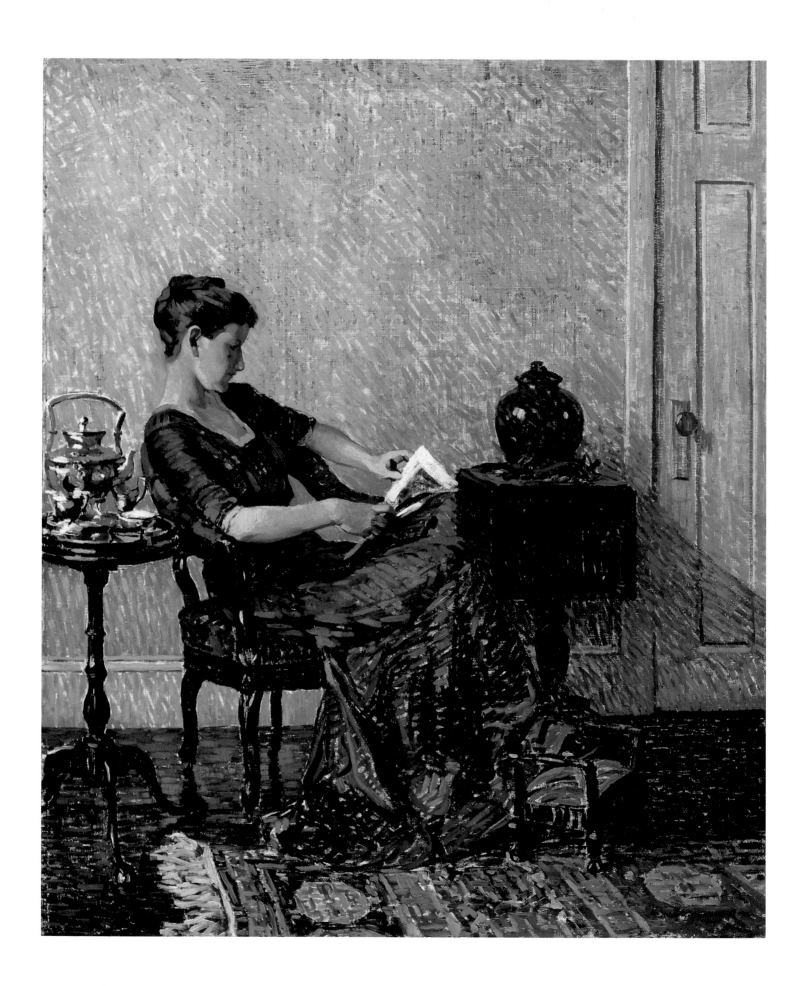

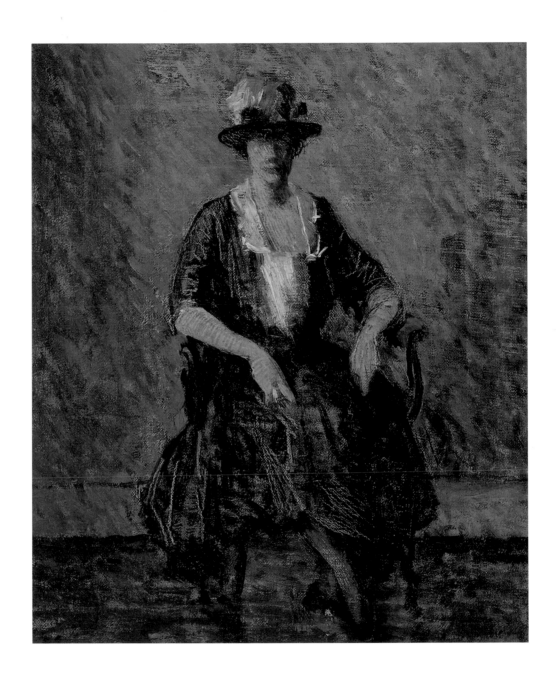

PLATE **44** *The Blue Gown* 1915

 oil on canvas
 36 × 30 inches
 Norton Museum of Art,
 West Palm Beach, Florida.
 Bequest of R. H. Norton,
 53.186

PLATE **45** *Study in Black –M. F. S.* 1929

 oil on canvas
 14 × 12 inches
 Collection of Gene and Laura Mako

85

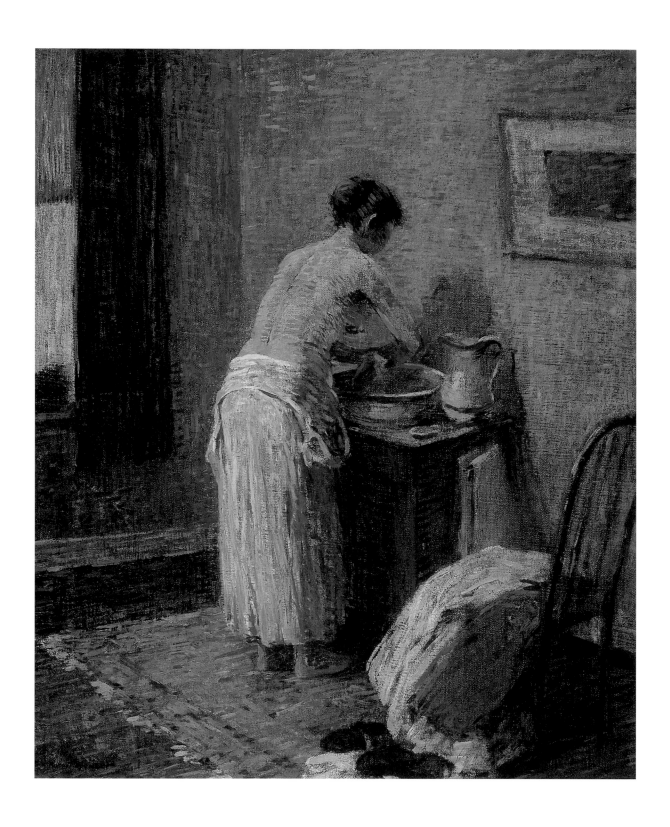

PLATE 46 *Woman Washing* 1917

(alternate title: *Woman Washing Herself*)
oil on canvas
24 × 20 inches
Collection of Walter and Lucille
Rubin. Photograph courtesy of
the Boca Raton Museum of Art

PLATE **47** *The Bath* ca. 1915–18

oil on canvas
14 × 14 inches
Collection of Mr. and Mrs. W. C. Rybolt

PLATE **48** *Woman Hanging Out Clothes* 1917

oil on canvas
15 × 11½ inches
private collection

"*Spencer's technique and color no less than his fine sense of design are undoubtedly what have enabled him to create works of art out of the commonplace. . . . With a playful and nervous touch he creates charming and varying surfaces that attract and hold one's attention like a beautiful embroidery.*"

FROM *THE HISTORY AND IDEALS OF AMERICAN ART*, 1931, BY EUGEN NEUHAUS

PLATE 49 *Washer Women* 1919

oil on canvas
30 × 25 inches
private collection

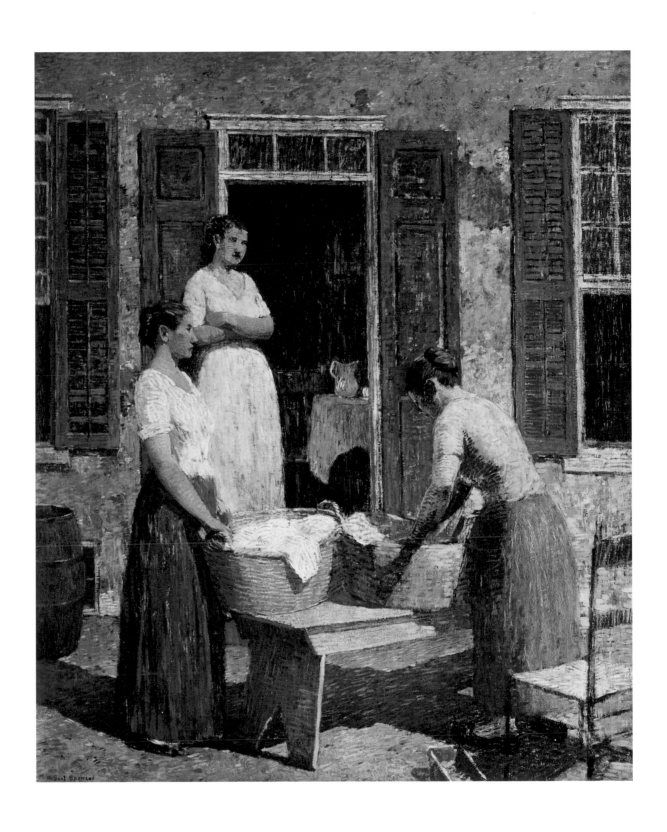

PLATE 50 *Washday* ca. 1918

oil on canvas
36 × 30 inches
Private collection of Jim's
Antiques Fine Art Gallery

89

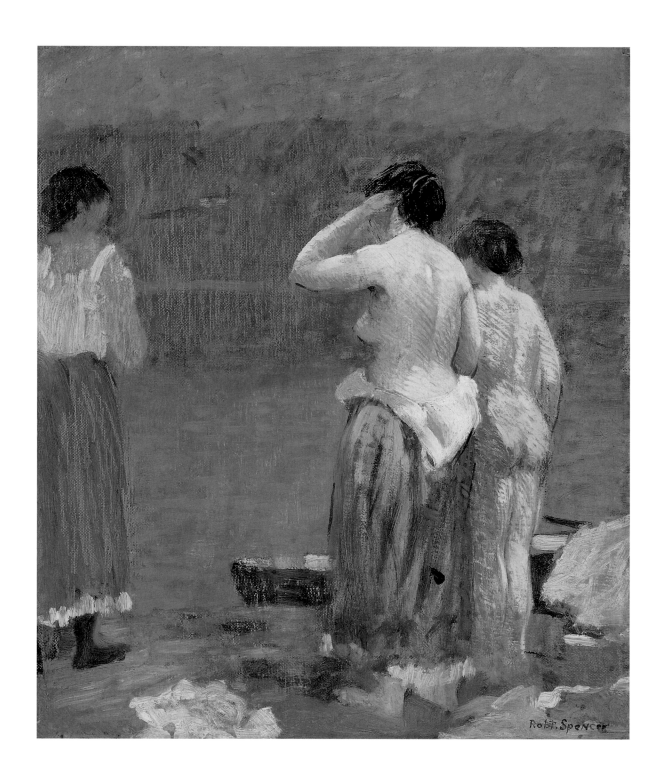

PLATE 51 *On the Bank* 1929

oil on canvas
14 × 12 inches
The Phillips Collection,
Washington, D.C.

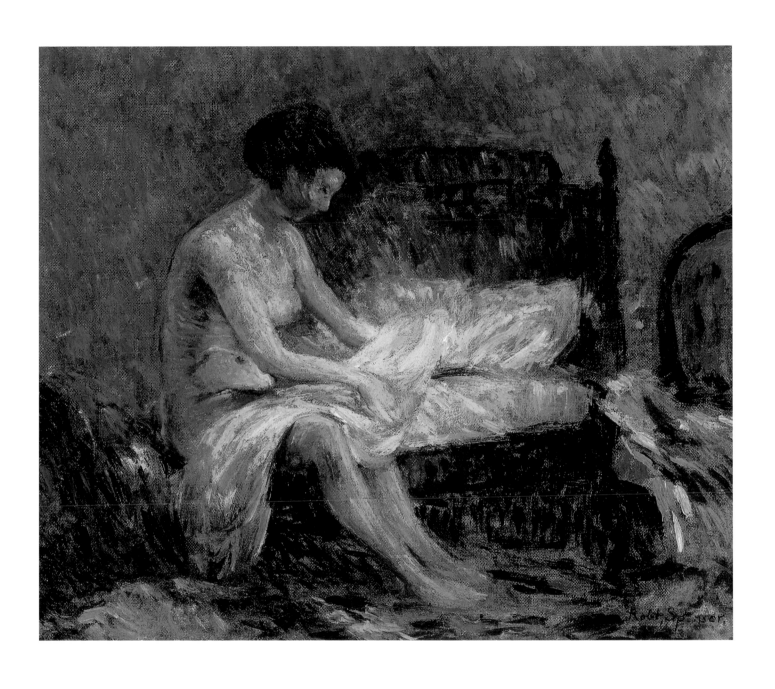

PLATE 52 *Seated Nude* 1931

oil on canvas
12 × 14 inches
Collection of Gregory
and Maureen Church

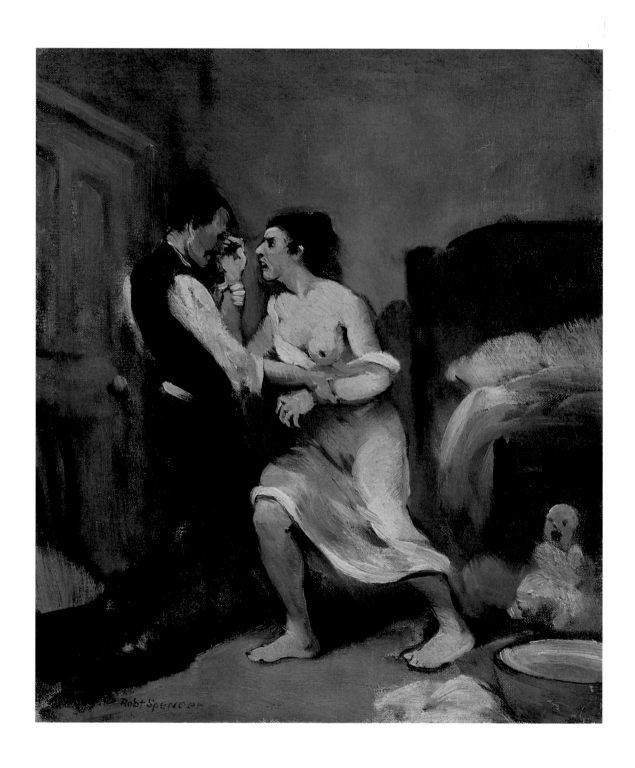

PLATE 53 *Happy Family* n.d.
 oil on canvas
 14 × 12 inches
 Collection of Shayla Spencer

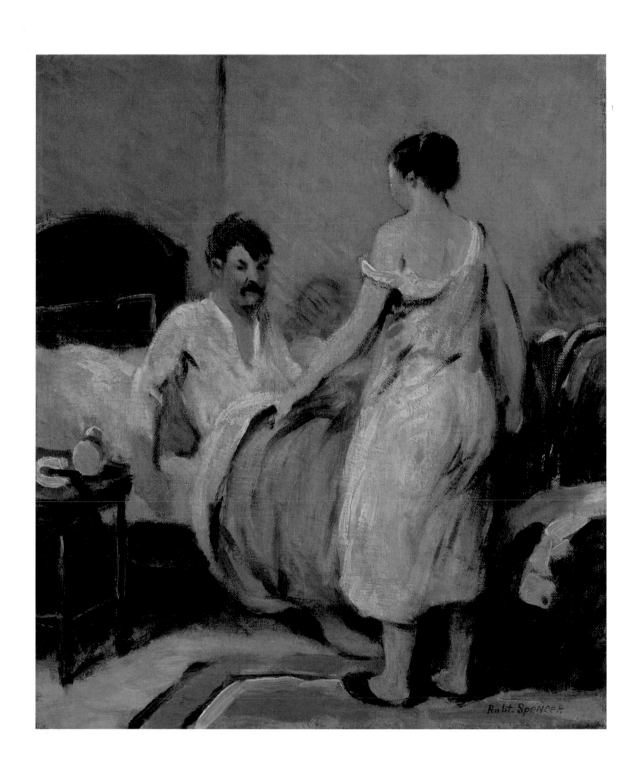

PLATE 54 *Alarm Clock* 1928

oil on canvas
14 × 12 inches
Collection of Gene
and Laura Mako

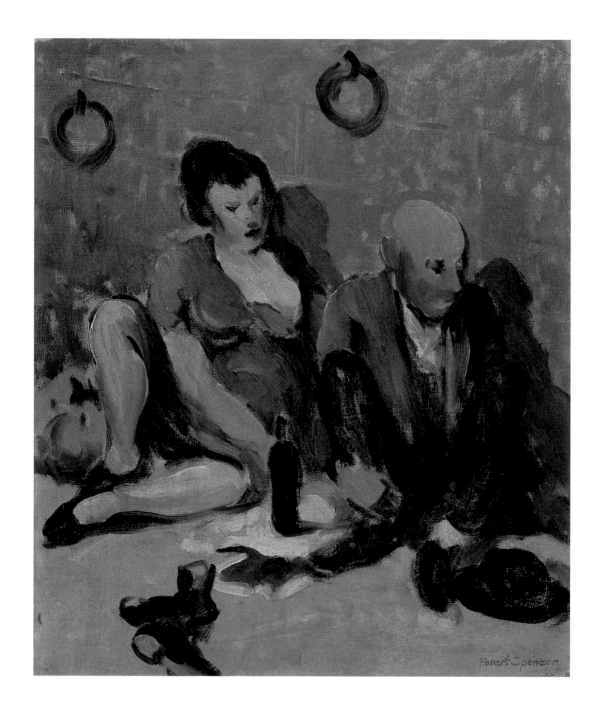

PLATE 55 *Dejeuner* 1930

 oil on canvas
 14 × 12 inches
 Collection of Gene and Laura Mako

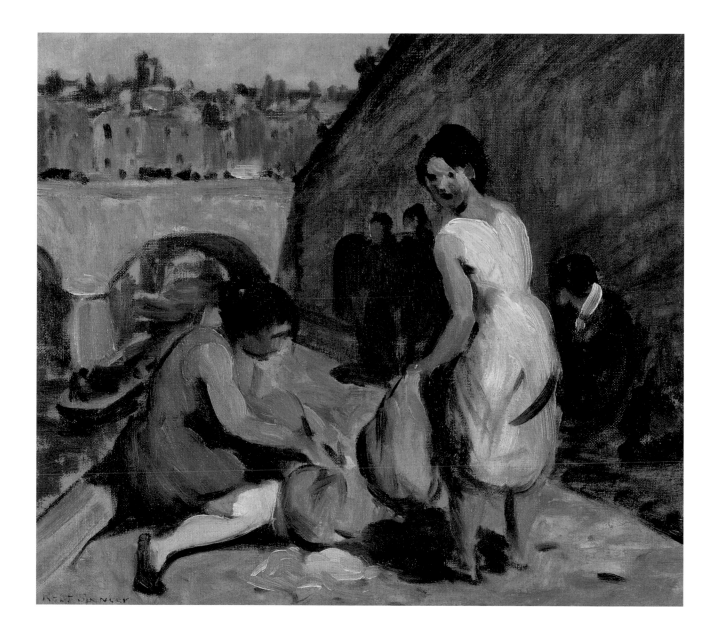

"By throwing the veil of his own poetic point of view over familiar scenes, Mr. Spencer has not only revealed a new beauty in them but has recreated them for his own purposes."

UNKNOWN MILWAUKEE NEWSPAPER, UNDATED, BY C. BURNHAM

PLATE 56 *On the Quai* 1929

(alternate title: *The Quay*)
oil on canvas
12 × 14 inches
Collection of Gregory and
Maureen Church

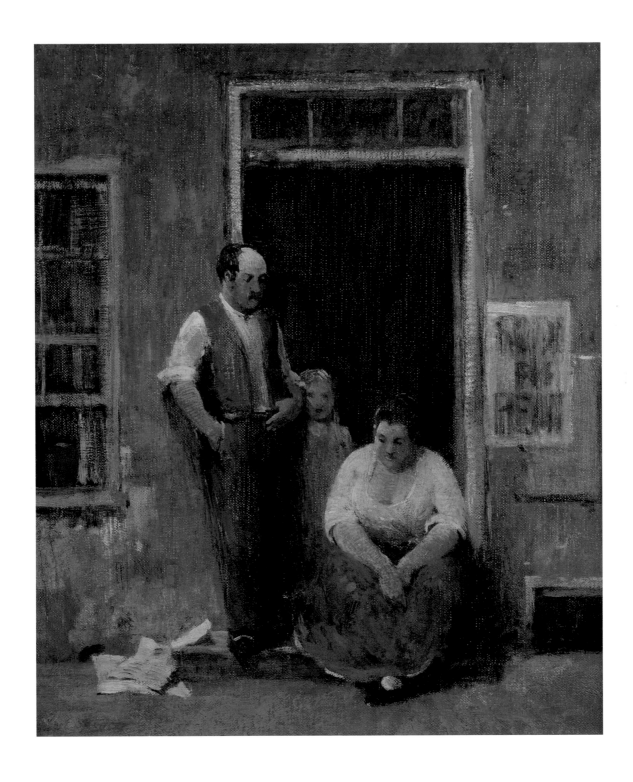

PLATE 57 *The Doorway* 1923

oil on canvas
14 × 12 inches
Collection of the New Hope
Museum of Art

"Mr. Spencer for the most part paints scenes that do not exist and presents
them with a tender realism, a glamorous matter-of-factness."

UNKNOWN MILWAUKEE NEWSPAPER, UNDATED, BY J. K.

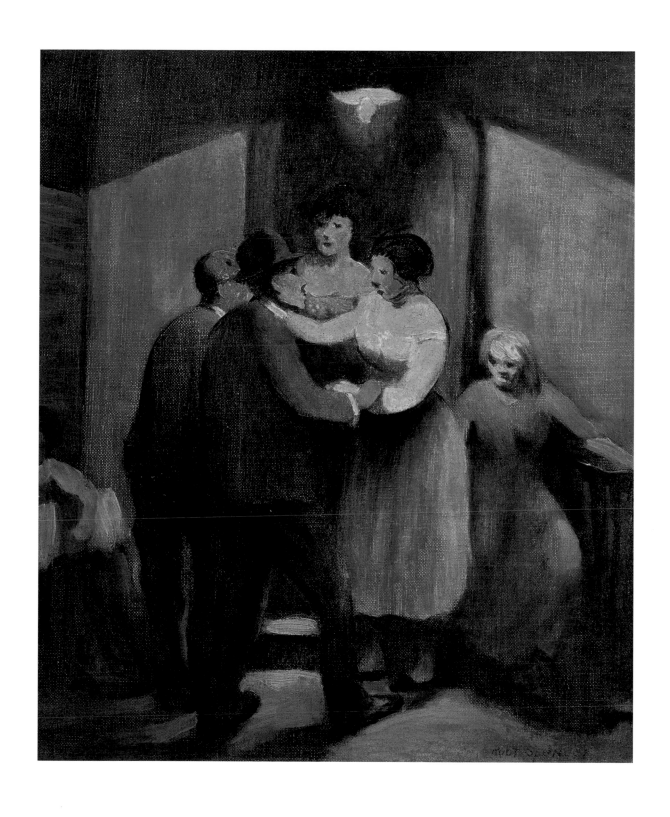

PLATE 58 *Night Life* 1931
oil on canvas
14 × 12 inches
Collection of Bonnie J. O'Boyle

BREAKING THE MOLD

Every artist's life unfolds differently, and it can be risky to generalize about how artists develop. Yet if one absorbs the life's work of enough creative people, certain patterns emerge. Some artists find their voices at a relatively young age, and though they may operate at a consistently high level they don't feel the urge to evolve and grow. Their work therefore doesn't change much as the years go by. Other artists become weary of doing the same thing over and over, and tend to push their work into new areas. In extreme cases artists have "conversion" experiences that cause them to completely abandon their previous habits; their later work may appear on the surface to be done by a different person.

Robert Spencer fell somewhere in the middle of this continuum. His basic subject matter never changed, though he gradually shifted his attention from Bucks County to New York to Europe. Even in the last year of his life he was still making large-scale views of cities and towns with people working, talking, and playing. It's true that the way he executed these pictures gradually evolved from a concrete to a more imaginary approach, as previously discussed.[1] If this was the only change in his work, one would be hard-pressed to call him an artistic explorer. But in the late 1920s he began to expand his horizons in at least two very different directions—directions that are guaranteed to raise the eyebrows of people who only are familiar with his pleasant Bucks County mill scenes.[2]

Spencer's creative life can be divided into four phases: (1) his student years (1899 to 1909) before he figured out who he was as an artist; (2) his years of self-discovery (approximately 1910 to 1913/14), when he began to make paintings that were recognizably his own; (3) his years of consolidation (1913/14 to 1925), when he acquired increasing refinement of and mastery over his working methods and ideas; and (4) his years of experimentation (1926 to 1931), when he began to break free from his earlier habits and appeared to be laying the groundwork for further growth.[3]

In this fourth period, beginning in the late twenties, it was not just his work that was changing. He spent long periods of time away from New Hope, partly to satisfy his wanderlust, partly to escape the tensions in his household. According to the accounts of his daughters, his problem with depression was getting worse, and he experienced an increasing sense of desperation and unhappiness in his life.[4] Yet in spite of this ferment, or maybe because of it, he brought a renewed intensity—both technical and intellectual—to his work in these years.

One of the first paintings to show real evidence of Spencer's creative restlessness is *Flowing Water* (1924; pl. 59). In many respects this canvas is not very different from dozens of earlier Bucks County canal scenes. The dappled brushwork in the trees, water, and foreground is similar to a number of paintings from the teens and early twenties, as are the colors and the stable, horizontal design scheme. But a more energetic quality has crept into this picture that foreshadows changes to come. The colors are richer and more intense; the brushwork in the foreground is more nervous. The placid, even cheerful atmosphere of more impressionist paintings like *The White Tenement* (pl. 16) and *Five O'clock June* (pl. 13) has disappeared, and there's now a greater sense of movement and activity, especially in the trees, which have begun to dissolve together in a single, vibrating mass.

What is suggested in *Flowing Water* grows more concrete in *The Upper City* (1927; pl. 60). The buildings are still relatively linear and precise, but they're reduced to mere outlines with relatively few details. The figures have become sketchy, vague presences. The energetic brushwork of *Flowing Water* is further broken and scattered, extending into the sky, which has turned into a deliciously jumbled conglomerate of blues and whites.

This process of simplification and abstraction continues in *Riviera Beach* (1928; pl. 61). Here the people in the foreground are rendered almost casually, with quick strokes that sometimes barely cover the surface

of the canvas. In the background, figures have become single, contoured, multicolored touches of paint that, from a distance, resolve to a crowded beach scene. The buildings are tangible yet barely there when compared with their solidity in Spencer's earlier work, and at first glance the picture appears to be unfinished, perhaps even a sketch. But of course it's not a sketch. In fact, this painting is one of Spencer's most ambitious and accomplished canvases.

Riviera Beach grew out of a simple question that Spencer had obviously begun to ask himself: How much, or how little, do I *need* in order to say what I want to say? In other words, he wanted to challenge himself by changing the rules of the game, and this adventurous spirit led to a reduction of detail and an overall simplification of line and gesture. He also appears to be working more quickly; there's an uninhibited, improvisatory quality to this picture. Yet at the same time the painting has a weight and substance that can only be hinted at in a printed reproduction. This combination of spontaneity and solidity is an uncommon achievement for any painter. For Spencer it represented a real advance.

Spencer grew bolder with these experiments. The next year, 1929, he made the small canvas *Collectors* (pl. 64). It's fascinating to compare the buildings in the background of this picture with *The Upper City*, made only two years earlier. In *Collectors*, the structures have been reduced to a vague outline on the horizon, and

Figure 1 Detail of *Riviera Beach*, plate 61

Figure 2 Detail of *Boating Party*, plate 62

Figure 3
John Marin (1870–1953)
Brooklyn Bridge (Mosaic) 1913
etching and drypoint, printed in black,
plate 11¼ × 8⅞ inches
The Museum of Modern Art, New York.
Gift of Abby Aldrich Rockefeller.
Digital image © 2003 The Museum of
Modern Art, New York

Yet the experimental nature of these later paintings —the sense that he was pushing the envelope of traditional, realistic painting technique—is similar to what certain American modernist painters were doing as early as the teens and continuing into the thirties and forties. It's not a large leap from *Collectors* and *Boating Party* to some of the semiabstract prints and watercolors of John Marin, for example (fig. 3). Marin painted in a sketchy style that was similar to drawing, and his pictures often have a lively rhythm and energy that Spencer strove for in his later work.[7]

In general, these tendencies toward abstraction, toward reduction of objects to their simplest details, and toward a spontaneous and free way of working— these were all basic elements of the modernist impulse in the first half of the twentieth century. Once painters liberated themselves from the compulsion to make detailed, realistic renderings of the visual environment, they were able to "cut loose," and the eventual result was the near-total abstraction of the abstract expressionist movement in the 1950s.

Spencer may have despised the modernist rush toward abstraction and simplification, but in his own work he was groping toward a new path that had many similarities to modernist aesthetics. There's a palpable sense of excitement and discovery in these paintings, as year by year he pushed the process further. Given his unshakable love of the tangible and the beautiful, it's unlikely that he would ever have gone over the edge into pure abstraction. But it's easy to imagine him eventually creating a spare, haikulike way of painting his buildings and figures, in which the energy and physicality of people and places would be inferred by the simplest of gestures. He certainly had the technique to make this kind of growth happen, as well as the desire, and had he done so his overall development as a painter would have been remarkable.

in some cases the lines marking the edges of individual buildings have almost disappeared. The buildings appear to melt into each other, and yet each one still retains a distinct presence.

His most adventurous canvas in this series may be *Boating Party* (ca. 1928; pl. 62). While the buildings are fairly distinct, their surfaces are summed up with a few loose squiggles of paint. The boats, docks, and water are nothing but quick, almost random strokes, and the people are differentiated solely by the use of single, carefully shaped dollops of color: a red blob, a blue blob, an orange blob, a yellow blob. Heads and hats are small black daubs. In this work Spencer appears to be developing a style that's closer to drawing than traditional oil painting. As with *Riviera Beach*, however, the canvas is in no way a sketch; it's a finished work of art with the artist's full stamp of approval.[5]

Spencer made his feelings absolutely clear when the subject of modern art came up. He hated it.

Modern, abstract art puzzles me. I cannot understand how a young man with a good stomach full of the music of life can do an old man's work. . . . The modern painter seems to me to be very old—very weary—and blasé—when not degenerate![6]

NOTES

1. See the end of the chapter entitled "The Cities, the Towns, the Crowds" for more on this subject.

2. See the next chapter, "Histories, Fantasies, and Ironies," for a discussion of Spencer's other area of exploration in his final years.

3. To some degree these divisions are arbitrary and are only meant as general indicators of changes in his work. Periods two and three are also a single continuum that lasts to the end of his life, even though his final five to six years were mostly characterized by experimentation. Also, some of his paintings were either lost in fires or for the moment have disappeared, and it's possible that these divisions would be refined or changed should more work turn up.

4. See especially Tink's poignant account of his piano playing at the end of the Spencer biography, p. 13.

5. Usually with the canvases that he considered most important, Spencer typed the title of the work on a small sticker with a printed red outline and pasted the sticker on one of the stretcher bars. Often he also wrote his own name and the painting's title on a stretcher bar in pencil, in a cursive style.

6. Robert Spencer, from an undated handwritten personal history in the Dewitt McClelland Lockman Papers, Archives of American Art, ca. 1925–30.

7. There is no indication that Spencer was directly aware of Marin's work, and it's unclear if there was any direct influence. Certainly Marin and other modernists were working in this style much earlier than Spencer, and no claim is being made here that Spencer was a modernist pioneer. Such a claim would no doubt have caused loud complaints from the artist himself! It's most likely that Spencer made these changes in his work on his own, out of his inner urges and without consciously following outside influences. However, it's possible that even without his conscious awareness, the explorations of others made Spencer's path that much clearer.

"One has grown accustomed to [Spencer's] canvases of rivers washing the banks of old towns with high storied houses—strange presentiment of unreality clothed in the outward phenomena of factories and tenements. . . . Such is Flowing Water, with its gray houses as foil for the fronds of green trees and the flowing of the placid stream giving a note of life to this tranquility."

UNKNOWN NEW YORK CITY NEWSPAPER, UNDATED, AUTHOR UNKNOWN

PLATE 59 *Flowing Water* 1924

oil on canvas
20 × 24 inches
private collection

PLATE 60 *The Upper City* 1927

oil on canvas
25 × 30 inches
private collection

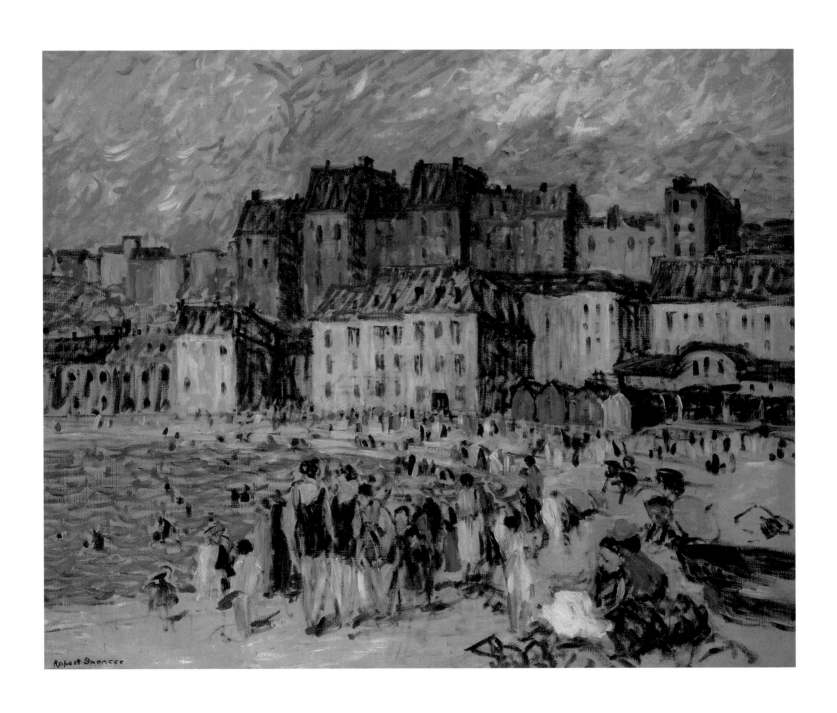

"Even the color harmonies have a subjective quality, as if they, too, were evolved much as the composition itself is evolved, through a subjective process in which the 'inner eye' of the artist gives expression to color and notes felt rather than seen."

UNKNOWN MILWAUKEE NEWSPAPER, UNDATED, BY C. BURNHAM

PLATE 61 *Riviera Beach* 1928

oil on canvas
30 × 36 inches
private collection

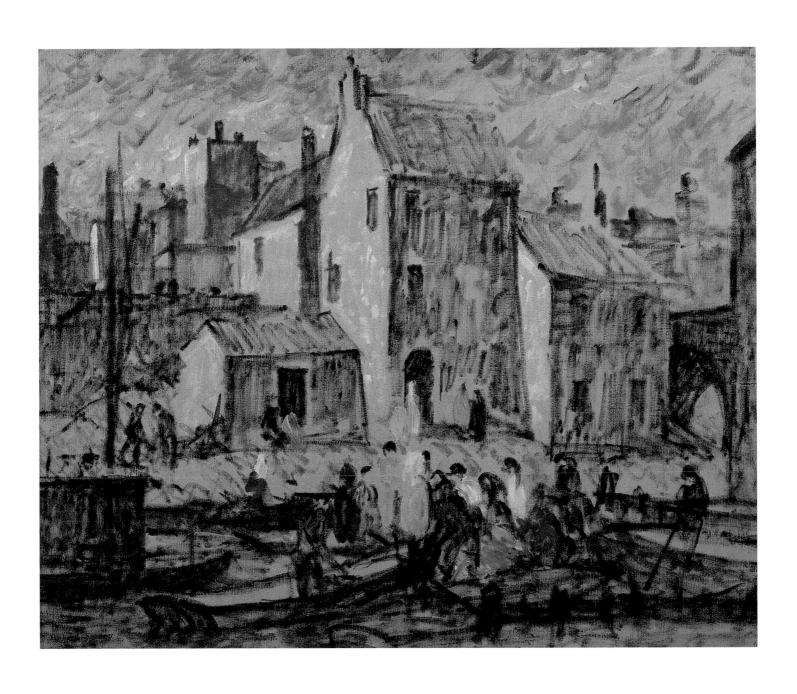

PLATE 62 *Boating Party* ca. 1928
oil on canvas
25 × 30 inches
Collection of Tom and Linda Tompkins

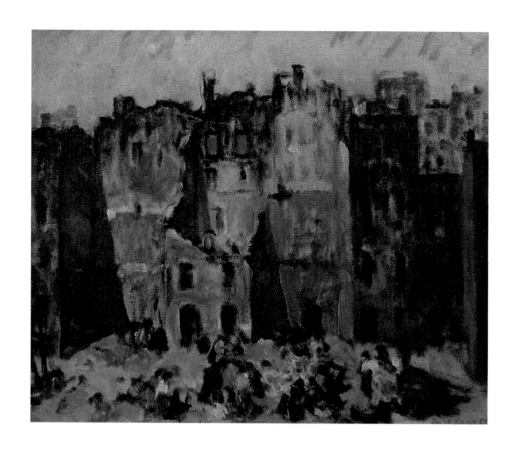

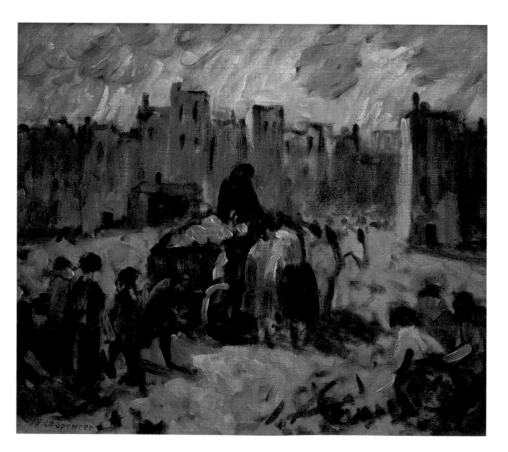

PLATE 63 *Torn Out Buildings* 1927

 oil on canvas
 12 × 14 inches
 private collection

PLATE 64 *Collectors* 1929

 oil on canvas
 12 × 14 inches
 Collection of Ellen and
 John Vreeland

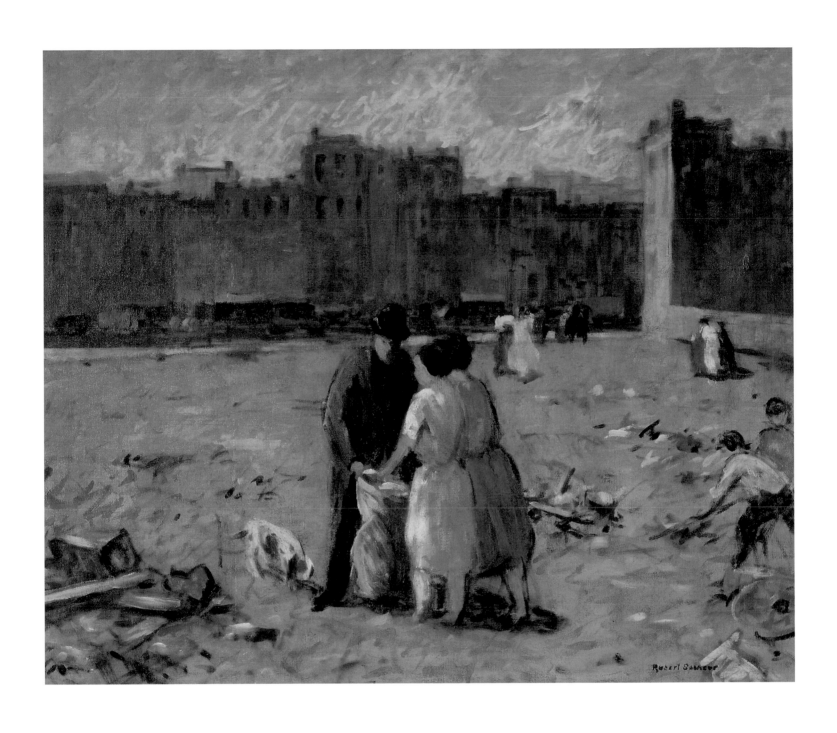

PLATE 65 *Vacant Lot* 1930

oil on canvas
30 × 36 inches
Collection of Shayla Spencer

HISTORIES, FANTASIES, AND IRONIES

One of the most intriguing aspects of Spencer's work is its gradual and somewhat covert evolution from the concrete to the imaginary.[1] His early Bucks County scenes depict real buildings (mills and tenements) and more or less real events (workers walking home at the end of a shift, barges floating down the canal). Toward the end of his life it's increasingly unclear where reality stops and his imagination begins. The later paintings at first glance aren't that different; his buildings and figures still look like buildings and figures. He never put any melting clocks or trains coming out of chimneys in his urban tableaux.[2] But to what extent were the things he painted real, and to what extent were they Spencer's own creations?

The artist himself addressed this tension between the tangible and the imaginary in a 1926 letter to Duncan Phillips: "I have to . . . build a city of real bricks and mortar before I paint it," Spencer said, "and the real bricks and mortar are imagination—solidified." Comparing himself to another artist who simply painted what he saw, Spencer lamented, "I first have to make what I see—so it's slow—dreadfully slow."[3]

What a strange, contradictory way of describing his creative process! It's perfectly sensible to make (i.e., paint) something *after* one sees it, but it seems impossible to paint something that one sees *before* it's actually seen. Yet Spencer insisted that he both imagined a painting and saw it. What this suggests is that in his later work at least, he first built up an entire urban vista—each brick of each building—in his head, then tried to render his imaginary scene with such vividness that it had the force and intensity of a real place that he had actually observed. The painting became, as he said, imagination—solidified.

By the mid-1920s when he began his European travels, Spencer already was comfortable with depicting real-looking places and people that were, in varying degrees, imaginary. Given his creative and personal restlessness in this period,[4] it makes sense that he would have one of those proverbial "lightbulb moments" and say to himself, "Hmmm—if I'm already depicting imaginary places and people, why not push things a little further and make imaginary events too?" He was certainly aware of the long and proud tradition of narrative painting, in which artists reimagined historical events or scenes from mythology and literature. So why not reimagine historical events that never really happened, or use contemporary versions of Biblical stories as metaphors for his dark view of modern culture?

Seen in this light, there's a peculiar logic to Spencer's enigmatic paintings of crowds and revolution from the late twenties. In the same way that he was

challenging himself by pushing his work toward a more spontaneous and semiabstract style akin to drawing, he began to challenge himself by opening the door to more or less completely imaginary subject matter. As with the vignettes discussed in an earlier chapter, this allegorical approach gave him an outlet for a bit of sly commentary on his less-than-perfect marriage.[5]

One of the earliest of these imaginary crowd scenes is *The Evangelist* (1919; pl. 66)—except this painting is probably based on real events and memories from the artist's childhood. This scene—a somber preacher on a platform addressing a crowd—must have been an almost daily occurrence for the young Robert Spencer, whose father was an itinerant Swedenborgian minister. While he had a close relationship with his father, Robert was ambivalent at best about his father's particular religion,[6] and there may be clues about Robert's feelings in this painting.

Most of the crowd is bathed in warm sunlight. The women are wearing bright, cheerful colors, and the men are dressed somewhat casually, as if they are ordinary farmers and townspeople who have put on their Sunday best. But the preacher and his followers on the platform are wearing dreary blacks and browns that look funereal when compared with the brightly lit crowd. One could easily imagine a different painting, in which the platform was bathed in light and the crowd was in shadow. The impression given by *The Evangelist* is that the sympathies of the artist are more with the crowd than the preacher.

This feeling is enhanced by Spencer's odd decision to completely obscure the face of the key figure, the preacher—something he did rarely, if ever, in other pictures. The darkened features could be attributed to the fact that the man has his back to the sun, but there's at least a hint of facial features in the other people on the platform or in the platform's shadow. Consistency would require that the preacher's face should also be partially illuminated. Instead it's utterly dark, as if the face has been sliced away. The effect is unsettling, even ominous, especially when seen in the context of the austere and gloomy figures around him.

The Evangelist is grounded in something familiar to the artist, but *The Seed of Revolution* (1928; pl. 69) and *Mob*

Vengeance (1930; pl. 70) come from more ambiguous terrain. Even Spencer's daughter Ann didn't know what to make of these pictures: "I remain puzzled by his last works of riotous mobs and lynchings. He was certainly no revolutionary."[7] The two canvases initially appear to be old-fashioned history paintings, but typically such paintings depict specific historical events that are referred to in the title. Here, not only are the titles ambiguous (Which revolution? Which mob?), but the architecture, clothing, and other details provide little information that would locate the scenes. The clothes worn by the crowds suggest European urban peasantry of the nineteenth or early twentieth century. But the lettering is obscured on the posters to the left of the central figure in *Mob Vengeance*, thus frustrating any attempt to figure out, circumstantially, where and when the unfortunate event is taking place.

Spencer's late crowd scenes must be viewed in the context of the experimental work he was making at the same time.[8] He had grown more confident of his ideas and abilities, and consequently less restrained by the conventional ways of working. "I am painting again with full force," he wrote to Duncan Phillips about *The Seed of Revolution*, "cutting deeper and with a freedom from painting conventions that I never had before.... I dare to say what is in my mind with conviction and a free brush and palette."[9] Note that, as opposed to his earlier letter to Phillips, in which he insisted on at least the illusion of reality ("I first have to make what I see"), here Spencer is completely comfortable with "saying" what is in his mind, and he doesn't utter a word about seeing. Now the freedom to paint what he imagines is what he most values.

Since his daughter had no idea why he made these pictures, and nothing the artist himself might have written about them has survived, any attempt to explain them becomes a matter of speculation. Spencer probably wanted the paintings to be seen as archetypal and perhaps allegorical crowd scenes. Their closest model might be a work such as Eugène Delacroix's monumental canvas *Liberty Leading the People* (fig. 1), which commemorates an 1830 revolution in France but also embodies allegorically the *ideas* of liberty and revolution in a female figure leading a battle.

Figure 1
Eugène Delacroix (1798–1863)
Liberty Leading the People 1830
Louvre Museum, Paris
Réunion des Musées Nationaux/
Art Resource, New York

Despite his daughter's protestations to the contrary, it's tempting to view these two paintings as expressions of Spencer's political beliefs. But Spencer himself argued strenuously against any overt political content in his work.[10] He simply wasn't the kind of man who wanted to storm the barricades on behalf of the oppressed people of the world.[11] From the beginning there was a streak of romanticism in his work; perhaps he had read about revolutionary events in history or literature, and his mind simply became excited by images of people revolting against the rule of a tyrannical master.

Spencer's granddaughter is convinced that the woman leading the unruly crowd in *The Seed of Revolution* is her grandmother, Spencer's wife Margaret.[12] It would be easy to dismiss that claim, except Spencer had a track record of using his wife as a subject, including at least two instances in which she is shown in a less-than-flattering light.[13] In *Happy Family* and *Alarm Clock,* the man is Robert and the woman is certainly Margaret; she is depicted as having dark hair and full breasts, wearing

a loose-fitting white housedress or slip (figs. 2, 3). The physical similarities with the rabble-rousing protagonist of *The Seed of Revolution* and *Mob Vengeance* are obvious, and even the clothing is similar. While the facial features are not an exact match with Margaret, there's a definite resemblance (figs. 2–5, 8).

The impression that Spencer is commenting on his marriage in these paintings is enhanced by a closer look at *Mob Vengeance.* Here, not only is the female figure on the shoulders of the lawless crowd, she is egging them on in their attempt to dismember an unlucky gendarme whose hat and shirt are scattered on the ground. She has hung a rope over a lamppost, and the poor gendarme is about to be hung by the riotous horde. "Mob vengeance" indeed—except the long, angular visage of the doomed jailer has an uncanny similarity to Robert Spencer's face (figs. 6–7)! As with the female figure and Margaret, the resemblance isn't exact. But given the turbulent nature of his domestic life, Spencer might have intended to maintain what politicians call "plausible deniability." Also, he wanted these pictures to be seen as more allegorical than literal; if he had placed obvious replicas of himself and Margaret in the scenes, the paintings might lose their healthy ambiguity and become little more than sad jokes at the expense of his wife.

One can imagine Spencer chuckling to himself as he painted the two main characters in *Mob Vengeance.* The term *gallows humor* fits very well here—except the crowd is in such a hurry to string up the hapless Spencer lookalike that they can't even wait for a proper gallows to be made! Given his suicide only a year or so after he made the painting, the bitter words he uttered to his daughter Tink a few minutes before he shot himself make the canvas seem more tragic than comedic: "That's the way it goes, Tinker. The queen reigns supreme."[14]

If these speculations about the covert family humor in *The Seed of Revolution* and *Mob Vengeance* are true, then the implicit politics of these canvases may actually be more right-wing than left-wing. Did Spencer really sympathize with the mob? By making his wife the leader of the uprising and himself its victim, he may have been implying that he found such events distasteful at best. His own daughter described him as "patrician"

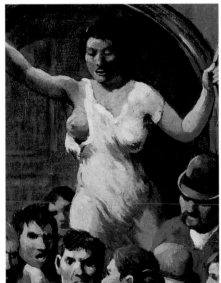

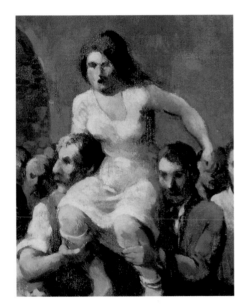

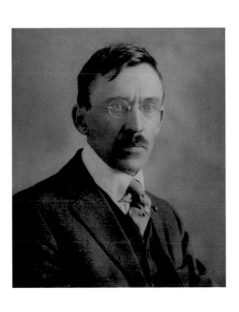

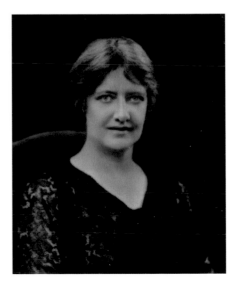

and suggested that he tended to romanticize workers and peasants rather than identify with them.[15] At the very least one should avoid the temptation to view these paintings as expressions of revolutionary politics, and remember that the artist himself no doubt wanted their specific meaning to remain enigmatic.

Equally enigmatic are the two late paintings that are based on Biblical themes, *The Exodus* (1928; pl. 68) and *Crucifixion* (1931; pl. 72). Again, these canvases can be seen as part of Spencer's gradual shift toward imaginary subject matter. But instead of ambiguous depictions of unnamed events, here he is working directly out of the narrative painting tradition in which mythological and Biblical stories are reinterpreted, often in contemporary settings. Both of these paintings must be seen in the context of the artist's deep-seated antipathy toward what he saw as the sterility and even godlessness of modern culture:

> *Has man so completely forgotten God and God's purpose, the world and its normal fecundity, that nothing not made by a machine is of value? . . . The function of man as man is of far greater importance than the function of any machine or doctrine made by man, and today the machine plays too great a part. The intellect outbalances life.*[16]

In the Biblical story of the Exodus, Moses leads the Israelites out of their Egyptian slavery into the promised land. In Spencer's version of the story, a bearded and dark-suited Moses (carrying a suitcase and an umbrella!) leads his people not out of Egypt but a modern city. Spencer's cities usually are full of activity and life, but this city is nearly empty, and the buildings lack their typical energy and character. There appears to be a message in this image: Spencer's beloved, archetypal city, the romantic center of human history, has become the barren home of the machine. The only response of the thinking and moral individual is to pack his things and leave, just as Moses left the hated home of his people's enslavement.

Crucifixion is more direct in its impassioned criticism of modern culture. Here there is no escape from slavery except death. Nine years after *The Evangelist* (1919), the brightly lit and peaceful crowd of listeners became the riotous herd of *The Seed of Revolution* (1928); three years after that, and shortly before Spencer's suicide, the crowd has become the evil mob that crucified Christ. The backdrop is once again the city, but the buildings are even more stark and ominous than in *The Exodus*. Three women in the lower right are in positions of fear and supplication, but every other person in the crowd is in some way participating in the violent events: digging the holes for the three crosses (note the discarded shovel and the man who appears to be putting a tool back into a large box); tying the hands of the criminals (one man is holding the rope); hammering the proclamation above Christ's head; or simply looking on with fascination and, even worse, boredom.[17]

In his final months, did Spencer's depressed and tormented mind begin to see the world as such an evil, soulless place that the crucified Christ became the most potent symbol of modern life? We know that he was contemplating suicide[18]—did he begin to see his own death as a kind of crucifixion at the hands of the "unloved, unlovable, distorted machine?"[19]

Tink believed that *Crucifixion* was a powerful expression of what her father was feeling before he died:

> *Beneath a sky of yellow-purple massing storm clouds [lies] a group of empty open mouths and expressionless eyes, men and women of the lowest tenement district. Black-cloaked police on horseback are watching, waist-high. . . . Two tough criminals, olive-skinned and stripped to loincloth, are strung by their muscled arms on crosses to the sides of a center cross. And there Christ hangs—gaunt, distinguished, slim of limb and torso. A gray and chalk-white body of a lonely savior who could not find his place among the work-dimmed, savage, bloodthirsty brains of his brothers.*[20]

In this painting there are no obvious physical similarities between the Christ figure and Spencer, but Tink makes the connection in her deeply felt prose. To her, Spencer in the end couldn't find his place in a hostile world, and he began to feel that death was the only way to ease his pain. Some of that pain can be felt in his daughter's words as she reflected on her father's tragic life:

> *There was so much goodness in him, so eternally an opening of empty arms, hope against hope that somehow luck might fill them once in return for what they offered. Yearning for a bit of peace, of understanding in the hollow of his heart.*[21]

NOTES

1. See the earlier chapter entitled "The Cities, the Towns, the Crowds" for a discussion of Spencer's early realism and his gradual shift to more romanticized and larger-than-life depictions of urban areas.

2. The reference is to famous surrealist paintings by Salvador Dalí and René Magritte.

3. Letter from Robert Spencer to Duncan Phillips, March 12, 1926. Courtesy of the Archives of The Phillips Collection. The other artist Spencer refers to is Edward Redfield, who was passionate about his desire to make his paintings reflect the tangible, physical presence of objects in the real world.

4. See the preceding chapter, "Breaking the Mold," for a discussion of Spencer's tendency toward experimentation in this period.

5. See the biographical essay earlier in this book for further information about Margaret Spencer and the Spencers' marital difficulties.

6. Ann Spencer Simon says in an undated and unpublished personal chronology, "My grandfather was a Swedenborgian minister, and soon retired from the pulpit to study Swedenborg's philosophy. Angels were quite prominent in their creed and my father would have nothing to do with their sexless, unsensual ways." In her unfinished, fifty-two-page draft manuscript of a Robert Spencer biography, Tink Spencer also comments on her father's religious leanings, saying that "if he were to become a convert to any religion he would choose the Roman Catholic."

7. From an unpublished and undated short manuscript in the possession of Shayla Spencer.

8. See the chapter "Breaking the Mold" for a discussion of Spencer's experimental work.

9. From a November 7, 1928, letter from Robert Spencer to Duncan Phillips in the archives of The Phillips Collection, Washington, D.C.

10. As noted in the biographical essay, Spencer says in the Dewitt McClelland Lockman Papers of the Archives of American Art, "Many people have made the mistake of thinking me socialistic—a friend of the working man and all that sort of thing. Not at all. . . . It is man, and not man's theories that I'm interested in."

11. A fascinating and disturbing glimpse into the dark side of Spencer's soul is provided by Tink in a story she relates about one of their French sojourns, in her unfinished, fifty-two-page draft biography. While eating dinner at an inn, Spencer made "rude remarks" about a large black man eating nearby accompanied by a "very blonde and buxomly beautiful woman." Spencer then discovered that they had been assigned the room next to his, and he proceeded to make loud demands on the innkeepers to remove the couple to another room. At first the innkeepers refused, but eventually Spencer won out and the couple left the next morning, "driving off with a liveried white man in the driver's seat." Tink says such behavior was very uncharacteristic of her father, that in fact this was the only such incident she ever saw; she attributes it to the "training" he was given by his "southern fathers." Even so, it's hard to imagine a man with such latent feelings ever making paintings purely out of solidarity with minorities and the oppressed.

12. This idea was first conveyed in a conversation between the author and Shayla Spencer in March 2001.

13. See the earlier chapter entitled "Vignettes" for more examples of Spencer's use of Margaret as a subject.

14. Margaret (Tink) Spencer, "Slow Burns the Genius," unfinished typed draft manuscript of Robert Spencer biography, sixteen pages, August 1969, p. 1.

15. The references by Ann Spencer Simon are from a January 22, 1995, letter from Ann Spencer Simon to Michael Holt, as well as an unpublished and undated short manuscript in the possession of Shayla Spencer.

16. Letter from Robert Spencer to Duncan Phillips, April 27, 1931. Letter is in the possession of Gene Mako, currently on loan to the Michener Art Museum.

17. Most of these and other details in the painting are taken directly from the Gospels. The women are described differently in different Gospels, but two of them are Mary (the mother of Jesus) and Mary Magdalene. The policemen are the Roman soldiers who struck and taunted Christ, and in the Gospels the proclamation nailed over Christ's head says THE KING OF THE JEWS. In the Biblical stories there are also three men crucified on that day, with Christ in the center.

18. His friend John Folinsbee recalled that Spencer had spoken of killing himself on more than one occasion; see the biographical essay for more on Spencer's suicide.

19. Letter from Robert Spencer to Duncan Phillips, April 27, 1931. Letter is in the possession of Gene Mako, currently on loan to the Michener Art Museum.

20. Margaret (Tink) Spencer, unfinished typed draft manuscript of Robert Spencer biography, fifty-two pages plus additional notes and sketches, ca. 1969, p. 39.

21. Margaret (Tink) Spencer, "Robert C. Spencer," typed draft manuscript, six pages, unpaginated, undated.

"The Evangelist *is a masterpiece of American genre. It would be difficult to find a picture in which a restless crowd has been represented with as much conviction and as little confusion. The contrast between the mellow lyric light of a summer afternoon and the austere silhouettes of the preacher and the platform is very poignant.*"

FROM *A COLLECTION IN THE MAKING*, 1926, BY DUNCAN PHILLIPS

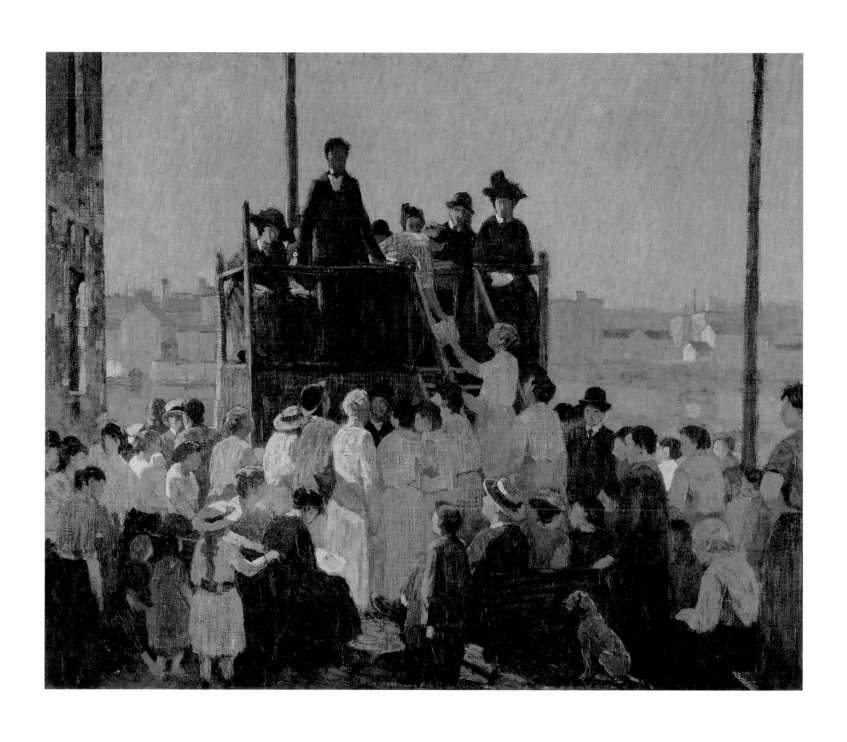

PLATE 66 *The Evangelist* 1919

oil on canvas
25 × 30 inches
The Phillips Collection,
Washington, D.C.

PLATE 67 *Study for "The Exodus"* 1927

 oil on canvas
 12 × 14 inches
 James A. Michener Art Museum.
 Gift of Kenneth W. Gemmill
 and Elizabeth M. Gemmill

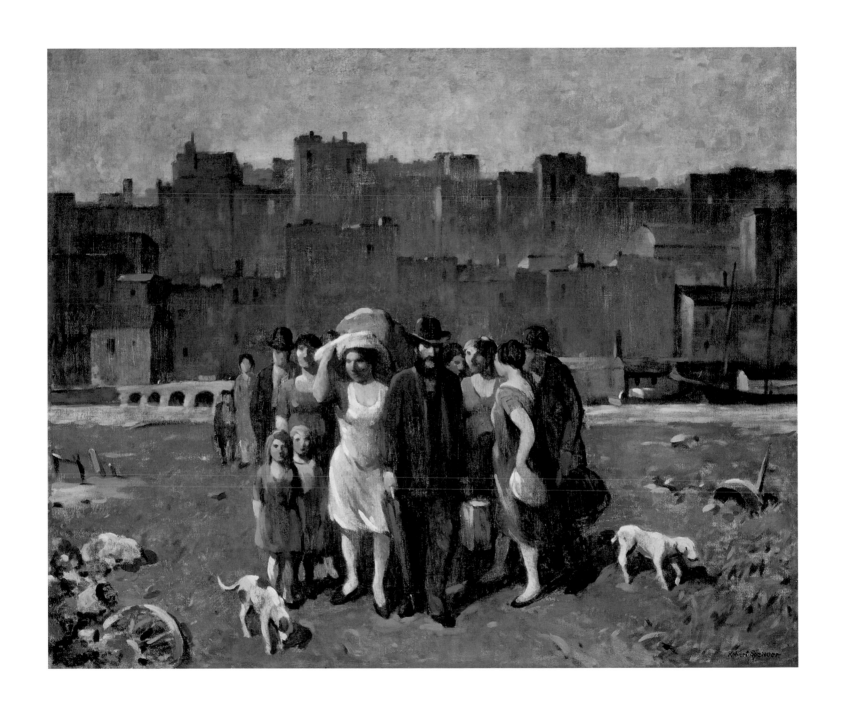

PLATE 68 *The Exodus* 1928

oil on canvas
30 × 36 inches
The Museum of Fine Arts,
Houston; Gift of the Houston
Friends of Art

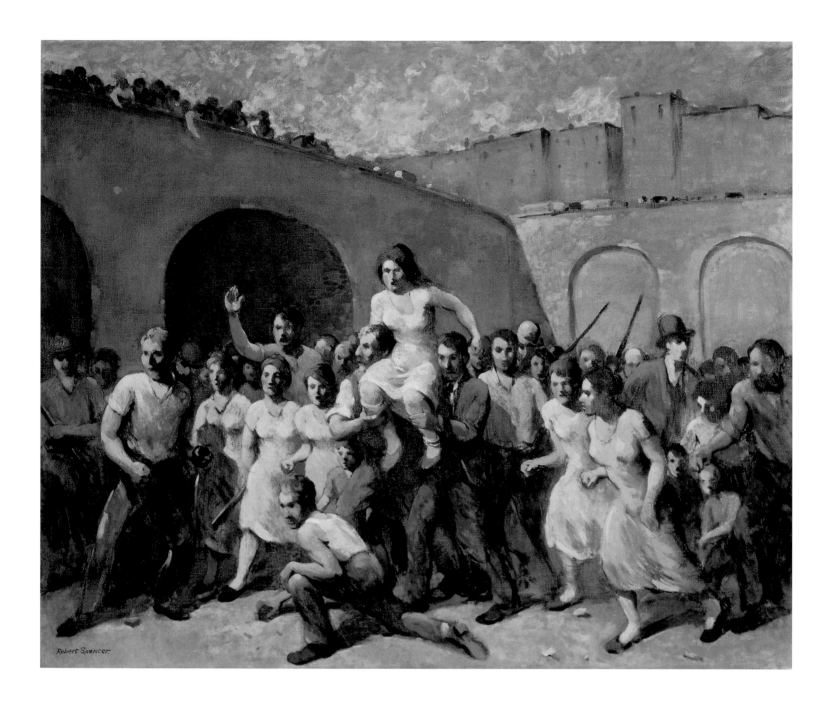

"In such paintings as The Exodus and The Seed of Revolution . . . [Spencer's] thoughts are more profound, more attending upon problems of human nature and social unrest. . . . What he did was paint the idea of revolt rather than the thing itself in all its fierce intensity."

NEW YORK HERALD TRIBUNE, JULY 19, 1931, AUTHOR UNKNOWN

PLATE 69 *The Seed of Revolution* 1928

oil on canvas
30 × 36 inches
The Phillips Collection,
Washington, D.C.

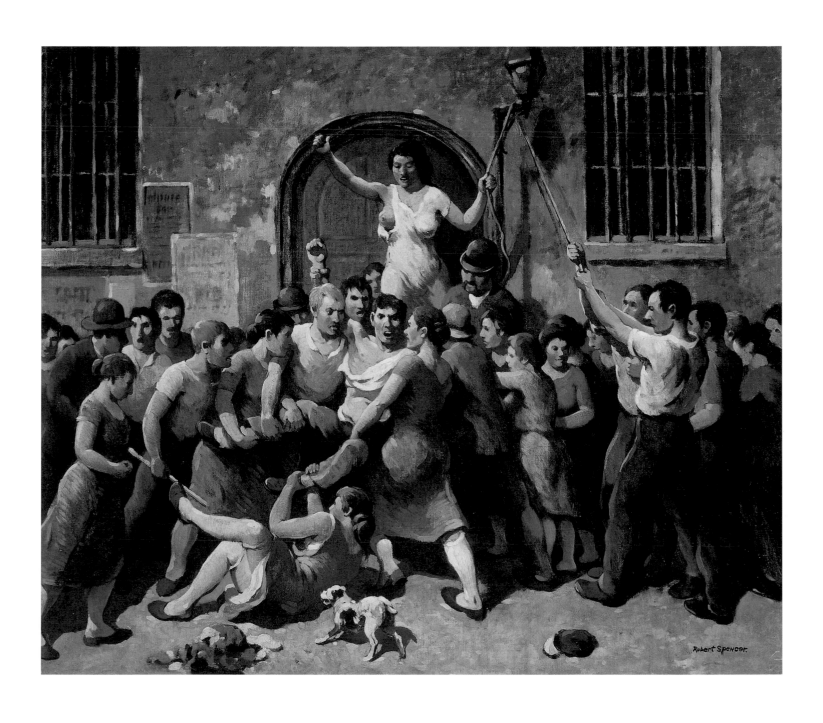

PLATE 70 *Mob Vengeance* 1930

oil on canvas
30 × 36 inches
Collection of Gene and Laura Mako

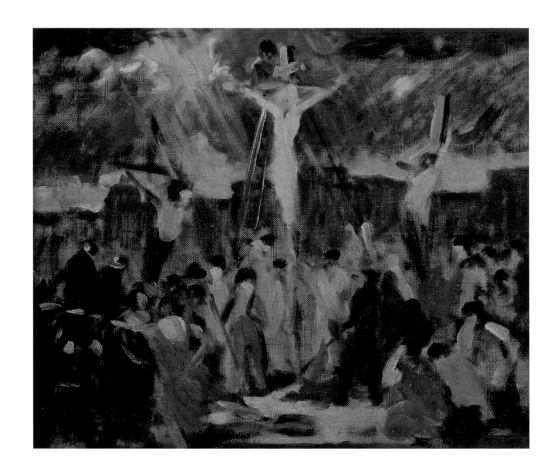

"And there Christ hangs . . . strung, beyond tearful pity, on his higher cross . . . dust in his redbrown beard drawing down the lines of his agonized mouth and eyes, marked with the strength that endured continual forgiveness of his brothers' unrelenting dumb and lustful savagery."

MARGARET (TINK) SPENCER, UNPUBLISHED MANUSCRIPT, CA. 1969

PLATE 71 *Crucifixion, Sketch #3* ca. 1930

oil on canvas
12 × 14 inches
private collection

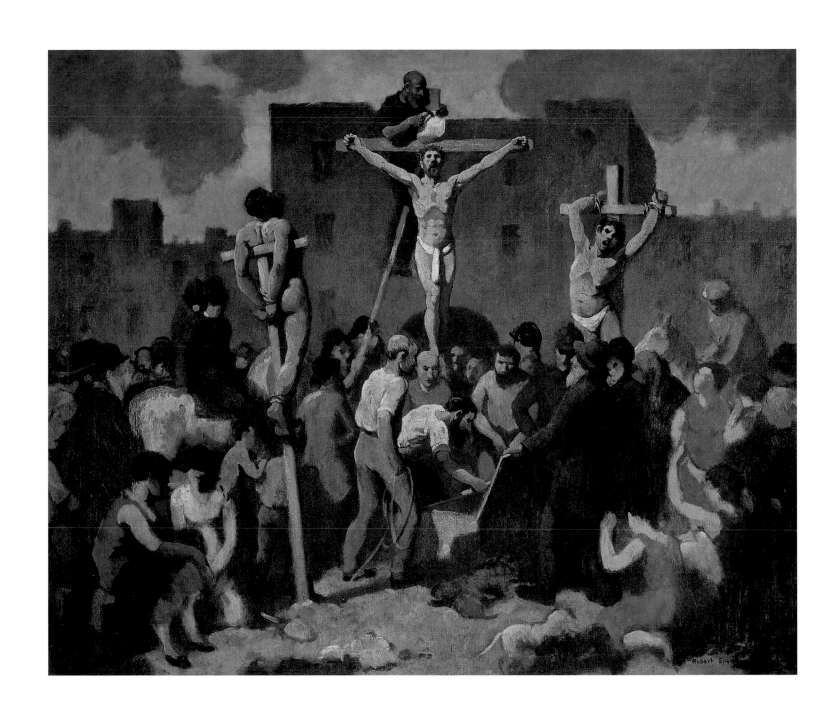

PLATE 72 *Crucifixion* 1931

oil on canvas
30 × 36 inches
Collection of Chantell Van Erbe

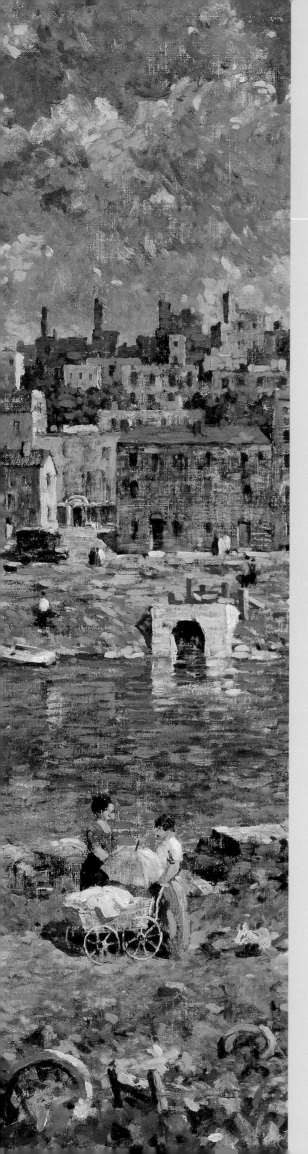

FINAL THOUGHTS

When an artist kills himself, there's a natural tendency to see everything he made in the context of his self-inflicted demise. With Robert Spencer this view of his work is particularly tempting because he suffered from chronic depression, and eight years before he died he acknowledged his illness, in print.[1] Thus one of the remarks one sometimes hears about Spencer is that there's an atmosphere of melancholy in his paintings, especially when compared with the more cheerful landscapes of his Bucks County colleagues.

Duncan Phillips voiced this sentiment in his letter of condolence to the family after Spencer's death: "His art revealed a subtle apprehension of harmonies in a minor key and of unities of mood pervaded by an unconscious wistfulness."[2] Almost twenty years earlier, long before he dreamed of making such obviously pessimistic paintings as *The Exodus* and *Crucifixion*, the artist himself expressed similar feelings: "Most of my work has a sort of sad tone—I myself like this—but I find the public as a rule [doesn't] and I don't blame them."[3]

What did Spencer mean when he referred to his own work as "sad"? Certainly his palette was generally darker and more monochromatic than most of his contemporaries, who loved brightly lit snow scenes and the lush greens of spring. And his typical subject matter—dilapidated buildings, tired workers trudging home at the end of a shift—was not exactly upbeat when compared with the picturesque villages and expansive river scenes of such painters as Edward Redfield and Charles Rosen.[4] But if Spencer had lived a healthy seventy or eighty years, and one could readily conjure up pleasant images of a gray-haired elder statesman bouncing his granddaughter on his knee, would the perception of the emotional tone of his paintings still be thought of as "in a minor key"?

Phillips's comment about "unconscious wistfulness" rings true. Despite the tendencies of his youth, when he often depicted real places realistically, in the final analysis Spencer was a dreamer and an idealist: a kid who never grew up, who romanticized his buccaneer ancestor,[5] and who loved to dream up worlds that were more colorful and larger-than-life than the most picturesque colonial village. As his friend F. Newlin Price said at the beginning of his 1923 article "Spencer—and Romance": "So let us introduce Robert Spencer, who has idealized the clumsy barges of the [Delaware] Canal and converted dark silk factories into dream castles, just as an artist must make things better than they seem to the layman to be."[6]

Whether or not a word like *sad* applies to Spencer's work is left to the eye of the beholder. Words like *excitement, contentment, discovery,* and *mastery* may fit just

as well: the excitement of the young artist as he found his own way of making paintings; the contentment of the maturing artist who knew exactly what he wanted to do, and did it; the sense of discovery in the older artist who was confidently breaking new ground for himself.

Mastery is a word that is reserved for the most accomplished artists: those who combine consummate technical skills with depth and universality of feeling, a powerful and searching intellect, and a richly textured and singular voice. Does Spencer's work as a whole rise to that level? The brutally honest answer to this question is—no. And yet there is so much intense exploration in his later canvases! He was starting to take his pictures to a new level, and he was hungry for growth.

A frank assessment of his work must take into account both his potential for mastery and certain nagging flaws. The human figure was absolutely central in Spencer's universe, yet one gets the feeling that figure drawing rarely came easily for him. It's not that his figures are always badly proportioned or ungraceful. In fact he developed an idiosyncratic way of painting people: somewhat stylized and spare, with rounded contours and simplified gestures. Yet sometimes there's an awkwardness to his figures, and in general it would be hard to describe his figure drawing as masterful—except in his experimental and "sketchy" canvases such as *Riviera Beach* and *Boating Party*. In these late paintings he was discovering a new and more advanced technique that allowed him to create a figure through suggestion rather than through careful detail. There are the beginnings of mastery in these canvases, especially *Riviera Beach,* which is almost miraculous in its ability to depict a fully realized scene in a simplified style that gives the impression of complete ease and spontaneity.

Spencer also was a portraitist (figs. 1, 2), albeit a reluctant one. He made portraits largely to put food on his table, and rarely had his heart in it.[7] His daughter Tink said he "did not relish" making portraits and "was prodded into portraiture by his friends."[8] One of the last paintings he made was a huge portrait of an actress named Hope Williams (fig. 2); this painting was on his easel the night he died. Recalling her conversation with him on that fateful evening, Tink says

he described the painting as "that God-damned portrait," and that he went on to exclaim, "Jesus, what a painter goes through to get the wherewithal to live so he can paint what he wants. I'm a lousy portraitist."[9]

It's strange that a man who was so in love with the human animal that he spent his entire adult life painting buildings and figures would have so much difficulty with portraiture, which after all is the most fundamental expression of the human in all of art. Spencer loved the hustle and bustle of life, and he loved humanity in general, but he had trouble with people. His daughter Ann pointed out that there was always a certain distance between Spencer and the workers and peasants in his paintings, and she described him as "patrician."[10] For the most part Spencer did not value genuine human intimacy in his work—if anything he was a bit threatened

Figure 1
Robert Spencer
Portrait of Brenda Biddle 1926
oil on canvas
60⅛ × 42 9/16 inches
Philadelphia Museum of Art.
Gift of Owen Biddle and
Peyton R. Biddle

by it—and thus he had little patience with that most intimate of art forms, the portrait. The exceptions to this tendency are his loving portrayals of Margaret in the early years of their marriage, which have a palpable tenderness and familiarity.

This lack of intimacy could be seen as a fatal flaw in his paintings, but that judgment would be based on a misunderstanding of what he cared about and where his work was heading. Spencer valued imagination over intimacy. Rather than penetrating into the heart of the individual human soul (as good portraiture would have required), he wanted to make ever more challenging and intricate visions of human life on a grand scale.[11] Spencer created his own realities, and he was learning how to do this in increasingly ambitious and masterful ways, to the point that his later work is tantalizing in the hints it provides about what he might have achieved.

In the end what Spencer most valued was freedom: not in the usual political sense, but the freedom of the fully realized and independent soul to say exactly what he or she wants to say, with confidence and with liberation from the bonds of artistic and cultural convention. To paraphrase the words of the Gospel, many are called to this task, but few achieve it.[12] Spencer began his journey toward this creative freedom in his first mature canvases of 1910–13, and in the last few years of his life he was hot on its trail—and he knew it. His 1928 letter to Duncan Phillips is worth repeating in this context: "I am . . . cutting deeper and with a freedom from painting conventions that I never had before. . . . I dare to say what is in my mind with conviction and a free brush and palette."[13]

It's difficult to reconcile the genuine excitement in this letter with the deeply depressed man who blew his brains out only three years later. But this was also the man who said, "I am sick and I know I'm sick."[14] It is hard to imagine a more potent example of the horror of mental illness: the way it eats away and eventually destroys the *potential* of a life. Instead of viewing Spencer's paintings in the context of how he died, perhaps it would be more accurate—and generous— to remember how much courage it must have taken for him to battle his disease and leave behind such a powerful and consistent body of work.

Figure 2
Robert Spencer
Hope Williams 1931
oil on canvas
84 × 48 inches
private collection
(black-and-white reproduction)

NOTES

1. F. Newlin Price, "Spencer—and Romance," *International Studio* 76 (March 1923): 489.

2. Undated letter from Duncan Phillips to Margaret Spencer. Letter is in the possession of Gene Mako, currently on loan to the Michener Art Museum.

3. From a December 1, 1912, letter from Robert Spencer to "Lum and Mary," the original owners of a Spencer painting entitled *Spring Sunshine.* This letter is part of a group of several letters unearthed by the deceased Bucks County art dealer Frank Bianco as part of an appraisal of this painting. Copies of the letters were given to the Michener Art Museum by Gerry Lenfest.

4. For more information on Redfield, Rosen, and the other New Hope painters, see Brian H. Peterson, editor, *Pennsylvania Impressionism* (Doylestown, Pa.: James A. Michener Art Museum; Philadelphia: University of Pennsylvania Press, 2002).

5. Margaret (Tink) Spencer, unfinished typed draft manuscript of Robert Spencer biography, fifty-two pages plus additional notes and sketches, ca. 1969, p. 1.

6. Price, p. 485.

7. A list of 215 paintings compiled by Tink Spencer from her father's records contains only five portraits, made between 1926 and 1931. The subjects are Mrs. Moncure (Brenda) Biddle (1926—currently in the collection of the Philadelphia Museum of Art), Mrs. Ellwood Hendrick (1928), Mr. Moncure Biddle (1929), Mrs. George Eustis (1931), and Hope Williams (1931). Of these five, two apparently were made as gifts to friends and three were commissioned: the portrait of Mrs. Biddle for $3,000, and the Williams portrait perhaps for $15,000 (the unconfirmed dollar amount provided by Tink in her list). With such handsome sums involved, it's easy to see why Spencer agreed to make these commissioned paintings despite his aversion to portraiture! At least one of his clients did not share Spencer's lack of confidence in his abilities as a portraitist. In an August 9, 1926, letter to Spencer, Mr. Biddle refers to the quality of "real genius" in the portrait of his wife, and says that this painting "will be very great because it will be one of the few portraits [by] one of our great landscape painters." Biddle also confirms that Spencer's fee for the portrait was $3,000. (Letter is in the possession of Gene Mako, currently on loan to the Michener Art Museum.)

8. Margaret (Tink) Spencer, *Robert C. Spencer,* typed draft manuscript, six pages, unpaginated, undated.

9. Margaret (Tink) Spencer, *Slow Burns the Genius,* unfinished typed draft manuscript of Robert Spencer biography, sixteen pages, August 1969, p. 1.

10. Ann Spencer Simon, from an unpublished short manuscript, n.d., in the possession of Shayla Spencer.

11. It's instructive in this context to compare Spencer's work with some of the smaller, more intimate portraits by Thomas Eakins as well as the Depression-era paintings of Raphael Soyer. Both Eakins and Soyer were temperamentally very different from Spencer. Eakins's portraits have an openness and a gritty, unflinching honesty that were foreign to Spencer's vision of humanity. Similarly, Spencer simply was not interested in creating the kind of searching and empathic depictions of immigrants and poor people that characterize Soyer's work.

12. The reference is to the famous phrase "Many are called, but few are chosen." Matthew 22:14.

13. From a November 7, 1928, letter from Robert Spencer to Duncan Phillips in the archives of The Phillips Collection, Washington, D.C.

14. Price, p. 489.

THE CORRESPONDENCE OF

ROBERT SPENCER AND DUNCAN PHILLIPS

Duncan Phillips (1886–1966) was the founder of
The Phillips Collection in Washington, D.C., and
was a pioneering collector and advocate for modern
art in the early twentieth century. Born in Pittsburgh,
Phillips was the grandson of the founder of the Jones
and Laughlin Steel Company, and grew up "in a high-
ceilinged house full of academic European and Amer-
ican paintings."[1] His family moved to Washington in
1896 and built a house near Dupont Circle that be-
came the original building for the museum. Phillips
was educated at Yale University, where he majored in
literature. His desire to study art history at Yale was
thwarted when the university dropped its only class
on the subject because there was not enough interest
among the students. He responded to this situation
by writing an essay entitled "The Need of Art at Yale."
Following his graduation in 1908, Phillips traveled
to such European cities as London, Paris, and Madrid
to see and learn about the masterpieces of European
art as well as visit artists' studios. He also started to
write about art, and began to see his life's work in
terms of the need to "share his own delighted under-
standing of art with an ever-growing audience."[2]

Originally called the Phillips Memorial Art Gallery,
Phillips's museum opened to the public in 1921 as part
of the family residence. The institution was the first
museum devoted to modern art in the United States,
and eventually grew to become one of the premier
collections of American and European impression-
ism and modernism, including prime examples by
such major figures as Renoir, Matisse, Monet, Degas,
Cézanne, and Picasso, as well as by American masters
such as Georgia O'Keeffe, Arthur Dove, and Milton
Avery. A trademark of Phillips's collecting style was

his desire to acquire not merely one or two works
but what he called a "unit"—that is, a more cohesive
and in-depth representation of an artist's entire
life's work.

It's unclear how Phillips met Robert Spencer,
but by the late teens they had become friends. When
Phillips opened his museum he owned eight paint-
ings by Spencer. In the twenties Phillips continued
to buy, sell, and trade Spencer's canvases, sometimes
even upgrading his Spencer holdings through direct
negotiation with the artist. Eventually he acquired
what is undoubtedly the finest institutional collection
of Spencer's work, including such classic paintings as
The Evangelist (1919), *Mountebanks and Thieves* (1923), *Ship
Chandler's Row* (1926), and *The Seed of Revolution* (1928).

As Phillips was conceiving and creating his new
museum, he invited Spencer to be a member of the
Advisory Committee on Scope and Plan for the Phil-
lips Memorial Art Gallery. The two men corresponded
regularly in the twenties, and because most of Spen-
cer's journals, letters, and personal records have not
survived, this correspondence has become a valuable
record not only of their relationship but of the artist's
ideas and mind-set in the last decade of his life. Spen-
cer clearly valued his relationship with Phillips and
shared some of his most private and intense feelings
about art and modern life with his friend. The letters
also provide a fascinating glimpse into the "horse trad-
ing" that goes into building a major collection with
sometimes limited means. On occasion Phillips nego-
tiated deals with Spencer in which smaller paintings
already in Phillips's collection were traded for larger
and better paintings, with the difference in value paid
in cash to the artist.

Figure 1 Marjorie and Duncan Phillips in the Main Gallery of the Phillips Memorial Art Gallery.
Photograph by Clara E. Sipprel, ca. 1922. The museum was renamed The Phillips Collection in 1961.

It's revealing that for his last known letter to Phillips, dated April 27, 1931, Spencer left behind both handwritten and typed drafts, but sent the final letter to Phillips in a handwritten form. As with his paintings, Spencer wanted to get this letter right, and what may appear to be a spontaneous outpouring was actually thoroughly considered and planned.

The Phillips Collection has kindly given the Michener Art Museum permission to print extended excerpts from the Spencer/Phillips letters. Unfortunately the correspondence is largely one-sided because most of Phillips's letters were lost in the same 1971 fire in Arizona that destroyed the Spencer material. I am greatly indebted to Birgitta Bond, librarian and archivist at the Michener, for her work in transcribing these letters.

BHP

NOTES

1. Laughlin Phillips, preface to *The Eye of Duncan Phillips: A Collection in the Making* (Washington, D.C., The Phillips Collection in association with Yale University Press, 1999), ix.

2. Ibid., p. x.

Brief biographies of individuals mentioned in the Spencer/Phillips correspondence:

PIERRE BONNARD (1867–1947) was a major French artist who was a founding member of the Nabis, a group of Parisian painters who were influenced by the highly colorful and rhythmic aspects of Japanese prints as well as by Paul Gaugin's expressive and unconventional ideas about color. Bonnard is best known for his domestic interiors often depicting his wife as she was bathing. He also painted landscapes and still lifes as well as a series of evocative self-portraits.

ARTHUR B. DAVIES (1862–1928) was an American painter and printmaker who made poetic and allegorical works that often were based on mythological themes. His paintings usually include nude figures that inhabit an idealized world of purity and fantasy. Also active as a leader and administrator, Davies was one of the principal organizers of the 1913 Armory Show, which introduced the American art public to European modernism.

ALBERT MCVITTY (1876–1948) was an important collector of American and European art who lived in Bryn Mawr, Pennsylvania, and Princeton, New Jersey. He made his fortune in the leather trade, and was both president and board chairman of the Philadelphia firm Leas & McVitty, leather merchants. McVitty's collection included 145 Rembrandt etchings and more than one hundred etchings by Mary Cassatt as well as paintings by such distinguished American artists as Ernest Lawson, Julian Alden Weir, and Childe Hassam.

JOSEPH PENNELL (1857–1926) was a printmaker and illustrator who specialized in architectural scenes and landscapes. He spent a considerable amount of time in England, where he illustrated a number of books dealing with the buildings of London and English cathedrals. He also journeyed to the American West, creating scenes of the Grand Canyon and Yosemite. In his lifetime he illustrated and/or wrote more than one hundred books.

MARJORIE PHILLIPS (1894–1985), the wife of Duncan Phillips, was an active and serious painter who studied at the Art Students League in New York. She focused primarily on landscapes and cityscapes, and was influenced by the impressionist style as well as postimpressionist painters such as Pierre Bonnard. After her marriage to Phillips in 1921, she became deeply involved in the activities of The Phillips Collection, and after his death served as director of the museum for six years.

AUGUSTUS TACK (1870–1949) was a New York–based painter known both for his portraits and large-scale murals executed in churches and public buildings throughout the United States and Canada. He also made many mystical landscapes and abstract paintings that explored spiritual themes. Tack was a close friend and associate of Duncan Phillips, and was very active in assisting Phillips with the formation of his museum. The Phillips Collection owns seventy-nine works by Tack.

All letters reproduced with the permission of The Phillips Collection Archives, Washington, D.C.

The earliest known letter from Robert Spencer to Duncan Phillips was quoted by Phillips in "Art and the War," a lecture delivered to the College Art Association at the Metropolitan Museum of Art in New York City, March 28, 1918:

Robert Spencer, the contemplative poet-painter of New Hope, Pennsylvania, wrote me a long letter which showed that he had been pondering deeply the problem of art in war-time and I must quote from it, for in this letter we are given to understand not only the artist's faith and courage about art and beauty but also his fervent response to the idealism which actuates the Allies in their defense of civilization and personal liberty. Incidentally we are reminded that in war-time not only should the artist help the state but the state should support the artist.

My Dear Mr. Phillips:

Thanks for your letter in which I am very interested.... This war is dreadful beyond thought but a necessity—a working out of destiny. The world will be more wholesome for it. It will help to wipe out degeneracy and give a new impulse to life the world over. As I see it—the fight is between Democracy and State Socialism. The Allies stand for the right of the individual to live and work as he sees fit. German Rule and Socialism mean one and the same thing—the end of man as an individual—the most terrible thing that could happen. Imagine every act of the individual dictated by a government, every picture painted at governmental instigation subject to governmental censorship! The triumph of Germany, or of Socialism would mean the end of joy in work, the death of pride, effort and ambition and of course the end of art.

I wish I could paint war pictures. I wish I had the power of the cartoonist.... But my point of view is too quiet. When I try to paint a moral or adorn a tale I find that it is out of my game. So I really have to do my bit in another way....

When I think of war in these days it seems almost a criminal waste of time for me to be peacefully sitting in the sun on a canal bank watching lazy barges floating by or noting the color and romance of mill hands coming out at closing hour. Yet per- haps Art's pleasure is meant to give men's thoughts occasional relief. Perhaps the artists are the mental branch of the Red Cross. One cannot live in Hell all the time.

I wonder if collectors ever think how particularly hard hit painters are just now, especially those who depend on sales for their bread and butter.... *Is it not worthwhile to keep artists alive for the sake of after time?* The artist walks a straight path. Instead of living as the best sellers live he is content to eat his crust and paint for posterity and the best there is in him. All true artists are doing what the Allies are doing. They are fighting for future generations.

Sincerely yours,
Robert Spencer

I quote this letter with Mr. Spencer's permission because I hope it will help others as it has helped me to keep art's vital function solicitously in mind throughout this crisis. We must see to it that artists are mobilized to make their willing contribution to the Cause and we must also see to it that while they are heartening us as we carry our packs, we are sustaining them through the hard times, for their own sake and for the sake of "after time."

March 27—1920

My Dear Mr. Phillips,

I got home last night after a tiresome journey due to bad connections. A freight wreck had tied things up at Trenton, so it was 2 P.M. when I arrived in New Hope. I did not stop in Philadelphia as when I got there I found that Garber was out of town.

That was a good inspiration I had to go to Washington and I wouldn't have missed it for a good deal. *You have a wonderful collection and to have kept out of the many pitfalls that so many collectors often fall into really presupposes a true painter's instinct on your part.* By collecting and writing you are expressing yourself just as much as if you were painting, and it's a fine expression. In a way, it's even a bigger expression than that of the single painter. *Painting to me is sort of a sacred thing—a religion if you will—and a true collector is one of the high priests—or a keeper of the temple—and it is a very serious thing.* It isn't

for yourself alone that you are collecting—but for posterity—and on your care of your collection depends the life of the artists represented—or I should say—on the care of all collectors of their collections. It's a sacred trust, the buying of pictures—and should not be lightly undertaken—and you are one of the few who approach the thing as it should be done. It is only just and right that the collector should do his part and should keep himself and his collection as true and as fine in his attitude toward art as should the painter, and it is also only just that the world should know the guardian of art as well as the creator of it. Collecting is really a great thing and cash alone won't do it. *The commercial collector is fully as bad as the commercial painter—and it requires real genius to collect well—a fine insight—taste—and a nice sense of balance. I have always held that it takes a Rembrandt to appreciate a Rembrandt—by that I mean that the buyer or appreciator of a fine thing must be as much of an artist in thought and feeling as the artist himself, and I hope that you will not feel that it is just flattery when I say that you are doing the thing as it should be done.*

I can tell a brother painter with a clear conscience that he has painted a fine picture—he knows I have nothing to gain and that my appreciation is sincere—but due to the fact that I have pictures to sell—it is a bit difficult to tell a collector that he has done the same thing—and it's a shame that it is so for a painter hates above all things to be misunderstood. I have said many things to you about other painters' work—which were said because I forgot the collector and talked to the artist—incidentally—I never did remember the buyer when I talked to you, which is a compliment, and I hope that you will take many of the things I said with a grain of salt and remember that a painter is full of prejudice. . . .

Thanking you for a fine visit, which I hope you will return by coming to see us soon in New Hope—

Sincerely
Robert Spencer

P.S. Please give my kindest regards to your mother. You are lucky to have her look after you. . . .

March 24—1921

My dear Mr. Phillips,

To be less formal—I have just had a mighty pleasant visit with a friend of yours in New York—Augustus Vincent Tack. My cousin, Ellwood Hendrick, was responsible for my meeting him at the Century Club. I visited Tack's studio and was quite swept off my feet by the scope of his work. Mighty few men today would have the daring to do the thing he is trying—or have the ability if they dared. He seems to know just where that narrow line lies which a truly great painter has to walk, a slight leaning to either side upsets the whole. His work was a real revelation to me and my only quarrel is—as I told him—that he does not give us enough chances to see it. Had I not visited you in Washington—I might not have known his work for some years to come. However—in another way I don't blame him—due to the general treatment our average exhibition accords a man of his unusual temperament. There is an excellent quality in his painting that is very rare—a really religious quality which is found by no sect, yet has tradition, and which is, one might say—the soul of religion, felt and seen by an artist. . . .

I have not met a man in years who seems so much in accord with the eternal and spiritual side of man, man's relation to God and the spiritual reactions of man to landscape as is Tack.

Davies is also spiritual in a way—but not in the same *pure* sense, for Davies is often totally tainted by an over exquisite sensualism. This is entirely lacking in Tack! He sails serenely above it. He acknowledges there is sin—but does not glorify it or needlessly dwell upon it. The struggle of man toward God—his dallying by the way—the glory and mystery of nature—the eternal trend of things toward God! When the average man deals with these things—he is generally just foolish—but Tack is not! Tack in his art may speak of sin—but it is only that out of sin comes the good as the old truth goes. Yet Tack is not a preacher or reformer. He is too great for that. He is not positing a moral—but stating a truth—just as Manet or Velasquez did. In short he is almost the first man I know to really deal in a fine way with the exalted things! It is curious—but Rembrandt, now I think of it—did much

the same thing with the things of earth—and it's what saves them!

Aside from the mainspring of Tack's art—his color is undoubtedly beautiful and his sense of the balance of things remarkable. I hope you won't misunderstand this. Tack's art is hard to talk about.

Sincerely
Robert Spencer

March 24—1921

Dear Mr. Phillips—

I consider it an honor to have been elected a member of the Committee on Scope and Plan by the Trustees of the Phillips Memorial Art Gallery. I will be glad to serve on the committee and to make it a point to attend the meetings in New York. As you know, from our talk during my visit to you in Washington, I am very much in sympathy with your project and believe that the gallery . . . will be a great work and of lasting value to the world.

Sincerely yours
Robert Spencer

March 12—1926

My Dear Duncan Phillips,

I have been meaning to write you ever since my return from Washington in regard to "Ship Chandler's Row." I consider your collection so important that I hardly know what to say. I would rather have my best work there than anywhere else in the country—but frankly—I am somewhat—in fact much more than somewhat—hard up due to that European trip and several other things, and "Ship Chandler's Row" seems to be a canvas which I think I will have little difficulty in selling, also it has been invited to Chicago for their fall annual—and I am very short of pictures at this time—due again to Europe and to my infernal slowness of production.

I can't paint them "while you wait." They have to grow—to become instead of imagination, places as they exist, real places where I sit and smoke and walk and talk. I have to almost really build a city of real bricks and mortar before I paint it—and the real

bricks and mortar are imagination—solidified. If I were Redfield—it would be easy enough—he paints what he sees, but I first have to make what I see—so it's slow—dreadfully slow.

I wonder if you would care to make the following arrangement. Let me keep "Ship Chandler's Row" for a year or so—and then if not sold—make the exchange. I hate to quibble this way—my desire is to make the exchange at once and the fact that you want the canvas is pay enough. I consider your collection the finest in America and to be represented in it one of the greatest honors that can come to a painter.

Damn! I hate to write this sort of letter. Art should not be a matter of dollars and cents—but if I'm to go on painting my family has—to be perfectly vulgar—to eat!

When I see you in Washington on the 25—26—or 27th . . . we can talk it over.

Very sincerely
Robert Spencer

P.S. Don't mention this reference to Redfield. I did not mean it as slighting as it sounds.

April 23, 1926

Dear Robert:

You must have been wondering why you do not receive the painting which we must give up in trade for your "Ship Chandler's Row" now at the Corcoran. The reason is that I have been unable to make up my mind as to the canvas we can best afford to part with. They are all so beautiful that it is a hard thing to give up any of them. I agree with you that the little early one entitled "End of the Day" is the least important, but it has a sentiment for me as I used to be extremely fond of it at a time when we had very few pictures. It is unquestionably a poetic little scene and has a rare quality of texture. . . .

But perhaps the most practical reason for not sending back this small canvas is that the difference in price between that and the "Ship Chandler's Row" would be so great that I could hardly afford to take on that much more of an obligation. Any other year than this, which has been a most unusual year

because of our purchasing so many valuable pictures, we would simply add the "Ship Chandler's Row" and not give up anyone for it. This year I feel, after serious consideration, that it is necessary to give up one of the larger canvases and to pay the difference between the price we paid and the price of $2500 on the "Ship Chandler's Row." I have decided to give up "Derelicts" and as we got that through a trade for two small pictures I do not remember the amount we paid for those. Sometime let me hear from you as to how much we will owe you for that swap. If you could give me credit for a thousand I should be less embarrassed to meet it, and the $750 credit you offered for the "End of the Day." Anyhow I am sending the "Derelicts" to New Hope and hate to see it go. If it does not sell in a year's time tell me about it and I will buy it back. I mean that, as it is a picture with lots of mood and emotional appeal.

We did enjoy your brief visit, every moment of it, and I think my wife has written to you how pleased she was and I also, about your splendid letter about her pictures which you went all the way to New York to see. She values your opinion and your praise has done her a lot of good. Thank you also for the promise about letting me know about that book on painters' materials, chemistry of colors etc. With best wishes for a very happy and profitable summer in which Marjorie joins,

Sincerely yours
[Duncan Phillips]

April 26—1926

Dear Duncan,

I have just returned from old Joe Pennell's funeral. Somehow Pennell has always seemed a bit pathetic to me. I saw a good bit of him at the Century. He was born a Quaker and his funeral was held in the Coulter Street Meetinghouse—and a finer, more dignified or truly simple tribute could not be [indecipherable] all those great men gathered there to do him honor, sitting in silence mostly, every now and then one would rise and speak as he felt the need—and the men there spoke well. . . . In spite of Pennell's bitter tongue he had a host of friends who really loved him and sincerely felt his loss. A great many Century Club men came in from New York. Could Pennell himself have been there, he would have been deeply touched. His funeral was a great honor to him. May ours, when the time comes, be as sincere!

"Derelicts" arrived today—and I will be only too glad to allow you the $1000.00 you speak of for it toward the purchase of "Ship Chandler's Row." As the season has ended—I will hang it in the house until next year—and will write you before I sell it, and of course the picture is yours at any time for the sum allowed—$1000.00 in case you wish it. If you don't want it when the time of sale comes—I will send you any profit over the $1,000.00 less the dealer's commission and shipping—insurance—etc. expenses. This is only fair to you—and I'd like it said at my funeral as they said at Pennell's—He was an honest man! By the way as to dealer's commissions they have now raised them to 33⅓%. A bit stiff—but when one considers the expenses—only fair.

I am glad you like "Ship Chandler's Row" and as I told you I am very proud to have it in your collection. Thank you and Mrs. Phillips for your appreciation of my letter about her pictures. They were a pleasure to see. The time you took to decide which picture to return to me was a real compliment to me and to your taste in choosing them. You and Mrs. Phillips must pay us a visit this summer—please let me know a few days beforehand so that I will be at home. New Hope is really a lovely place.

Sincerely, in haste
Robert Spencer

Nov. 7—1926

Dear Duncan,

I am much pleased that you have bought "Mountebanks and Thieves" and will be very glad to take back "End of the Day" giving you a credit of $500.00 for it leaving $2,000.00 to be paid me for the balance on "Mountebanks and Thieves." I am very fond of "Mountebanks and Thieves" myself and am glad it is going to you. There is a certain

romanticism there that is the main keynote of my character.

It was fine to see you and your wife at Carnegie. I found the show very interesting—but it left me with a feeling that modern painting was at a rather low tide. There are fewer than usual dominant painters or men with a personal viewpoint who are able to express themselves well. Schools and fashion rule. . . . The revolution is still too young. Many thanks for the invitation to visit. Mrs. Spencer and I will surely do it before long. Perhaps you and Mrs. Phillips would stop here sometime on your way to New York.

With fond regards—

Yours sincerely,
Robert Spencer

P.S. I have the feeling that most Modern art takes too much for granted—it stutters and has too limited a vocabulary. It stops where the real test of a painter begins—that is to go beyond the sketch!

I saw a wonderful thing in Chicago—the portrait of Manet by Fantin-Latour—a complete expression of a great man—not the immature talking of a child who was afraid to spoil his masterpiece by carrying it to a conclusion.

Nov. 24—1926

My dear Duncan—

"The End of the Day" arrived in good shape—and I was glad to see it again. I owed Mr. McVitty of Bryn Mawr a 20 x 24 on an exchange and have given him "The End of the Day." He is much pleased with it. About three years ago he exchanged a larger canvas for 2 (20 x 24's) and took only one at the time—waiting until he found what he wanted for the other one—and the moment he saw "The End of the Day" he claimed it.

I also received your check for $2,000.00 making full payment for "Mountebanks and Thieves"—which I am mighty glad you have—I would rather have it in your collection than any place I know.

It is very encouraging—your appreciation of my work. Not many people understand what I am trying

to do—but every once in a while someone whose opinion I care for does—which makes the thing worthwhile.

By the way—McVitty also really understands pictures and would enjoy seeing your collection. I wonder if it would be all right for me the next time McVitty is in Washington—to give him a letter of introduction to you. He is very very shy—never says much and is on the surface—due to his shyness, unresponsive—but after one knows him—it is very different. He is a remarkably fine man and one of the few who really cares.

With best wishes to you and Mrs. Phillips—

Very sincerely
Robert Spencer

P.S. When you are in New York—why not drop in at the Hendricks . . . and see that portrait of my cousin Mrs. Ellwood Hendrick. I think it is one of the best things I have done. She would love to have you and so would Ellwood. Take Mrs. Phillips with you. It is rather badly lighted. You will sort of have to maneuver around to see it—but it is hard to light a picture in the ordinary house.

Carnegie Institute sent me a letter with the following quotation from an interview that Pierre Bonnard gave out in Paris to a French newspaper. It gives me more pleasure than the prize.

"Our task as juries lasted two days. The principal artists, well known in Europe, were represented. We toiled over the difficult task in our excellent spirit of confraternity and justice. Not one of us tried to favor his own nation to the detriment of other nations. The first prize was awarded to an Italian artist, the second to a French artist, Xavier Roussel; the third to an American artist, Mr. Spencer. The latter is in the full vigor of his talent, which is great. His art does not resemble European art, a rare fact in America."

So many people have spoken of me as being European—hence you can see how it pleased me! Please pardon the pride I have in this—but I really am pleased—as much as a child with a new toy!

Jan 2—1927

My dear Duncan,

Many, many thanks for that fine book, "A Collection in the Making." I was just on the point of ordering one from the bookseller when it came. It is a wonderful collection, and while I have known for a long time how much love and work and real genius you have put into the making of it, yet this book has brought the point home. I have always said that the true collector who collects for posterity as well as for himself is a creator fully as much, perhaps even more than, the artist himself. Collectors in your sense are rare, in fact you are about the only one I know of, so many things are necessary. Taste, sanity, breadth of vision, physical means, the creative instinct, unflagging interest. It is seldom, once in a blue moon only, that one man has them all. You are very fortunate and have done and are doing a tremendously great thing, and I am very proud of the honor of being part of it.

Very sincerely
Robert Spencer

P.S. Just as I was about to seal this—Albert McVitty called me on the telephone and proposed a trip to Washington by motor—Mr. and Mrs. McVitty—Mrs. Spencer and myself. The trip is planned for sometime during the coming two weeks—after Thursday—Jan 13th. What days are your pictures visible, and will you be at home? We expect to be in Washington just one day....I'd like to have you meet my wife and Mr. and Mrs. McVitty. Would it be too much trouble to drop me a line? With kindest regards to Mrs. Phillips and yourself, and again thanks for that book....

Jan 17—1927

My Dear Duncan—

Many thanks for your good letter. However much to our disappointment this snowstorm and cold have for the time being put the trip out of the question. McVitty is laid up and Mrs. Spencer also, and to add to our confusion, we are having troubles with maids. So we will put off the trip until toward spring when the Gods of weather and domesticity are in a more favorable mood.

In regards to your book—it may be that in not speaking of the literary style—you have been paid a fine compliment. The book is so well written and so well put together that the workmanship is not obvious. I never think—unless my attention is called to it, of the making of a fine thing—but of the content—and now that I think of it, Whistler said the same thing in regard to the sweat of the brow in painting. One is always aware of bad painting—bad writing—or bad manners. Your book reads so easily and there is so much meat and flavor in it—that one thinks only of the things said—in short the interest is so well held that the means does not matter.

However—it was not an easy thing to do. To sum up a painter's life and work in half to three quarters of a page—and to make it good reading requires nothing short of genius—and you have done it.

I had a good visit with Tack a few days ago in New York. He is really a remarkable man. I know of no other painter who has the real religious spirit and the ability to express it. His peace of mind and sureness of things is to be envied.

I am dreadfully disappointed about our trip—but it is only deferred.

With best regards to Mrs. Phillips and yourself—and hoping that the Southern trip will not be necessary—

Sincerely
Robert Spencer

November 6, 1928

Dear Spencer:

Congratulations on the splendid picture you have at the Corcoran, the "Seed of a Revolution." It is badly hung and I almost missed it and the glass made it difficult for me to see it even after I had found it. Once seen however, it is the kind of picture one does not forget. And such superb painting and such original composition! Alas for my usual state, this time it is worse because of building a permanent home just outside of the city. We are therefore out of the market and can only buy if we

have sold for an equivalent amount. I have secured three splendid Derains recently but only by sacrificing other pictures and this is never a good thing to do. I hate to ask you to trade once more but there is one picture in our group which I could part with because of its strong resemblance to another one. I refer to "The Barracks" which is not unlike the "Mountebanks and Thieves" in general tone, the relation of the figures to the background etc., etc. I would send you this picture back and pay you $500 for the Revolution if that is perfectly satisfactory. Just now "The Barracks" is out on an exhibition circuit and I can find out just where it is and have it for sale or else I can have it shipped back at once. I feel that this mob scene is so powerful and outstanding a work that we should have it if it can possibly be arranged, but the only way I can purchase it without losing another one is to sell one or two pictures consigned to dealers for that purpose.... Let me know sometime in advance of any trip to Washington so that, if possible, I can arrange to put you up in our house. It is always such a pleasure to see pictures with you.

Sincerely yours
[Duncan Phillips]

Nov. 7, 1928

My Dear Duncan Phillips,

Many thanks for your good letter. It cheered me after that abominable hanging which I can only explain by a personal [indecipherable] on the part of certain members of the hanging committee.

As to the "Seed of the Revolution" I have just written you a long letter—which I destroyed. The picture should certainly be in your exhibition. It is the one place for it. I always think of the Phillips Memorial Gallery as the Prado of America....

"The Seed of the Revolution" is the first thing I have painted since the Biddle portrait—two years ago—and it is the forerunner of a number of [indecipherable] things that I have ever done! These last two years I have literally lived in hell. You have no doubt heard of some of my troubles which have been—to be frank—domestic....

I am painting again with full force, cutting deeper and with a freedom from painting conventions that I have never had before. By that I do not mean that I have any new doctrines or method, just that I dare to say what is in my mind with conviction and a free brush and palette.... If I can now weather the present financial storm—I am sure of the future. As to the offer you have made—can we discuss it when I come to see you on the 10th or 11th....

I have an offer to make which you may prefer to the one you made me. Once again—thank you for your fine letter—with best regards to you and Mrs. Phillips—

Sincerely,
Robert Spencer

April 27, 1931

My dear Duncan Phillips,

I wonder if you and Mrs. Phillips would like to motor over to New Hope to spend a few days with us while spring is here and the daffodils are in bloom. We would be awfully glad to have you.

As to painting, I am in many ways all at sea. Not as to my own, but art in general. The art of today is as chaotic as is society. It does not seem to be going anywhere, just traveling in aimless circles at full speed. Speed and more speed, but speed with no aim. A speed which does not seem to belong to humanity. I often wonder what it all means. For all our great mechanical progress we do not appear to sleep better, enjoy our food more, our life contains no new happiness. There is a kind of inhuman quality about modern art and modern life that I cannot get the value of; I cannot see the point.

Not long ago I saw a woman's head and bust by Renoir. It gave me a great thrill. Such a wonderful appreciation of a live thing, a living woman, a lovely animal; painted for the love of youth, the love of pulsating, living flesh, the love of a thing created by God, as opposed to a thing manufactured by man. It made one want to pet it, to stroke it, as if it were a kitten. It was hard to keep one's hands off. No painter has ever appreciated the divine animal as has Renoir. No one has ever understood

the *"human animal"* or its importance as completely. *Wine* and *food* and *flesh;* the Garden of Eden before the temptation of the apple; the joy of life, of the earth for its own sake; no one knew or could talk about it as Renoir. What a joy life must have been to him, and how absolute was he in his philosophy of life.

Then I found Matisse—one of his typical women, a thing of brush strokes and intellect; and Picasso, he left me bitterer yet; not because of painting doctrine, but because if Matisse and Picasso represent life—if that is how wine and food and life should taste—the world for me is dead!

Then I found some of the pictures of cog-wheels, but they do not seem to contribute. You cannot eat them—taste them or love them. All they do is grind one....

I do not know—The Academy is dead—has always been dead. The new movement is just as dead, even more so. Of course movements and Academies never do produce art, but they do affect public opinion. Where are we going, and why? And what is the pleasure or use of it all?...Why turn from the corpse of the Academy to the Frankenstein of today—an unloved, unlovable, distorted machine....Is it time for another flood? Has man so completely forgotten God and God's purpose, the world and its normal fecundity, that nothing not made by a machine is of value? Is life worthwhile when a pill takes the place of a full dinner? Or a distorted mannequin the place of a fine woman? I grow tired of the things I make; I wonder if the world may not be the same. Does any healthy human being grow tired of the products of nature? Is it possible that after all is said and done, that God and his purpose in creating the world may exist in spite of modern philosophy? Is it possible that, after all, Nature is more right than the Professors? It would seem to me that there is a balance; the balance of spirit and matter, of brain and animal. Go too far one way, too far the other, the result is trouble, and life is bitter in one's mouth!

I saw the German show. If the world is like that, I don't want to live. And I saw our last Academy; just as bad, if not worse!

There, I should not have unloaded all this and bored you—but somehow it does seem to me time that a wholesome, sane, and happy trend occurred in art. Rembrandt, Titian, El Greco, Goya, Daumier, Renoir, Bonnard, all were landmarks in just that. Man as God made him; good or bad, and man's reaction to nature, was their song! They took man as they found him, and sang of him as they saw him. In short, they were glad to accept him just as man—sometimes happy, sometimes sad, sometimes evil, sometimes good, but always the normal product of Nature!

It may be that I am a sensualist, a man of the earth, earthy. I do not know. I love life, not motor-cars; I love women, not modern lay-figures; I love wine and food, not scientific formulas for a meal! It does seem to me that the function of man as man is of far greater importance than the function of any machine or doctrine made by man, and today the machine plays too great a part. The intellect outbalances life....

That head and bust of the woman, or of the young girl, by Renoir, was a flash of divine wisdom to me. Please give Mrs. Phillips our best regards, and do come to see us. Once in a long while it is good to empty one's heart to those who will understand.

Sincerely,

Robert Spencer

May 19, 1931

Dear Robert,

I have read and re-read your letter many times and I keep it in my pocket to remind me to answer it at the earliest moment that there is leisure. As the time never seems to come I will simply acknowledge it with many, many thanks instead of attempting to answer it with a leisurely consideration of the important matters you discuss....Of course I agree with you as to the inhumanity of any art which tries to divorce itself from life and all relations with it, and yet the unanswerable argument of the Modernists is that they are [as] entitled to be [respected] as architects or musicians [are] and equally justified

in using abstractions. We do not complain of the inhumanity of a building nor of a sonata, and both are capable of expressing the individual taste and even the emotion of their maker. In other words, it is only painting which is expected to be picturesque or reproductive. There having been more periods of art for art's sake, with plastic values paramount, than of art for life's sake. I am always pleading for the combination of humanity and plastic simplification. Most of all I plead for sincerity and for great individualistic expression. Respect for the individual and deep concern for the sanctity of human life are the two things closest to my heart.

When we get back from this trip to Pittsburgh, Marjorie and I want to see you and Mrs. Spencer. Perhaps we will motor to New Hope and perhaps we will prefer to have you come here but we must see you.

<div align="right">Ever sincerely
Duncan Phillips</div>

<div align="right">[undated, ca. July 1931]</div>

Dear Mrs. Spencer,

We appreciated so much the fine and profoundly understanding letter of your daughter thanking us for the flowers we sent. It is hard to write to you all what we feel about Robert's death. We were very fond of him and are stunned and bereaved by his death. For you and your children the loss must be terrible. I fear that he worked beyond his physical powers of endurance bringing on that nervous exhaustion to which all of us who are sensitive are subject. It is good to hear that he had just finished a masterpiece of portraiture. It had been our intention, and we spoke to him about it, to have him paint our portraits, my wife and me. We were simply waiting for a time when funds to pay for it were in sight.

He loved life with a zest and a beautiful responsiveness to its tones and flavors. His art revealed a subtle apprehension of harmonies in a minor key and of unities of mood pervaded by an unconscious wistfulness.

<div align="right">[Duncan Phillips]</div>

SELECTED REVIEWS AND ARTICLES

Sometime in his mid-thirties, after his paintings had begun to achieve some renown, Robert Spencer hired a clipping service that regularly sent him articles and reviews from newspapers around the country. Over the next fifteen years he accumulated close to 150 of these clippings that discussed his solo exhibitions at museums and commercial galleries as well as his many group shows, the latter often involving other prominent New Hope painters. Spencer never got around to organizing these clippings, and when he was asked by a Boston gallery director to provide some samples of his reviews, Spencer said, "I have stacks of clippings —etc.—but I have never kept them in any order—more shame to me—and it would take me a week to find those which may refer to these pictures."[1]

These clippings were preserved by Spencer's daughter Tink, and were part of the extensive Spencer material loaned to the Michener Art Museum by the Los Angeles art dealer Gene Mako. As Spencer suggests, the clippings are indeed disorganized. Some have complete identifying information, with the date of the article noted as well as the names of the newspaper and author. Others have one or more pieces of crucial information missing and may have only a hastily scrawled notation that lists the city or the year. In many cases the article has simply been cut from the newspaper, and there is no other information available.

The clippings provide a fascinating record of how Spencer's work was perceived by his contemporaries. One can't help but wonder if the artist might have thrown away his bad reviews, because they are almost exclusively positive. Most reviewers were intrigued by his choice of subject matter, and there are many thoughtful and even poetic descriptions of his old,

dilapidated mills and tenements. Naturally the reviewers disagreed with each other about the nature and significance of his work. One writer, for example, was bothered by the fact that Spencer didn't limit himself to literal depictions of the places he painted, and spoke of a "softness" of subject matter that left the viewer "groping for facts." Another writes about "a backbone of actuality which gives each canvas a certain touch of authenticity," while still another glowingly describes Spencer's work as a "Never-Never land" in which one "might expect almost anything of a pleasantly fairytale sort."

There was an occasional complaint about Spencer's low-key and even drab palette: "He is addicted to a key of gray which is not, to tell the truth, very beguiling." But one critic praised his canvases for having "none of the mad extravagance of those romantic painters who heap their canvases with molten jewels and with glaze upon glaze to entice the imagination," while another lauded him for his "beautiful arrangements of warm and cold grays, violets, blues, and reds" that "harmoniously blend together." As to the overall emotional tone, one article refers to the "sad minor key of poetry" in his work, while another writer was moved by the fact that Spencer could make his subjects "smile with a touch of the sunlight."

In fairness to these critics, there is indeed a great deal of variety in Spencer's work; the emotional tone and the palette are sometimes bright, sometimes muted. And in his earlier work he was much more literal in his depictions of Bucks County buildings, but toward the end of his life he often created his subjects completely from his imagination. Overall the reviewers were remarkably perceptive, even discerning

one of his literary heroes ("There is a little touch of Dickens" in his subjects), and often accurately observing the level of imagination in his later work: "these places that the artist has built exist because they exist in his imagination" and "one feels they were created in the artist's brain instead of being reproduced in the whole from any one place."

Excerpts from the clippings are printed here in chronological order, with undated articles grouped at the end.

BHP

NOTE
1. From an October 5, 1925, letter from Robert Spencer to Sidney C. Woodward. Archives of American Art, Sidney C. Woodward Papers.

The Philadelphia Public Ledger, November 19, 1916, author unknown

"At the Arlington Galleries the work of Robert Spencer, of the Delaware Valley School at New Hope, still continues. Writing of these a New York critic remarks: 'Nearly all have to do with subjects drawn from the life of the mills, and the artist's silvery tonalities and bland, discreet workmanship more or less conceal his close attention to prosaic fact.' He approaches his rectangular brick buildings in an idyllic mood, caressing their flat, weather-worn surfaces with a tender brush. His picture *The Closing Hour* won a gold medal at the Panama Pacific Exposition last year and deserved a more exclusive honor. His un-bemedaled *Courtyard at Noon* is in some respects the most interesting picture in the room. The rather difficult composition presents problems that are solved with an appearance of ease, and the color, while bringing out the shape of the objects, has an ingratiating quality of its own."

New York City Evening Mail, November 1916, date and author unknown

"Robert Spencer is known to New York picture lovers chiefly through the few paintings of mill town scenes shown in the National Academy of Design. ...In his first independent exhibition here in the Arlington Galleries he shows himself to be a painter of infinitely varied artistic resources of which we have had only a partial glimpse before this. In addition to his Pennsylvania mill town scenes, he shows landscapes that reflect the best Gaelic influences and some studies of mill workers at leisure that are extraordinarily fine. There are passages of painting in some of his views of workmen's houses that vie with the greatest of modern work in quality, in addition to which they are marked with a grave kind of beauty that gives them a place apart from most contemporary American art. It is no wonder that Mr. Spencer has won all the prizes that have come to him in the few years he has been exhibiting. As a rule, art prizes are not so worthily awarded."

New York World, 1916, date and author unknown

"Although he has won medal honors in the National Academy and elsewhere, Robert Spencer is making his first appearance in this city in a gallery exhibition, in the Arlington Galleries...and the event is proving very attractive to his comrades of the brush, for he is essentially an artist's painter. His exhibition shows why the others like him. One may well suppose that his grasp of subject is definite before he approaches the canvas, and he can thus apply himself boldly and without hesitancy to what he wishes to express. His command of technique is reinforced by a fertile fancy. However long he may work at a canvas, it invariably looks at the finish as if there had been no break in the continuity of its production....

"*Three Houses* is an example in which the artist's skill has depicted simply and with singular fidelity the varying wear of weather on tenements of the same age ranged along the bank of a canal."

Unknown St. Louis newspaper, February 11, 1917, author unknown: "Spencer Paintings Now Exhibited at City Art Museum—Collection Includes Commonplace Subjects Which Possess Special Charm, Winning Prizes"

"Much interest has been aroused by the collection of 20 paintings by Robert Spencer, which is on exhibition at the City Art Museum.... The paintings by

Spencer being shown are princely views of old time-stained factory buildings and mills, tall rickety tenements, tenement courtyards and similar subjects. These, however, he paints, not with the atmosphere of grime and squalor, which is usually associated with industrial regions, but with the warm sunshine of summer caressing old lichen-covered factory walls and sparkling over grass and foliage. His composition *Five O'clock June,* for instance, has a certain lyrical, almost joyous quality, with its brilliant sunlight, its warm green foliage and its groups of gaily-clad operatives, despite the fact that the subject represents nothing more romantic than the closing time at a factory. . . . Mr. Spencer's pictures are painted in an Impressionistic style, somewhat similar to the technique of certain modern Frenchmen. The colors are applied with a short, precise stroke of the brush, and viewed at the proper distance, they mingle and vibrate in a way that produces all the illusion of a transparent, enveloping atmosphere."

The Democrat Chronicle, Rochester, New York, April 15, 1917, author unknown: "Novel Group of Paintings—Those of Robert Spencer are of Tenements and Factories"

"A group of 20 or more paintings by Robert Spencer has just been added to the exhibition at the Memorial Art Gallery, and is one of the most interesting as well as important features of the present display. . . . In selecting factories and tenements for his theme, Mr. Spencer has obviously taken the hard rather than the easy way to 'picturesqueness.' These buildings in themselves have nothing of the picturesque that makes them pleasant to look upon. They are the most uncompromising of bare walls, often without so much as a tree or bush to soften their outlines. They express first and last their proper function as factories and tenements. What his pictures say, in effect, is that ugly dwellings and the life and labor that center in them have in the scheme of things fully as great a beauty and dignity as any other phase of nature, and offer to the artist just as fine an opportunity to express himself in color and line and form."

The Buffalo News, Saturday, March 2, 1918, author unknown: "Fine Canvases of Americans Much Admired —Garber, Lathrop and Spencer Pictures in Albright Gallery Excellent Examples of Modern Art"

"The exhibition of the paintings of Garber, Lathrop and Spencer at the Albright Art Gallery is proving of great interest to the people of Buffalo. These fine canvases indicate what the modern American artists are doing and prove that American art takes a worthy stand with the art of other countries."

The New York Tribune, February 29, 1920, by Royal Cortissoz

"Mr. Robert Spencer, who is making an exhibition at the Arlington Gallery, is hardly to be characterized as a Whistlerian. . . . He does not work the magic that Whistler had in mind, yet he aims at something akin to it. He paints the dull buildings along sordid waterfronts, he paints the drab walls of ugly tenements, and by quality of talent and a certain originality he seeks to give them an artistic investiture. He is addicted to a key of gray which is not, to tell the truth, very beguiling, and we think it handicaps him in his pursuit of an admirable idea. To see several of these pictures of his together is to find them a little mannered and monotonous. But let the observer turn to some of the smaller canvases . . . immediately one sees that this artist is after all on the right path, having a vision of his own and giving it convincing form. He wins us, too, in those pictures of his which are filled with deftly painted leafage, the green of which is given its full value. We wonder here and there if he has not, perhaps unconsciously, been influenced by such painters as Willard Metcalfe and Childe Hassam, but in the long run we feel that the vitality of his art springs from an altogether individual source."

Unknown New York City newspaper, March 6, 1920, author unknown: "Personalities in Artists"

"A visit to three exhibitions in an afternoon left the impression that American painters are approaching the world which is theirs to paint with considerable originality. . . . To the poorer sections of the town

Robert Spencer goes also with his paints and with his gift. In an exhibition of his work at the Arlington Galleries he has painted the rundown districts of Dutch Pennsylvania. He has painted the derelict houses and sordid waterfronts. Yet this world, as he visions it, is not sordid, for through his art there runs a sad minor key of poetry utterly lacking in [John Sloan's] ardent dramas. He sees the quiet, poverty-stricken life as might some young poet of the people. The everyday scenes are not seen in caricature as an outsider would see them. Even a tumbling tenement, with its scrambling humanity, is painted with this rare quality of sympathetic understanding. Absolutely clean of sentimentality, his art has the great quality of sentiment."

Unknown New York City newspaper, April 8, 1920, by Peyton Boswell: "Art Academy Has Record Exhibit" (review of National Academy of Design exhibition at the Brooklyn Museum)

"The Second Altman landscape prize went to Robert Spencer for *The Green River*, an exquisite work done in his characteristic manner, by the use of little rectangles of color in juxtaposition. This work has the beauty of a fine piece of textile, and is a worthy successor of The Silk Mill, by which the artist first won recognition in 1913, when he was awarded the second Hallgarten Prize."

The New York Times, 1920, date and author unknown: "Paintings by Robert Spencer"

"Robert Spencer's painting has qualities of surface that recommend it to his fellow technicians. In his exhibition at the Arlington Galleries there is ample opportunity to watch his delightful manipulation of his pigment which gives him so much for so little. He has none of the mad extravagance of those romantic painters who heap their canvases with molten jewels and with glaze upon glaze to entice the imagination. The layman readily might conceive that Mr. Spencer cared very little for his material. He scrapes off all superfluity of paint and produces his effect with an amazing economy of physical substance. But no one intimately acquainted with the ways of pigment

FINE CANVASES OF AMERICANS MUCH ADMIRED

Garber, Lathrop and Spencer Pictures in Albright Gallery Excellent Example of Modern Art.

The exhibition of the paintings of Garber, Lathrop and Spencer at the Albright Art gallery is proving of great interest to the people of Buffalo. These fine canvasses indicate what the modern American artists are doing and prove that American art takes a worthy stand with the art of other countries.

Robert Spencer's pictures are landscapes and scenes in the work-a-day world. He was born in Harvard, Neb., and is a member of the National Academy of Design, New York. He is represented in the Metropolitan Museum of Art, New York, and in other galleries.

Among the prizes he has received may be mentioned the Inness gold medal, National Academy of Design, New York, and the second Hallgarten prize, National Academy of Design.

Figure 1 Newspaper clipping from *The Buffalo News*, March 2, 1918. Courtesy of Gene Mako Galleries

could fail to observe the affection of his delicate craftsmanship. He weaves a fabric-like lace—lace in which are caught little primitive patterns of life among laborers."

International Studio, March 1923, by F. Newlin Price: "Spencer—and Romance"

"So we might call this painter of back-yards a great romancer, who built around some gray and gloomy corner of the land a sort of hallowed romance of places better than the real. Certainly he interprets beauty that to most was quite invisible.

SPENCER PAINTINGS NOW EXHIBITED AT CITY ART MUSEUM

Collection Includes Commonplace Subjects Which Possess Special Charm, Winning Prizes.

Much interest has been aroused by the collection of 20 paintings by Robert Spencer, which is on exhibition at the City Art Museum. Mr. Spencer was a pupil of Chase, Du Mond, Henri and Garber, and his works have in recent years won awards in art shows all over the country. He belongs to the well-known group of painters residing at New Hope, Pa., whose work is regarded by many as the beginning of a new school of American art. Two of the New Hope painters, Daniel Garber and W. L. Lathrop, are represented in the permanent collection of the museum.

The paintings by Spencer being shown are principally views of old, time-stained factory buildings and mills, tall rickety tenements, tenement courtyards and similar subjects. These, however, he paints not with the atmosphere of grime and squalor, which is usually associated with industrial regions, but with the warm sunshine of summer caressing old, lichen-covered factory walls and sparkling over grass and foliage.

COMMONPLACE SUBJECTS.

His composition, "Five O'Clock, June," for instance, has a certain lyrical, almost joyous quality, with its brilliant sunlight, its warm green foliage and its groups of gayly-clad operatives, despite the fact that the subject represents nothing more romantic than the closing time at a factory. Mr. Spencer was awarded a gold medal for this composition at the Pennsylvania Academy of the Fine Arts in 1914.

Dealing with the same subjects and treated in the same individual manner are the canvases, "One O'Clock" and "The Closing Hour," which was awarded a gold medal at the Panama-Pacific International Exposition.

Mr. Spencer's pictures are painted in an impressionistic style, somewhat similar to the technique of certain modern Frenchmen. The colors are applied with short, precise strokes of the brush, and viewed at the proper distance, they mingle and vibrate in a way that produces all the illusion of a transparent, enveloping atmosphere.

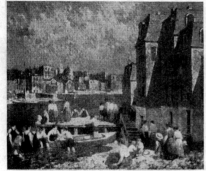

EXHIBITION AND SALE
OF
OIL PAINTINGS
BY
ROBERT SPENCER, N. A.

The Bathers

October 26 to November 14, 1925

THE CASSON GALLERIES
575 BOYLSTON STREET
COPLEY SQUARE
BOSTON

LEFT Figure 2 Newspaper clipping from an unknown St. Louis newspaper, February 11, 1917. Courtesy of Gene Mako Galleries
RIGHT Figure 3 Exhibit announcement, The Casson Galleries, Boston, 1925. Courtesy of Gene Mako Galleries

"'I don't care whether the building is a factory or a mill; whether it makes automobile tires or silk shirts,' says Spencer. 'It is the romantic mass of the building, its placing relative to the landscape and the life in and about it that count. People ask me what is made in my mills. Damned if I know.'

"Back-yards are genuine, unpretentious.... Every brick, every angle, every opening in a mill means something, especially if the mill be old. The stains on the walls, the broken places are landmarks of battles with storm and sunshine, with man-made machines, with time. Every workman, every year leaves some impression of himself or itself, and how rich in this sort of thing is an old tenement, each succeeding family leaving its mark, until the very structure becomes human and fits into the moods of the town."

Unknown newspaper, 1923, date and author unknown

"Spencer presents the rare type of painter whose intellectual and emotional powers are at a true balance in his work.... He never succumbs to the grand gesture of propaganda by emphasizing the individual characters, nor does he make them merely spots of color against the dull colored mills. Spencer seems to visualize his mills and his people as inseparable. He imparts to the mills the impress of the people who have dwelt within their walls. They partake of the dignity of human beings' work. The immediate people, in turn, that Spencer uses, seem to share the ancient dignity of the mill. His compositions are so well designed, his color so fitting, that he achieves a performance that, on study, may be recognized as superb."

Unknown New York City newspaper, April 11, 1925, author unknown: "Robert Spencer at Rehn's"

"An interesting group of landscapes by Robert Spencer is now on view at the Rehn Galleries.... This American painter has a unique manner of imaginative landscaping which more or less weakens the interest in his work on the one hand, and gives a certain piquant flavor on the other.

"There are certain elements of river, shore, and architecture that invariably find themselves in a Spencer composition, and they are grouped and regrouped for the various scenes with considerable dexterity and variety. In practically all cases there is a backbone of actuality which gives each canvas a certain touch of authenticity. But the real question is whether or not Mr. Spencer's style and techniques are sufficiently elastic to support the often weighty superstructures that he raises on his thematic foundations.

"These landscapes are pleasant pieces of painting, of that there is no doubt. Charm of color, buoyant mood, and good taste in design all make Spencer's work appealing. But there is a softness of subject matter that stands very conspicuously in the way of these pictures ever acquiring the forcefulness that they should rightly have. They leave the

spectator groping for facts after the initial pleasure has subsided."

The New York World, April 12, 1925, author unknown: "Robert Spencer" (review of exhibition at the Rehn Galleries)

"Robert Spencer, soon after his earlier successes, developed a rather fixed formula for his painting. It was an agreeable way of painting with a pleasant personal touch, but repeated too often in exactly the same mood it became slightly monotonous. It is, therefore, pleasant to find in the present exhibition that a refreshing influence has come into Mr. Spencer's painting. There is more light, more air, more vividness in his work, and the same affection for the quality of old buildings and unusual urban settings remains. This artist composes his pictures without feeling the restrictions of a specific place and has imagination in improvising his scenes."

The New York Times, April 1925, date and author unknown: "Imaginative Landscape"

"Robert Spencer is exhibiting work of the last four years at the Rehn Gallery. He lives in a world of his own, takes a house from here and a bridge from there and reconstructs a picture amazingly full of reality. These places that the artist has built exist because they exist in his imagination. There is a little touch of Dickens in them and something of central France, though Mr. Spencer has never been to either France or England.... His early technique depended to a certain extent on something of a formula he had arranged for himself. Trees should be painted so and water so. He has freed himself from these rigid rules.... He is a most exacting craftsman."

The Pittsburgh Post-Gazette, October 4, 1925, by Penelope Redd Jones: "Canvases of Five American Painters on View Downtown" (review of exhibition at the Carnegie Institute)

"Robert Spencer, in the Gillespie exhibit, shows consistent growth in his style. Spencer has already achieved a reliable prestige in a convincing por-

trayal of the old stone buildings to be found in the Delaware River Valley.... Spencer's gradual departure, from a type of painting wherein there was no obvious story-telling element, toward a style of painting which braved the shallows of the sentimental, has been accomplished without detriment to his authentic aesthetic merit.... Robert Spencer, who troubles not at all about critics, has done an invaluable good by compelling one to meditate upon the perfunctory manner with which episodes and life are generally dismissed as subject matter for the painter."

A Collection in the Making, by Duncan Phillips, The Phillips Collection, Washington, D.C., 1926, p. 67

"There is no other painter, not John Sloan nor even Edward Hopper, more pungently American in expression. *The Evangelist* is a masterpiece of American genre. It would be difficult to find a picture in which a restless crowd has been represented with as much conviction and as little confusion. The contrast between the mellow lyric light of a summer afternoon and the austere silhouettes of the preacher and the platform is very poignant.... His friend Daniel Garber influenced his choice of subjects and induced him to settle at New Hope, Pa. There he found motifs for the dream-towns he could build with his pigments, mill towns traversed by a sleepy canal, populated by men, women and children whose lives he would suggest with genuine sympathy. This he has done with ever increasing skill so that now he has become the philosopher and the laureate of the little American industrial village, painting again and again its old houses, its mysterious factories, its 'types' coming out of the mill at the noon whistle and its 'Society of the Door Steps.'

"Spencer is a philosopher glad to leave the pageantry of life to others, content to have found a hidden vein of beauty, which is his particular legacy. It is his aim to paint old walls of brick and stone and peeling plaster which tell tales of human habitation. ...In such a picture as *Ship Chandler's Row* every inch of the surface and every contour of form are delectable in themselves and at the same time inseparable

from the color-mask and the form-organization of the canvas as a whole. Harmonies of shell blue, shell violet, shell pink, bone color and black, with repetitions of shapes, fuse into a subtle symphony. Spencer has a great deal to say about the unrecognized beauties of life and all the while his art becomes more important in its orchestration of functioning lines and muted closely related colors."

The Philadelphia Public Ledger, October 14, 1926, author unknown: "Penna. Artist Wins Second Honor in Week—Robert Spencer Captures Third Prize at Carnegie International Exhibition"

"For the second time this week the lightnings of fame have played round the head of Robert Spencer, Pennsylvania painter. At Pittsburgh, on the eve of today's opening of the 25th International Exhibition of Paintings at the Carnegie Institute, it was announced that the International Jury of Awards has conferred on Mr. Spencer, Nebraskan by birth but now living at New Hope, Pa., the highest honors awarded for any of the 106 American works included in the 378 canvases. And it was only last Sunday that announcement was made that Mr. Spencer had received one of the seven gold medals conferred by the Sesqui for paintings and oils by American artists."

The History and Ideals of American Art, by Eugen Neuhaus, Stanford University Press, Stanford University, Calif., and Oxford University Press, London, 1931, p. 270

"Among those who in recent years have come to the fore, no more original and capable artist may be found than Robert Spencer (1879–), a Nebraskan by birth, and trained under Chase, DuMond, and Henri. His homemade subjects are striking evidences of the picturesqueness of the small American city. It is surprising and gratifying alike to find an artist courageous enough to follow his artistic convictions and paint the busy backyards of the crowded sections, factory districts teeming with life, and all the various out-of-the-way corners of the much-maligned American city and yet succeed in striking a note popular with artists and public alike.

"Spencer's technique and color no less than his fine sense of design are undoubtedly what have enabled him to create works of art out of the commonplace. Homely subjects under his hand become appealing and interesting to an unusual degree. His technical means are well adapted to the surface variations of the dilapidated brick structures, the outhouses he so loves to paint. With a playful and nervous touch he creates charming and varying surfaces that attract and hold one's attention like a beautiful embroidery. His color is personal and most distinguished. Beautiful arrangements of warm and cold grays, violets, blues, and reds harmoniously blend together to form many different objects which he includes in one canvas, and the atmospheric truthfulness of his work is a proof of his fine sense of observation, as well as of his power to create fine color harmonies of very subtle quality. In opening our eyes to the beauty of our American world, Spencer is rendering a fine service to American art...."

New York Herald Tribune, Sunday, July 19, 1931, author unknown: "The Late Robert Spencer"

"Robert Spencer...contributed materially to the strength of American art during the closing years of his career as a painter. His work was well regarded by his colleagues in the conservative ranks of painters and by various museum and private collectors who own his pictures....As a painter Robert Spencer was notably serene. This was true despite the fact that in many of his canvases he revealed a keen interest in life, which included in its radius the laboring classes and suggested innate sympathy with their struggles and aspirations. The growth of these tendencies, however, seems to have been gradual, for in many of his earlier works the background of American life rather than life itself, is the foremost consideration....

"In such paintings as *The Exodus* and *The Seed of Revolution*...the same rather drab background persists to a certain extent, but the 'medley of figures' assumes a more salient dramatic import. His thoughts are more profound, more attending upon problems of human nature and social unrest....But

though his title suggests the warmth of a slumbering emotion, Mr. Spencer seldom aroused himself into a white heat of passion over his social thesis. It was not in him, apparently, to be terrified. What he did was paint the idea of revolt rather than the thing itself in all its fierce intensity. But his pictures are honest and convincing, nevertheless."

A Bulletin of the Phillips Memorial Gallery, October 1931–January 1932, by Duncan Phillips: "Un-selfconscious America," pp. 28–29

"*The Evangelist,* by Robert Spencer, recalls another American experience of fifty years ago, when the artist as a boy drove with his father, a Swedenborgian revivalist, from little town to little town for these outdoor meetings by the side of a river. Spencer's tragic death during the past summer will revive interest in a distinguished personality or in qualities of genial kindliness and mellow humor blended with a persistent melancholy. His art of sensitive and subtle tones puritanically repressed, did not quite conceal an underlying seriousness and a longing for abundant life. Spencer's lyrics of small towns and of old houses, of plain people passing the time of day in and about their places of toil or rest were based on French classic compositions and French Impressionist ideas and technique. And yet Spencer was an individualist of a peculiarly American self-reliance. Conservative? Certainly. He could not see the new theoretical ways, and naturally he resented a School which obscured his own predilections and purposes. Academic? Quite the reverse. He was a rebel always against the standardized and the stereotyped in art. Sadly he recognized and vigorously he denounced the expansive power of our mass mediocrity. Yet he loved America all the while, and he is one of our truly national painters."

Philadelphia Public Ledger, letter to the editor, year unknown, signed: Birge Harrison, N.A., New Hope, Pa., March 22

"To the Editor of the Philadelphia Public Ledger:

"Sir—In your issue of Tuesday, March 20, there appeared an editorial devoted to the painters of the Delaware Valley, who have made for themselves so notable and distinguished a place in the art world of the United States. In perusing this article I was somewhat surprised to notice that no mention was made of one of the justly celebrated members of this group, Mr. Robert Spencer. As Mr. Spencer's work is widely known throughout the country, having received almost every first medal and prize at the disposal of the various museums and art exhibitions everywhere, the writer of the article in question would seem to have displayed either lamentable ignorance or such personal animus and prejudice as should not be permitted in the columns of a journal as well known as *The Ledger* for its broad-minded fairness upon all topics of general interest.... Inaccuracies such as this are no credit to a great newspaper—if they are simply inaccuracies—and still less credit if they are due to a personal grudge on the part of the writer."

The Christian Science Monitor, date and author unknown: "New York Art Exhibitions and Gallery News"

"[Spencer] is a master manipulator of soft blurs and misty spots of many hues, that croon rather than 'sing' together. When the sun does shine, as in *Village Lane, Across the River,* or the languid late afternoon of *The Closing Hour,* it is a tranquil, pale golden sunlight, which he expresses very much as Claude Monet would express in paint brush terms, a similar glow of gladsome peace and serenity. Everything is broadly and sketchily noted, but at the same time sensitively felt and carefully observed."

Unknown newspaper, date and author unknown: "Spencer"

"It is often declared by both artist and layman that we in America have no national art, that our painters do not portray American subjects. If this is the case, Robert Spencer is an exception. Near his peaceful home on the Delaware River in New Hope, Pa., he finds his pictures, usually painting the factories there or the river scenes along the Delaware Canal. ...He makes us feel the pathos and drabness of mill life. Even the brick walls tell their story. They are old, worn, chipped, with the paint blistered and peeling off—the walls of the earlier factories of

America which have been used for years and years and on which little money has been expended....

"Robert Spencer peoples his canvases with the typical, small town millworkers; men and women of the peasant type, heavy in build and slow in movement and thought, expecting like their foreign ancestors, to toil for their daily bread. About them hangs an atmosphere of patient living without much pleasure."

Unknown New York City newspaper, date and author unknown

"Robert Spencer and three other artists of the so-called New Hope group make up the current exhibition at the Milch Galleries.... Robert Spencer first attracted attention six or seven years ago when he won a prize at the National Academy of Design with a homely subject, the exterior of a silk mill, that struck a new note in American art. It was a sober picture, of a gray tonality, but because of its peculiar technique, with little swipes of pigment, it fairly vibrated with gentle light. Added to this was the commonplaceness of the theme, about which Mr. Spencer wove a very manifest interest.

"It is upon this style that the artist has built. He has been true to his first love, inasmuch as his pictures all show a homely appreciation of rural and small town life, but of late he has been putting more of beauty and more of vitality in his color, and the result is the progress that the public looks for in a young artist's work."

Unknown New York City newspaper, date and author unknown: "Robert Spencer"

"Robert Spencer is showing paintings at the Rehn Galleries. Mr. Spencer is an Impressionist who has apparently aligned himself with a tradition so that he may be more free to express his own reaction to the visible world.

"One has grown accustomed to his canvases of rivers washing the banks of old towns with high storied houses—strange presentiment of unreality clothed in the outward phenomena of factories and tenements. There are a number of these canvases here. Such is *Flowing Water*, with its gray houses as

foil for the fronds of green trees and the flowing of the placid stream giving a note of life to this tranquility."

Unknown New York City newspaper, date and author unknown

"To Robert Spencer, a young American painter, has been given that gift of the gods which enables an artist to see beauty where one might least expect to find it. To the casual observer there seems little charm in box-like factories and the tenements of the poor, even when the June sunshine falls across them and the workers are gathered in picturesque groups in the sunshine or in the cool dampness on the shady side of the buildings. Yet it is by the inspiration of such subjects that Spencer filled the Arlington Galleries during November with canvases which reflect the ever-changing moods of nature in the same spirit in which Monet and other of the French Impressionists first saw and pictured their fleeting changes. Like these earlier painters of the out-of-doors, Spencer tries to catch the varying beauties of nature, remembering that trees and clouds and sunshine no more stand still for their portraits than do the shifting groups of factory workers, who unconsciously make kaleidoscopic patterns of changing color and fantastic shadow."

Unknown Milwaukee newspaper, date unknown, by C. Burnham

"Among the landscape painters of America, few men have gone further in evolving a poetic and individual interpretation of the everyday aspects of houses, streets and waterfronts than Robert Spencer, fifteen of whose canvases form the new January exhibition at the Milwaukee Art Institute. There is a marked similarity among many of these paintings, quite as if they were all variations of a single theme which represented the artist's favorite view of nature.

"This theme, as those of you who saw the paintings by Mr. Spencer shown at the Art Institute last summer will remember, consists of a composition in which tall, flat-surfaced buildings form the outstanding motive. Most of the canvases, to be sure,

are enlivened with groups of people standing or sitting in doorways, walking up and down the waterfront or emerging from dark doors. But the interest remains the same—a pattern of tall structures outlined against a cloudy sky arising above the waters of a river or a canal.

"They are imaginative compositions, at once intimate and remote, for one feels they were created in the artist's brain instead of being reproduced in the whole from any one place. By throwing the veil of his own poetic point of view over familiar scenes, Mr. Spencer has not only revealed a new beauty in them but has recreated them for his own purposes.

"Even the color harmonies have a subjective quality, as if they, too, were evolved much as the composition itself is evolved, through a subjective process in which the 'inner eye' of the artist gives expression to color and notes felt rather than seen."

Unknown Milwaukee newspaper, date unknown, by J. K.: "Spencer is Giving Show at Gallery—Unusual Experience Awaits Those Who View the Unique Art of Famous Painter"

"Imaginative and sensitive paintings by Robert Spencer have replaced Philip Hale's work at The Art Institute, and even in the holiday rush have been viewed by many. Mr. Spencer has a place peculiarly his own among American painters. One critic, writing of his work, said that he had passed through several phases of realism to evolve a sort of 20th century romanticism: 'Possessed of an alert eye and an imaginative logic, he evolves from existent notes in nature, new harmonies, which are very personal.' To elaborate, Mr. Spencer for the most part paints scenes that do not exist and presents them with a tender realism, a glamorous matter-of-factness. . . ."

The New York Herald, date and author unknown
"Mr. Spencer doesn't need pinnacles for picturesqueness. His canvases abound in rectangles—flat facades, as of old mills or deserted warehouses, with many windows shallowly placed—and yet he so paints them that one seems to be going around a corner with the artist and suddenly coming upon them in a territory that one only enters when the light is just

right or the visions slips into some nook that fits between the known dimensions and another.

"It's quite impossible to describe this eerie feeling when one looks at his pictures. There's no apparent reason for it. Everything seems quite usual; the buildings are solid affairs, foursquare and wholly un-ghostlike; the surrounding landscape might be met in many a familiar American scene; and yet there's a faint creepish feeling along the spine, as though one had entered some Never-Never land and might expect almost anything of a pleasantly fairytale sort."

Unknown Boston newspaper, date and author unknown: "Saint Botolph Club—Exhibition of Paintings by a Strong Pennsylvania Group of Artists, Messrs. Garber, Lathrop and Spencer"

". . . Robert Spencer paints the most squalid and ugly sort of things and brings out a sort of beauty in them, a sort of romantic quality—which is a remarkable stunt. . . . Out of the grime and smoke and deadly commonplace of the mills, the ugliness of the tenement houses, the sickening squalor of a row of unpainted shacks lining the farther side of a canal, he manages to extract the 'fleur du mal,' the blossom of beauty emerging from the slime of the gutter. Not only is this a great achievement, it is worthwhile, very well worthwhile. . . . There is little merit, Spencer seems to say to himself, in being cheerful and happy when all's going well; but watch me when I am surrounded by gloom and shadows and squalor and ugliness! There's nothing so hopeless, so repulsive, but I can make it smile with a touch of the sunlight, or bring out some latent charm and interest in its local color."

BRIEF CHRONOLOGY

Figure 1
Charles Rosen
(1878–1950)
Robert Spencer 1914
oil on canvas
30 × 25 inches
National Academy
of Design, New York

1879 Born, in Harvard, Nebraska, to Solomon Hogue Spencer and Frances Strickler Spencer; father was an itinerant Swedenborgian minister, and as a boy Robert lived in Illinois, Missouri, Pennsylvania, New York, and Virginia.

1899 Graduates from high school in Yonkers, New York; begins his art training at the National Academy of Design in New York City; later studies at the New York School of Art.

1906 Moves to the Bucks County area, residing for several years in communities along the Delaware River.

1909 Spends the summer living and studying with Daniel Garber at Garber's home Cuttalossa; takes up residence in the Huffnagle Mansion in New Hope with painter Charles Ramsey. Exhibits at the National Academy of Design.

1910 Exhibits at the Philadelphia Art Club, the Carnegie Institute International Exhibition, the Corcoran

Gallery of Art, and the Pennsylvania Academy of the Fine Arts.

1914 Sells the painting *Repairing the Bridge* to the Metropolitan Museum of Art; wins the Jennie Sesnan Gold Medal for the best landscape in the Pennsylvania Academy of the Fine Art's Annual Exhibition; wins the Inness Gold Medal at the National Academy of Design; marries the architect and painter Margaret Fulton at the home of William L. Lathrop in New Hope.

1915 Wins a Gold Medal at the Panama-Pacific International Exposition, San Francisco; builds a house called Willow Brook Hill near the Delaware River just north of New Hope, designed by his wife; birth of daughter Margaret (Tink).

1917 Receives solo exhibitions at the St. Louis Art Museum and the Syracuse Museum of Fine Art.

1918 Begins his correspondence with Duncan Phillips; birth of daughter Ann.

1920 Elected an Academician of the National Academy of Design.

1922 Spends the first of several summers in Wainscott, Long Island.

1925 Travels to Europe for the first time, visiting France, Spain, and Italy; teaches briefly at the Pennsylvania Academy of the Fine Arts' studio in Chester Springs, Pennsylvania.

1926 Wins a Gold Medal at the Sesquicentennial International Exposition, Philadelphia.

1927 Travels to France.

1928 Wins the Isidor Gold Medal at the National Academy of Design; wins Gold Medal at the Art Club of Philadelphia.

1929 Travels again to France, staying for a year and a half.

1931 Commits suicide at the age of fifty-one in his studio.

APPENDIX I

RECONSTRUCTED EXHIBITION RECORD

Many artists are careless about the details of their careers, leaving the record-keeping and even procurement of exhibits either to family members or to posterity. But there is strong circumstantial evidence that Robert Spencer kept excellent records: he never repeated a title of a painting, for example, and his daughter Tink was able to assemble from his records an accurate list of more than two hundred canvases, organized by date, with the price paid for each one sold. While this list has survived, most of the original Spencer material (including his journal) was destroyed in a 1971 fire in Tucson, Arizona.

It is not known if Spencer maintained a comprehensive listing of his exhibition record. All that remains of his extensive exhibit history are the partial list of honors and awards compiled by his wife (see Appendix 2), the published records of his participation in the major annual exhibitions (see Appendix 3), and the source material for the earlier section of this book entitled "Critical Responses to the Work of Robert Spencer: Selected Reviews and Articles." These printed pieces, mostly from newspapers, also constitute a kind of exhibition record for Spencer, a record that is no doubt inaccurate in the details. Newspapers are notoriously unreliable as research documents, yet sometimes they're the best source we have, and that is the case with Spencer's exhibit history.

This appendix represents our effort to reconstruct a partial exhibit record for Spencer from these newspaper articles. Organized chronologically, the material includes the location of the exhibit, paintings shown, and the "context," that is, the nature of the exhibition and the names of other artists who participated. In general the information appears as it was in the source article; when possible, we've corrected misspellings of artists' names, and in some cases we've been able to provide the geographical location of a gallery or museum when that information was missing. We have not attempted to track the changes in institutional names that occurred over the years; museum and gallery names are presented as they appeared in the reviews.

I am greatly indebted to Michael Jaeger Smith, who spent many hours during the summer of 2003 organizing and compiling the relevant information in nearly 150 reviews and articles about Spencer.

BHP

Exhibition of Paintings

by

ROBERT SPENCER

APRIL 6 TO APRIL 27
1925

AT THE GALLERIES OF

FRANK K. M. REHN
693 Fifth Avenue
BETWEEN 54 AND 55 STREETS

Figure 1 Exhibit announcement, Rehn Galleries, New York City, 1925. Courtesy of Gene Mako Galleries

Date	Location	Painting(s) Exhibited	Context
December 1913	Club Galleries, New York City		Group exhibition
1913	New York City		Group exhibition
March 1914	Fine Arts Society, New York City		Group exhibition
1915	Art Club of Philadelphia		Group exhibition
1915	Vanderbilt Gallery, New York City		Group exhibition with Douglas Volk, Joseph T. Pearson Jr., Charles Rosen, Luis Mora, and Joel Levitt
July 1916	Mahoning Institute of Art, Youngstown, Ohio		Group exhibition with Daniel Garber, R. Sloan Bredin, Morgan Colt, W. L. Lathrop, and Charles Rosen
October 1916	Philadelphia Art Federation		Group exhibition
November 1916	Arlington Galleries, New York City	*The Closing Hour, Village Lane, Three Houses*	Solo exhibition
December 1916	Art Institute of Chicago	*Barracks*	Group exhibition
December 1916	State University Library, Columbus, Ohio	*The Closing Hour, Courtyard at Noon*	Solo exhibition
February 1917	National Arts Club, Philadelphia		Group exhibition with William Chase, Robert Henri, George Bellows, Gardner Symons, E. L. Blumenschein, Oscar Fehrer, Ritschel, C. M. Dewey, and Ben Foster
February 1917	St. Louis City Art Museum	*The Closing Hour, Five O'clock June, Courtyard at Dusk, The Peddler's Cart, Grey Mills, The Silk Mill, The Blacksmith Shop, Three Houses, One O'clock*	Group exhibition with Maurice Sterne

Date	Location	Painting(s) Exhibited	Context
March 1917	Gibbes Memorial Art Gallery, Charleston, South Carolina		Group exhibition
April 1917	Memorial Arts Gallery, Rochester, New York		Group exhibition with A. C. Wyatt
May 1917	Charleston, South Carolina, Art Association		Group exhibition including Charles Rosen
June 1917	Detroit Museum of Art	*On the Canal, New Hope*	Group exhibition
April 1918	Rhode Island School of Design, Providence		Group exhibition with Daniel Garber and W. L. Lathrop
May 1918	Arlington Galleries, New York City	*Mill Door*	Group exhibition with Ernest Lawson, Walter Griffin, and J. Francois Murphy
May 1918	Philadelphia Art Club	*Waterloo Place*	Group exhibition
August 1918	Albright Gallery, Buffalo, New York	*The Auction, The Closing Hour, The Black River, Rats Castle*	Group exhibition with John Sloan, Albert Sterner, Dwight W. Tryon, and Douglas Volk
May 1919	Ferargil Galleries, New York City		Group exhibition with Charles Rosen, John Folinsbee, W. L. Lathrop, Childe Hassam, Elmer Schofield, and Harry Waltman
March 1920	Arlington Galleries, New York City	*The Evangelist, The Green River, The Passing Boat, A Street Corner, Derelicts, Warehouses, Jack's Castle, Waterfront Tenements, A Day in March, The Closing Hour*	Solo exhibition
April 1920	Brooklyn Museum, New York City	*The Green River*	Group exhibition with Elmer Schofield, Armin Hansen, Kentaro Kato, John E. Cestigan, and Henry R. Rittenberg

Date	Location	Painting(s) Exhibited	Context
April 1920	Carnegie Institute, Pittsburgh		Group exhibition with Abbot H. Thayer, Algernon Talmadge, Walter Ufer, George Coates, and Frederick Bosley
April 1920	Spring Academy, New York City		Group exhibition
December 1920	Powell Gallery, New York City		Group exhibition
February 1921	Baltimore, Maryland	*Passing Boat*	Group exhibition with Edward Redfield, Robert Henri, and George Bellows
February 1921	Milch Gallery, New York City	*The Blacksmith Shop, Gray Day in Spring, The Doorway, The Little Village*	Group exhibition with William Lathrop, Joseph T. Pearson Jr., and Daniel Garber
March 1921	Salmagundi Club Gallery, New York City	*One O'clock*	Group exhibition with Edmund Greacen and Cullen Yates
May 1921			Group exhibition
October 1921	Carnegie Institute, Pittsburgh	*Mountebanks and Thieves*	Group exhibition
January 1923	Macbeth Galleries, New York City	*The White Tenement*	Group exhibition with Alden Weir, Emil Carlsen, Haley Lever, Charles H. Davis, Frederick Frieseke, Elliot Daingerfield, Albert Groll, and Louis Loeb
March 1923	Grand Central Art Gallery, New York City		Group exhibition
May 1923	New York City	*The Green River, Derelicts, The Little Village*	Group exhibition with Henry Golden Dearth and Daphne Dunbar
1923		*The White Mill*	Group exhibition
April 1924	Carnegie Institute, Pittsburgh	*The Tower*	Purchase for group exhibition

Date	Location	Painting(s) Exhibited	Context
April 1924	Vanderbilt Gallery, New York City	*Mountebanks and Thieves*	Group exhibition
September 1924	Canadian National Exhibition, Toronto		Group exhibition
February 1925	Pennsylvania Academy of the Fine Arts, Philadelphia		Group exhibition
April 1925	Rehn Galleries, New York City	*Flowing Water, Quiet, Society of the Steps, Swimming Hole*	Solo exhibition
October 1925	Carnegie Institute, Pittsburgh		Group exhibition
1925	Milwaukee Art Institute	*The Little Village, The Stone Crusher, The Blacksmith Shop, The Huckster Cart*	Solo exhibition
January 1926	Anderson Galleries, New York City		Group exhibition with Charles Hawthorne, John Noble, and Rudolf Evans
January 1926	Brooklyn Museum, New York City	*The White Tenement*	Group exhibition
October 1926	Carnegie Institute, Pittsburgh	*Mountebanks and Thieves*	Group exhibition with Gerruccio Ferrazzi, K. X. Roussel, Max Kuehne, John Carroll, Dod Proctor, Antione Faistauer, Walter Sickert, Fiovanni Romagnoli, Charles Cottet, Felix Vallotton, and Mary Cassatt
November 1931	Carnegie Institute, Pittsburgh	*Hope Williams*	Group exhibition
	Vanderbilt Gallery, New York City		Group exhibition with William Lathrop
	Casson Gallery, Boston	*The Seed of Revolution, The Exodus, The Old City, Five O'clock June, The Bathers, The Doorway*	Solo exhibition
	Republican Club Auditorium, Trenton, New Jersey		Group exhibition with R. Sloan Bredin, Morgan Colt, Daniel Garber, William Lathrop, and Charles Rosen

Date	Location	Painting(s) Exhibited	Context
	Braus Galleries, New York City	*The Passing Boat*	Group exhibition
	Corcoran Gallery of Art, New York City	*Ship Chandler's Row*	Group exhibition
	Philadelphia Art Club	*Spring*	Group exhibition
	London		Group exhibition
	Fort Worth Museum of Art, Texas		Group exhibition
	Arlington Galleries, New York City		Group exhibition
	Pennsylvania Academy of the Fine Arts, Philadelphia	*The Auction*	Group exhibition
	Broadway School, Mystic, Connecticut		Group exhibition including Charles Rosen
	New York City		Solo exhibition
	St. Louis Museum	*Across the River*	Group exhibition
	Paris		Group exhibition
	Detroit	*Rabbit Run Farm*	Group exhibition
	Pyle Art Gallery		Solo exhibition
	New Jersey State Museum, Trenton		Solo exhibition
	Toledo Museum of Art, Ohio		Group exhibition with Daniel Garber, William Lathrop, Morgan Colt, Charles Rosen, and R. Sloan Bredin
	Saint Botolph Club, Boston		Group exhibition with Daniel Garber and William Lathrop
	Carnegie Institute, Pittsburgh	*The Tower*	Group exhibition

APPENDIX 2

SELECTED LIST OF HONORS AND AWARDS

Compiled by Margaret Fulton Spencer for a posthumous exhibition at the Ferargil Galleries, New York, January 10 to February 1, 1932

Carnegie Institute International Exhibition, Pittsburgh. Honorable Mention, 1910

Art Club of Philadelphia. Honorable Mention, 1913 and 1923

National Academy of Design, New York. Second Hallgarten Prize, 1913

Pennsylvania Academy of the Fine Arts, Philadelphia. Jennie Sesnan Gold Medal, 1914

National Academy of Design, New York. Inness Gold Medal, 1914

Boston Art Club. Gold Medal and Purchase Prize, 1915

Panama-Pacific International Exposition, San Francisco. Gold Medal, 1915

Art Institute of Chicago. Norman Waite Harris Bronze Medal, 1919

National Academy of Design, New York. Second Altman Prize, 1920 and 1921

Salmagundi Club, New York. Members Purchase Prize, 1921

Wilmington Society of Fine Arts, Delaware. Mrs. William K. Dupont Prize, 1921

Carnegie Institute International Exhibition, Pittsburgh. Third Prize, 1924

National Academy of Design, New York. Ranger Fund Purchase, 1924

Sesquicentennial International Exhibition, Philadelphia. Gold Medal, 1926

National Academy of Design, New York. Isidor Gold Medal, 1928

Art Club of Philadelphia. Gold Medal, 1928

Mrs. Robert Spencer presents an exhibition of paintings from the Studio of the late

ROBERT SPENCER
1879–1931

JANUARY 10 TO FEBRUARY 1, 1932

~

FERARGIL GALLERIES
63 EAST 57TH STREET, NEW YORK

Figure 1 Exhibit announcement, Ferargil Galleries, New York City, 1932. Courtesy of Gene Mako Galleries

SPENCER AND THE JURIED EXHIBITS: ART INSTITUTE OF CHICAGO, CARNEGIE INSTITUTE, CORCORAN GALLERY OF ART, NATIONAL ACADEMY OF DESIGN, PENNSYLVANIA ACADEMY OF THE FINE ARTS

COMPILED BY Birgitta H. Bond and Michael Holt

The Annual Exhibition Record of the Art Institute of Chicago, 1888–1950

1911	*Lime Kilns, Point Pleasant, Pennsylvania*
	Deserted Cottage
1912	*The Two Mills*
1913	*The Silk Mill*
1914	*The White Tenement*
1915	*Five O'clock, June*
1916	*The Huckster Cart*
1917	*The Auction*
1918	*The Coal Barge*
1919	*The Barracks*
1920	*The Green River*
1921	*Rag Pickers*
	The Stone Crusher
1922	*Evening*
1923	*Mountebanks and Thieves*
1924	*The River Town*
1925	*Gossip*
	Inland City
1926	*Mansions of Yesterday*
1928	*Weather*
1929	*Derelicts*
1932	(Deceased) *Huckster Cart*
1939	(Deceased) *Green River*

Record of the Carnegie Institute's International Exhibitions, 1896–1996

(* indicates an award-winning entry)

1910	*Deserted Cottage*
	The Flume
1911	*The Marble Shop*
	The Roadside
1912	*The Grey House*
	The Two Mills
1913	*The Silk Mill*
1914	*The Grey Mills*
	Spring
1920	*The White Mill**
1921	*Rag Pickers**
	The Stone Crusher
1922	*The Little Village*
1923	*The Tower*
1924	*The Other Shore*
1925	*Ship Chandler's Row*
1926	*Mountebanks and Thieves**
1927	*Inland City*
	Mansions of Yesterday
	Mill Valley
1930	*Portrait of Mr. Moncure Biddle*
	Portrait of Mrs. Moncure Biddle
1931	*An Old City*
	Hope Williams

Biennial Exhibition Record of the Corcoran Gallery of Art, 1907–1967

1910	Lime Kilns: Point Pleasant, Pennsylvania
	The Flume
1912	The Bridge
1914	The Grey Mills
	Courtyard at Dusk
1916	The Black River
	The White Mill
	Across the River
1919	The Red Boat
	The Barracks
1921	The Market
	Mill Valley
	The Bathers
1923	The Doorway
	Women Dressing
	The Stone Crusher
1926	Ship Chandler's Row
	Mansions of Yesterday
1928	The Seed of a Revolution
	Derelicts
1930	Gossip
	Mob Vengeance

The Annual Exhibition Record of the National Academy of Design, 1901–1950
(* indicates an award-winning entry)

1909	The Farm
	The Flume
	The Crossroads
1910	Lime Kilns: Point Pleasant, Pennsylvania
	The Marble Shop
	The Apple Tree
1911	The Grey House
	Buildings in Plumstead
	Deserted Cottage
	The Two Mills
	The Mill Yard
1912	The Bridge
	The Church
	A Grey Day
1913	The Silk Mill*
	Repairing the Bridge
	The Grey Mills
1914	Closing Hour
	The White Tenement*
	Five O'clock, June
1915	Rabbit Run Farm
	The Brook
	The Blue Gown
	The Huckster Cart
1916	On the Canal: New Hope
1917	The Auction
	The Red Jar
	The Coal Barge
	The White Mill

PRIZES AT THE ACADEMY

W. Elmer Schofield Awarded First Altman Prize of $1000—Robert Spence Second—Other Awards

The prize winners in the ninety-fifth annual exhibition of the National Academy of Design, which opens on Tuesday at the Brooklyn Museum, Eastern Parkway, Brooklyn, have been announced. The largest prize of the exhibition, the Altman prize of $1000, was awarded to W. Elmer Schofield, the New York artist, for "The Rapids," the best landscape in the exhibition painted by an American-born citizen. The second Altman prize of $500 was won by Robert Spencer of New Hope, Pa., with a landscape entitled "Green River." The Thomas B. Clarke prize of $300 for the best American figure composition, painted in the United States by an American citizen without limitations of age, went to James R. Hopkins of Cincinnati for a picture called "Mountain Courtship," and Henry Rittenburg of New York won the Isaac N. Maynard prize for the best portrait in the exhibition with a portrait of the artist, Elliott Daingerfield.

Figure 1 Newspaper clipping from *The Evening Transcript*, Boston, March 31, 1920. Courtesy of Gene Mako Galleries

1918	Waterloo Place
	The Black River
1919	A Fisherman's House
	The Market
	The Village Lane
1920	The Green River
1921	Rag Pickers*
	Grey Day in Spring
	A River Town
1922	The Stone Crusher
	The Tower
1923	Mountebanks and Thieves
	Mill Valley
1924	The Other Shore
1926	The Crowding City
	Inland City
1928	The Exodus*
1930	Portrait of Mrs. Ellwood Hendrick
1931	Woman Washing Herself

The Annual Exhibition Records from the Pennsylvania Academy of the Fine Arts, Vol. II, 1876–1913, and Vol. III, 1914–1968

1910	End of the Village: Lumberton
	The Marble Shop
	Deserted Cottage
1911	The Roadside
1912	The Two Mills
	The Grey House
1913	The Courtyard
1914	Five O'clock: June
	Gray Day
1915	The White Tenement
1916	The Blue Gown
	The Huckster Cart
	Rabbit Run Farm
	Back Yards

1917	Across the River
	The Black River
1918	The Village Lane
	The Coal Barge
	The Auction
1919	Courtyard at Dusk
	Derelicts
	Washerwomen
1920	The Barracks
	The Little Village
1921	The City
	The Green River
1922	Mill Valley
	The Tower
1923	The Other Shore
1924	Evening
	The River Town
1925	Wharves
1926	Inland City
	Gossip
1927	The Crowding City
1928	The Blacksmith's Shop
	The Peddler's Cart
	Weather
1929	The Exodus
	Portrait of a Lady
1931	Mob Vengeance
	An Old City
1932	(deceased/memorial group)
	In Spring
	Stone Crusher
	Peninsula
	Red Shale Road

JAMES A. MICHENER ART MUSEUM
STAFF 2004

Diane Ambrose, Tourism Sales Manager, Volunteer
 Coordinator
Marion Anderson, Administrative Assistant to Director
Basil Antrobus, Security Officer
Eleanor Bauer, Membership Assistant/Front Desk Staff
Birgitta H. Bond, Librarian/Artists Database Coordinator
Bryan Brems, Preparator
Candace Clarke, Education Coordinator
Sarah Colins, Front Desk Staff
Judy Eichel, Personnel Administrator/Administrative
 Assistant
Jack Emerson, Security Officer
Elisabeth Flynn, Public Relations Manager
Anita Greenspan, Front Desk Staff
Christine Hacker, Buyer/Visitor Services Manager
Carole Hurst, Director of Institutional Advancement
Marna Hydrusko, Marketing Assistant
Michael Jayne, Assistant Facility Manager
Bruce Katsiff, Director and CEO
Constance Kimmerle, Curator of Collections
Dorothy Landes, Director of Accounting
Tracie Lear, Front Desk Staff
Amy Lent, Director of Marketing and Retail Services
Paulette Lidert, Director, Educational Outreach
Sarah Lipoff, Assistant Curator of Education
Margaret MacDonald, Administrative Assistant, Annual
 Fund and Corporate Business Partners Program
Faith McClellan, Assistant Registrar
Janet Moore, Front Desk Staff
Bettina A. Murdoch, Director of Annual Fund and
 Community Outreach

Adrienne Neszmelyi Romano, Associate Curator of
 Education
Heather O'Donnell, Front Desk Staff
Brian H. Peterson, Senior Curator
Charles E. Quasté, Sr., Director, Protective Services
 and Building Operations
Carol Rossi, Registrar
Jack Schiller, Security Officer
Pamela Sergey, Front Desk Staff
Susan Sherman, Children's Gallery Coordinator
Zoriana Siokalo, Curator of Education and Public
 Programs
Erika Jaeger Smith, Associate Curator of Exhibitions
Tana Steen, Front Desk Staff
Christine Tokugawa, Facilities Assistant
Deborah Velardi, Bookkeeper
Joan Welcker, Membership and Information
 Technology Manager
Gilbert Winner, Facility Manager
Louise Zappulla, Front Desk Staff

New Hope Staff
Sherri Brinkman, Front Desk Staff
Hollie Brown, Site Manager
Erin Frater, Front Desk Staff
Edward G. Knellinger, Manager of Safety and Security
Melissa Stavey, Front Desk Staff
Christine Tokugawa, Front Desk Staff
Ray Worner, Security Officer
Beverly Zuber, Front Desk Staff

JAMES A. MICHENER ART MUSEUM
BOARD OF TRUSTEES 2004

Honorary Trustees—Kitty Carlisle Hart,
 Denver Lindley, Jr., Ann Silverman

Chairman Emeritus, Herman Silverman
Chairman, Carolyn Calkins Smith
President, Hon. Edward G. Biester, Jr.
Vice President, Molli Conti
Secretary, Leslie Skilton
Treasurer, William S. Aichele

Dana G. Applestein
William F. Brenner
Robert L. Byers
Anthony C. Canike
Louis Della Penna
Edward Dougherty
Neil Ellenoff
Edward Fernberger, Jr.
Charles H. Gale, Jr.
Frank N. Gallagher, Esq.
Elizabeth Beans Gilbert
J. Lawrence Grim, Jr., Esq.
M. Carole Knight
William Mandel
Mira Nakashima-Yarnall
G. Nelson Pfundt
Albert W. Pritchard, Jr.
Kevin S. Putman
Katharine Steele Renninger
William H. Rieser
Bryce M. Sanders, Jr.

Director/CEO, Bruce Katsiff